Albrecht Dürer

Albrecht Dürer

Artist in the Midst of Two Storms

Stacey Bieler

CASCADE *Books* • Eugene, Oregon

Cascade Books
An Imprint of Wipf and Stock Publishers
199 W. 8th Ave., Suite 3
Eugene, OR 97401

www.wipfandstock.com

PAPERBACK ISBN: 978–1-5326–1965-6
HARDCOVER ISBN: 978–1-4982–4611-8
EBOOK ISBN: 978–1-4982–4610-1

Cataloging-in-Publication data:

Names: Bieler, Stacey, author.

Title: Albrecht Dürer : artist in the midst of two storms / Stacey Bieler.

Description: Eugene, OR: Cascade Books | Includes bibliographical references.

Identifiers: ISBN: 978-1-5326-1965-6 (paperback) | ISBN: 978-1-4982-4611-8 (hardcover) | ISBN: 978-1-4982-4610-1 (ebook).

Subjects: LCSH: Dürer, Albrecht, 1471–1528—Criticism, interpretation, etc.

Classification: N6888 D4 B54 2017 (print) | N6888 D4 (ebook)

Manufactured in the U.S.A. 10/30/17

To Tom and Renee

Contents

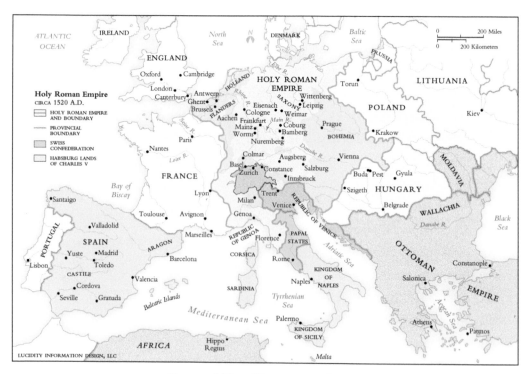

Figure 1. A Map of Europe around 1520.

1

Art, Religion, and Politics

In 1520, the artist and entrepreneur Albrecht Dürer lived and worked in Nuremberg, a wealthy crossroad city-state in Germany. While the innovations of Dürer influenced art and media, the theological writings of the German monk Martin Luther altered Dürer's views on life and death. These two men inspired changes in art, religion, and politics that are still rumbling through culture and social structures today.[1]

Dürer lived in the midst of two storms that threatened the Holy Roman Empire, which stretched from the border of France to Austria, and from the Netherlands to the border of the Republic of Venice. Charles V of Spain, grandson of the former emperor and Hapsburg ruler, was crowned at the age of twenty to become the Holy Roman emperor in October 1520.[2]

Suleiman, a young sultan of the Ottoman Turks who came to power less than a month earlier, was the menacing storm from the outside as he sought legitimacy through taking Vienna and even Europe, a goal his father had failed to achieve. In 1521, Suleiman took Belgrade, which is more than half of the way between the Ottoman capital, Constantinople, and Vienna, the capitol of the House of Hapsburg since 1282.[3]

Martin Luther was the powerful inner storm, challenging both the authority of the pope in Rome and of the emperor. Even German princes began to follow Luther's teachings rather than those of the Catholic Church.[4]

These two storms interacted with each other.[5]

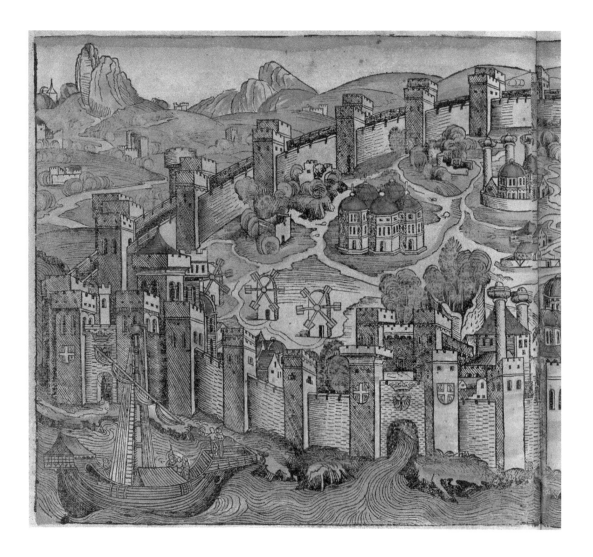

Figure 2. Attributed to Michael Wolgemut, *Constantinople,* 1493. Colored woodcut from the *Nuremberg Chronicle.* The large blue dome in the lower right part of the city is the Hagia Sophia.

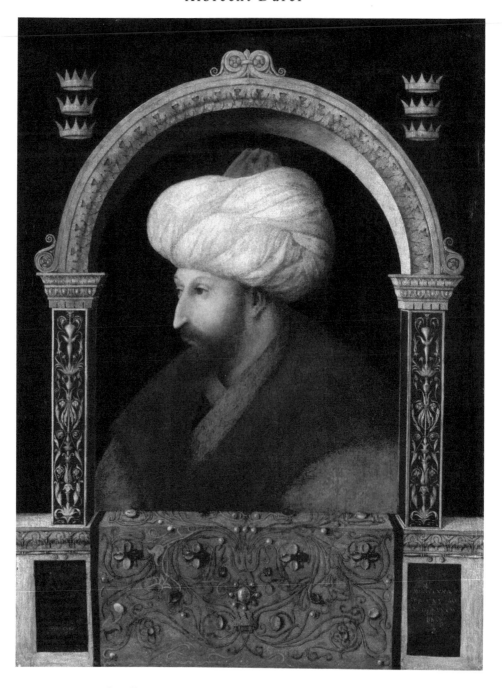

Figure 3. Gentile Bellini, *Mehmed II*, 1480. Oil on canvas, 27.5 x 20.5 in. (69.9 x 52.1 cm.).
National Gallery, London.

2

The Recurring Outer Storm

One hundred years before Dürer, two similar storms had threatened the empire. A recurring outer storm begin when the Ottoman Turks took Constantinople (today's Istanbul, Turkey) in 1453, and then stormed up the Danube to Belgrade in 1456. The Europeans feared that the Turks would soon be at Vienna, the doorstep of Europe. Belgrade changed hands between the Hapsburgs and the Ottomans numerous times during the following decades.[1]

When the Roman emperor Constantine moved his capitol from Rome to Byzantium in AD 330, he renamed it Constantinople. He built a strong wall around the city, a strategic location between the European and Asian regions of the Roman Empire. In 476, the city of Rome was overrun by German barbarians from the north. Though Constantinople was the wealthiest and largest city in Europe from the fourth century to the early thirteenth century, the Byzantine Empire had shrunk to little more than the city itself after the Mongol Invasion (1242–43) and civil wars.[2] One hundred and fifty years after the Ottoman Empire was founded in northwestern Anatolia (Turkey), the young Ottoman ruler, Mehmed II, age twenty-one, laid siege to Constantinople. On May 28, Emperor Constantine XI held a solemn service of communion in the huge cathedral, the Hagia Sophia (Holy Wisdom). The following day, the emperor died in battle and the city fell to the Ottoman Turks. Mehmed converted the cathedral into a mosque. Mehmed, now called the Conqueror, took Southeast Europe as far as Bosnia and eyed Hungary as his next conquest.[3]

As Venice had grown rich through its role as a conduit of goods from Asia and Africa to Europe, it became one of the centers of Renaissance art in Italy. However, it suffered due to the decrease of trade and the war with the Ottomans. In an offer of peace, Mehmed asked Venice to cede certain territories, send tribute to gain trading privileges, and to send a painter to paint the Sultan's portrait. The Venetian Senate chose their best painter, Gentile Bellini, to go to Constantinople as a cultural ambassador.[4]

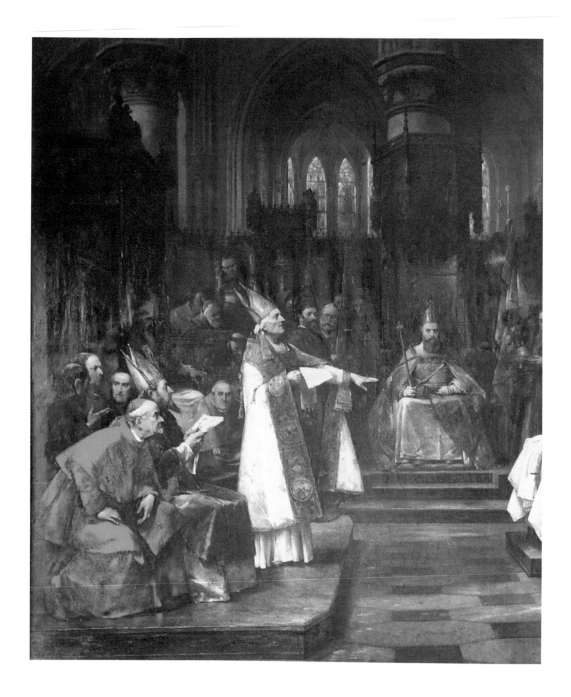

Figure 4. Vaclav Brozik, *Jan Hus in Council of Constance*, 1883.
Oil on canvas, 196.9 x 315 in. (500 x 800 cm.). Old Town Hall, Prague.

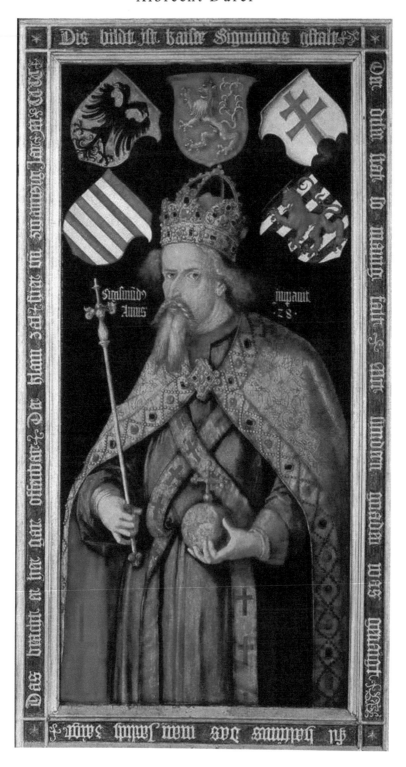

Figure 5. Albrecht Dürer, *Emperor Sigismund*, 1511–1513.Oil and tempera on lime. 84.6 x 45.3 in. (215 x 115 cm.). Germanishes Nationalmuseum, Nuremberg.

3

An Earlier Inner Storm

An earlier inner storm began after the priest Jan Hus read the writings of the English reformer John Wycliffe. Hus began preaching in Czech, instead of Latin, in Prague and called the church to reform. He refused to go to Rome to explain to the pope why he was still preaching in a chapel that was not on the list of acceptable locations. In 1411, the pope excommunicated Hus, barring him from taking the sacraments. Since the church was understood to be the mediator between the people and God, an excommunicated person was thought to be cut off from God and denied entrance into heaven.[1]

King Sigismund of Hungary, Croatia, and Germany invited Hus to defend himself before the Council held in Constance in southern Germany. Though the King promised Hus safe conduct to the Council, Hus was treated as a prisoner after he refused to recant. The next time he appeared before the Council, he was in chains. The third time, July 6, 1415, he was condemned as a heretic. He was taken past a pyre, where his books were being burned, to a stake where he was tied and burned.[2]

The Bohemians were enraged that their national hero had been murdered. People rioted against both the clergy in Prague and the Bohemian nobles. In response, the Church led five military attacks against Bohemia from 1420 to 1431, but they all failed.[3]

In 1424, King Sigismund moved the imperial coronation clothing, crown jewels, and relic collection from Prague to Nuremberg, his hometown, because he was afraid that the treasures could fall into the hands of the Hussites. The expanding storm caused the people of Nuremberg to widen the moat and build new ramparts around their city in 1427, for they feared a Hussite attack.[4]

In 1432, the Church Council agreed to the Four Articles presented by the Bohemians. First, the Word of God would be freely preached throughout Bohemia. Second, communion would be given of "both kinds," that is, both the bread and the cup would

be given to the laity (not just the bread). Third, the clergy would be stripped of their wealth and live in poverty. Finally, sins, such as simony (buying or selling church offices or positions) would be punished. The ancient and powerful Church had never made such concessions before.[5]

In 1433, Sigismund was elected the Holy Roman emperor. He only ruled four years. Each new emperor was required by law to convene his first formal assembly, or imperial diet (pronounced "dee-et"), in Nuremberg.[6]

Albrecht Dürer the Elder, born in 1427 in Ajtos (near Gyula), in eastern Hungary, completed basic training as a goldsmith under his father. At the age of sixteen or seventeen, he left his home because he wanted to escape the Hussite Wars that had spread beyond Bohemia. He traveled westward, probably along the Rhine, enjoying the medieval goldwork found in the cathedral treasuries in the cities along the river. After receiving further training in the Netherlands, he finally settled in Nuremberg, Germany, in 1455.[7]

4

Nuremberg

Albrecht Dürer the Elder found employment with Hieronymous Holper, a master goldsmith who had designed part of the official seal for the King of Bohemia and Hungary in 1454. After working for twelve more years, Dürer became a master goldsmith and later married his master's young daughter, Barbara. He received orders from ecclesiastical groups and Emperor Frederick III. The city fathers considered Dürer trustworthy enough to give him his father-in-law's office of official assayer, the person who judges the weight and worth of silver and gold.[1]

Their fourth child, Albrecht Dürer, was born on May 21, 1471. Albrecht Dürer the Elder outlived fifteen of his eighteen children. The young Albrecht was the eldest child to survive.[2]

Albrecht Dürer's godfather, Anton Koberger, was a well-established goldsmith. In the year of Albrecht's birth, Koberger became a publisher. His 1483 Bible, the second one in German, was published, in two large volumes with gilded initials and hundreds of woodcuts illuminated in watercolor. In 1494 he published the *Nuremberg Chronicle*, a world history that focused on cities. It was the first largely illustrated book in German. Since most of his customers were distant, he shipped his books unbound, in barrels, all over Europe. Koberger was influential later when young Albrecht established his printmaking business.[3]

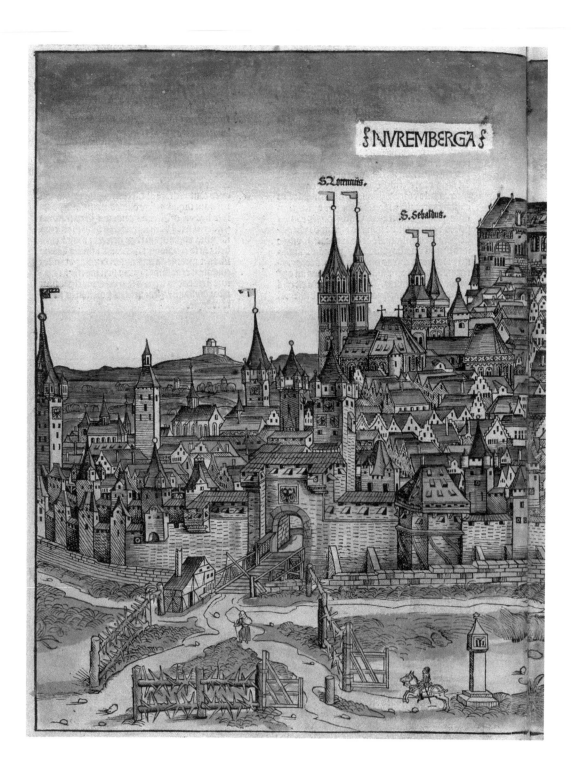

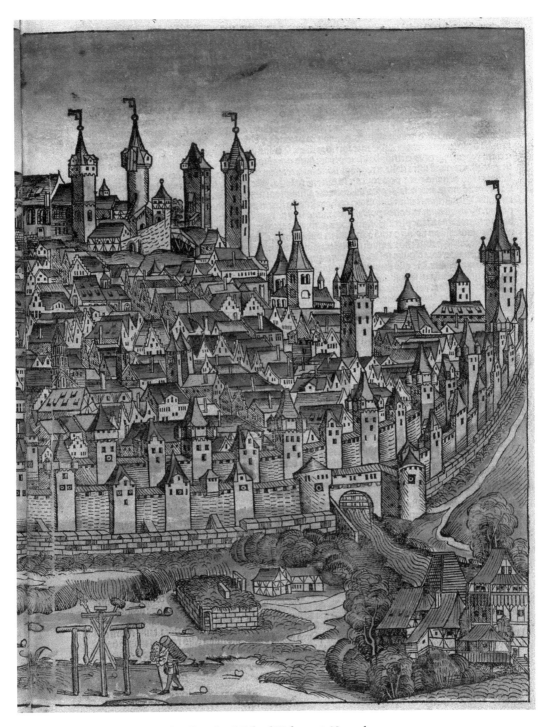

Figure 6. Attributed to Michael Wolgemut, *Nuremberg,* **1493.**
Colored woodcut from the *Nuremberg Chronicle.*

Figure 7. Heinrich Beheim, Schöner Brunnen (Beautiful Fountain), 1385–96. Painted metal, 19 meters high. Nuremberg's Market Square. The tall fountain, shaped like a Gothic spire, is decorated with forty heroes and prophets from the Old and New Testaments and antiquity.

The walled city of Nuremberg, at the convergence of twelve major trade routes, was the market center of Europe. Baltic merchants brought amber, furs, and salt fish from the north. Travelers from Hungary and Bohemia in the east came with gold, silver, copper, and horses. Spices, silks, and luxury goods came from Venice. From the Netherlands, merchants brought woolen cloth to sell. Visiting merchants also brought epidemics, like the plague. The town had almost no natural resources, no navigable waterway nearby, and poor soil, but it had reciprocal trade agreements with seventy cities. Each successive emperor protected the city as a source of revenue. The population grew until it surpassed that of Rome.[4]

Two of the parish churches in the city were built in the thirteenth and fourteenth centuries. The older church, St. Sebald, on the north side of town, was built to celebrate the great charter given by the emperor in 1219. The light coming through the tall Gothic stained glass windows glowed on the Nuremberg reddish sandstone. The newer church, St. Lorenz, had a large rose window and two towers. Rich families filled the side chapels with carved altars and paintings by local artists. The church kept the time for the city by ringing bells through the day and celebrating saints' days throughout the year.[5]

Nuremberg was known for metalworking. Craftsmen made astronomical instruments, globes of both the earth and the sky, and measuring devices of all kinds. Artisans acquired materials from around the known world and distributed their products to a global market, which continued to expand as voyagers explored new territories. Weights, guns, brass trumpets, and scientific instruments were stamped with the stamp of its maker as well as "N" or the Nuremberg eagle after inspection.[6]

The city fathers were proud of the variety of special products made by their renowned craftsmen. In 1490, a Nuremberger, who became a world traveler, made a beautiful globe called "earth apple" that stood in the town hall. A sculptor who carved wooden altars contributed to Emperor Maximilian's tomb. A bronze sculptor had commissions from cardinals and bishops as well as the emperor. One clockmaker made pocket watches in the shape of eggs that ran on tiny steel wheels. A city official and his assistants supervised the weighing and sales of goods, from apples to wine, and more than one hundred crafts.[7]

Nuremberg was a "free city" or "imperial city"—one of more than sixty in the Holy Roman Empire under the direct authority of the emperor. Its residents gave the emperor a formal oath of allegiance and paid taxes to him rather than the bishop of the diocese of Bamberg, forty miles to the north. Their third duty was to offer the emperor hospitality. Since no emperor wanted to live in its drafty rooms of the medieval fortress on Castle Rock during the winter, the emperor and his entourage stayed in one of the comfortable homes of wealthy residents within the city.[8]

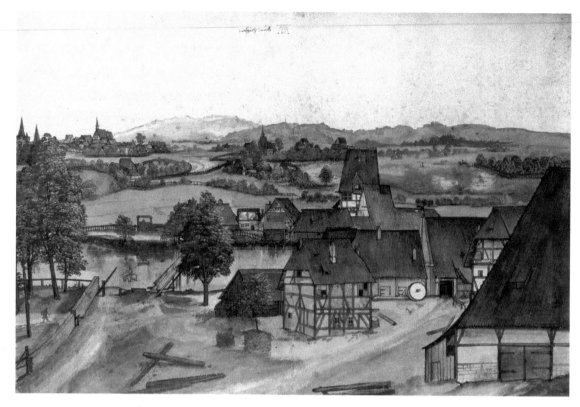

Figure 8. Albrecht Dürer, *Wire-drawing Mill*, c. 1489. Watercolor and gouache on paper, 11.26 x 16.77 in. (28.6 x 42.6 cm.). Gemäldegalerie, Kupferstichkabinett, Berlin.

Since the emperor rarely resided in Nuremberg, the city-state was run by its own city council of wealthy upper middle-class citizens who met three times each week. The town hall stood on the north side of the city square. The two hundred members of the Greater Council, in their black robes and berets, sat on long cushioned benches discussing and writing decrees on subjects from washing to war. Adjacent to that chamber was the eighty-foot-long great hall where the emperor held court when he was in town and where the wealthy hosted receptions, dances, and weddings. The Small Council, the elite forty-two members, met in a smaller chamber next door. The coronation regalia and relic collection, kept in locked storage in the Hospital of the Holy Spirit, were displayed annually in the market square facing the town hall.[9]

5

The Young Apprentice

Dürer the Elder grew rich enough to maintain a house and a separate shop in Nuremberg. His son painted him, holding a rosary as a symbol of piety, for he took great effort to raise his children to love and honor God and to act honestly with their neighbors.[1] Like most children of merchants in Nuremberg, young Dürer was probably sent to a small, privately run school where he learned enough penmanship, arithmetic, and reading to do business. A math book printed in German in Nuremberg in 1492 included problems that dealt with the sale of tin, grain, pepper, wine, and saffron. Because Dürer did not go to a Latin school, he never mastered Latin. Later in life, he had to wait for editions of the writings of Martin Luther or Euclid, the Greek mathematician, to be printed in German. After three or four years, his father withdrew his son from school to train him as a goldsmith. Young Dürer learned to draw and to handle the engraver's burin, or steel cutting tool.[2]

At the age of thirteen, Dürer drew the first of his many self-portraits in silverpoint. In his own hand he wrote: "I drew this myself from a mirror in the year 1484, when I was still a child. Albrecht Dürer."[3]

Scribes first developed silverpoint in monasteries in the Middle Ages. This difficult medium uses a silver stylus on paper parchment or vellum made from cleaned, treated calfskin. The paper or vellum is first coated with a preparatory ground of glue-water and lead white, a common pigment. Then it is burnished or polished. When the stylus is drawn through the prepared ground, a chemical change occurs. When the picture is "ripe," or done, it is a brownish line drawing. Mistakes cannot be erased. To start over, the whole paper or parchment needs to be washed and recoated with ground.[4]

This particular drawing is noteworthy. First, self-portraits were just becoming an acceptable genre of painting. Second, this young boy figured out how to draw himself using a mirror. Third, working in silverpoint shows that Dürer had an unusual degree of ability, assurance, and precision.[5]

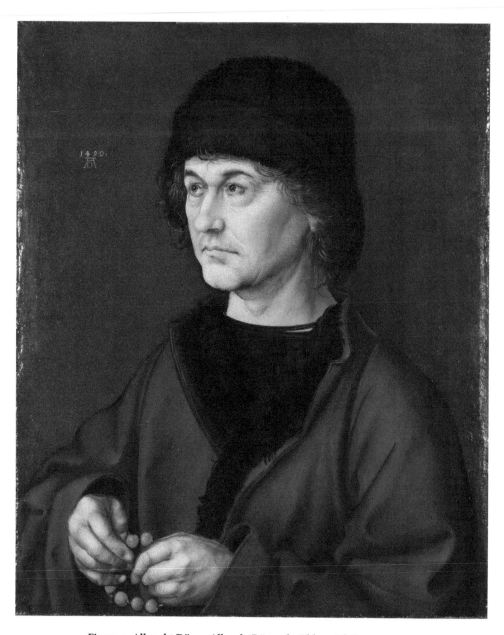

Figure 9. Albrecht Dürer, *Albrecht Dürer the Elder with Rosary*, 1490.
Oil on oak panel, 15.6 x 18.7 in. (47.5 x 39.5 cm.). Uffizi Gallery, Florence.

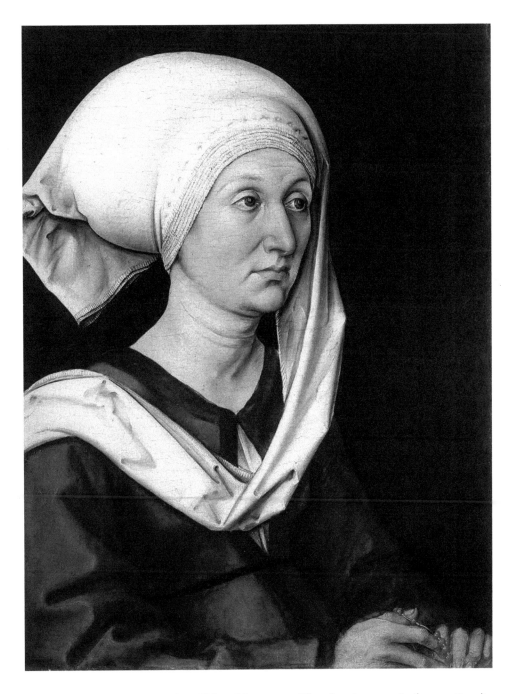

Figure 10. Albrecht Dürer, *Barbara Holper Dürer*, 1490. Oil on fir, 18.5 x 14.1 in. (47 x 35.8 cm.). Germanisches Nationalmuseum, Nuremberg.

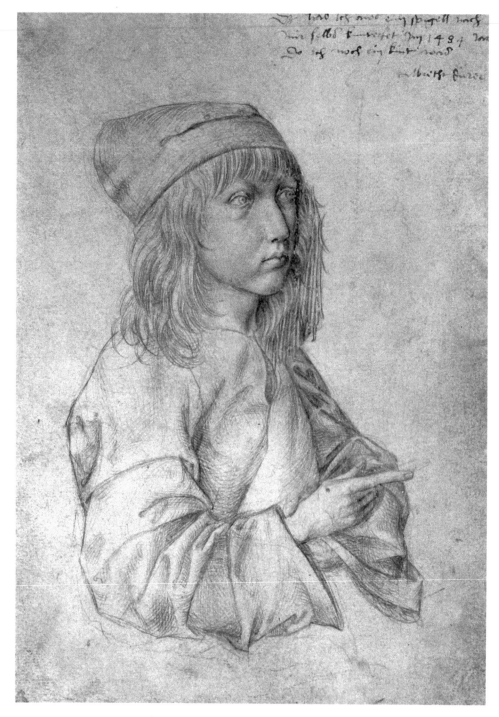

Figure 11. Albrecht Dürer, *Self-Portrait at the Age of Thirteen*, 1484.
Silverpoint, 10.8 x 7.7 in. (27.5 x 19.6 cm.). Albertina, Vienna.

6

Wolgemut's Woodcuts

Following four years of training with his father, young Dürer wanted to apprentice as a painter. His father sent him to work with a neighbor, Michael Wolgemut, who operated the largest workshop in the city. Wolgemut was not a great painter, but he was an effective organizer who accepted commissions for paintings, sculpture, stained glass, and woodcuts. He was the first German painter to contract directly with a publisher.[1]

Dürer started this apprenticeship when he was fifteen instead of the more customary age of ten or twelve. This may be why he wrote that he "endured much from [Wolgemut's] apprentices." During his basic training Dürer learned how to prepare wooden panels, mix colors and drawing inks, and compose large-scale works, such as altarpieces for churches. Dürer also learned the art of woodcutting from Wolgemut, whose woodcuts were among the best in Europe at the time. In 1493, Wolgemut's studio provided 652 different woodcuts for the *Nuremberg Chronicle* (e.g., figures 5, 52, and 77).[2]

A woodcut was made by first covering a block of soft wood (often pear) with white ground and drawing a composition on it. Using various tools, the artist takes away areas from the block that are not to have ink in the print. Then the block was inked using a roller. Woodcuts could be printed by hand, requiring almost no equipment, or by using a printing press.[3]

Johannes Gutenberg invented the press around 1440 in Mainz, Germany. The woodblocks were locked into the press bed next to columns of text set in movable type (letters) made from a metal alloy. Gutenberg's first production was two hundred typeset Bibles in Latin in 1455. The first dated item printed by his workshop were indulgences sold by the Church to raise money to fight against the Ottomans who had recently captured Constantinople.[4]

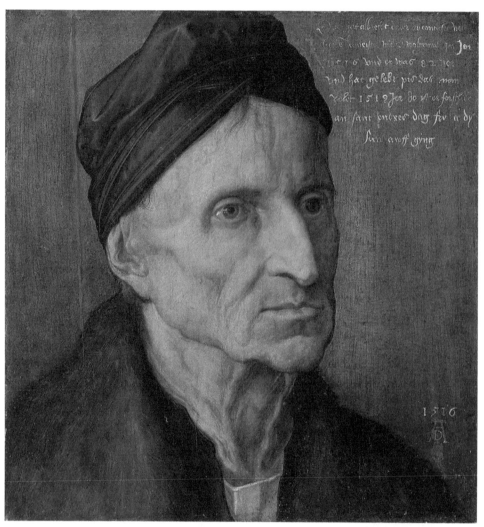

Figure 12. Albrecht Dürer, *Portrait of Michael Wolgemut*, 1516. Oil and tempura on linden wood, 11.4 x 10.6 in. (29 x 27 cm.). Germanisches Nationalmuseum, Nuremberg.

Figure 13. A printing press. Part of the Johannes Gutenberg Memorial, Mainz, Germany.

Figure 14. A printer sitting in front of a box filled with type.
Part of the Johannes Gutenberg Memorial, Mainz, Germany.

This new means of disseminating and exchanging new ideas, as well as "secrets of the ancients" (Greeks and Romans), spread rapidly to German and Swiss-German towns. Before the younger Dürer was born, printing presses were already operating in Rome, Milan, Florence, and Naples. Johannes Mentelin printed the first Bible in German in Strasbourg in 1466, more than fifty years before Martin Luther's well-known translation. When Dürer was a child in the 1470s, presses were also running in Paris, Lyon, Bruges, and Valencia.[5]

7

A Journeyman

Now that Dürer could support himself, he wanted to learn another artistic skill. Since no one in Nuremberg could teach him how to engrave and print intaglio or incised plates, he set off as a journeyman just before his nineteenth birthday.[1]

Engravings were made on plates of rolled copper, using a tool with a steel shaft sharpened to cut grooves into the copper. After the plates were carefully inked and wiped, they were put into a press where damp paper was forced into the incisions on the plate to pick up the ink.[2]

Dürer's father hoped that his son would be able to work for Martin Schongauer in Colmar, across the Rhine River in today's eastern France. Schongauer was the first major German graphic artist known to be trained as a painter rather than as a goldsmith. Many artists in Spain, the Netherlands, and Italy copied his work.[3]

Dürer left Nuremberg in April 1490 with letters of recommendation from his godfather, Anton Koberger. He made no record of his travels for the next eighteen months, but when Dürer arrived in Colmar in early 1492, he found that Schongauer had died a year earlier, probably from the plague. Schongauer's brothers welcomed Dürer and allowed him to make a careful study of the old master's paintings and engravings. They encouraged him to go to Basel, Switzerland, where their fourth brother, a goldsmith, lived.[4]

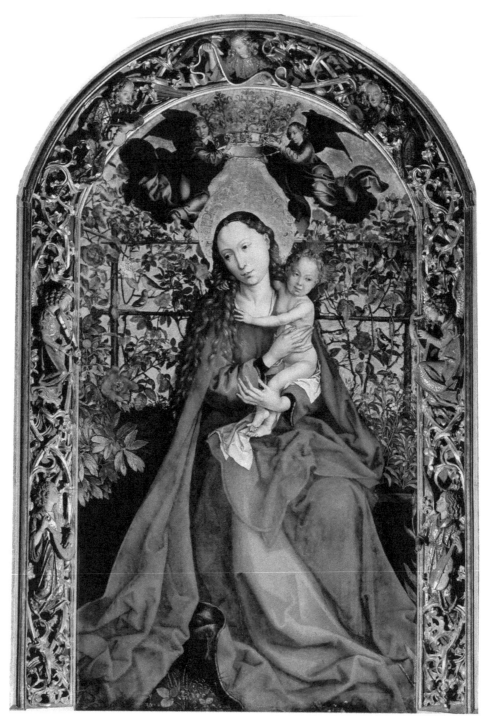

Figure 15. Martin Schongauer, *Madonna in Rose Garden*, 1473.
Oil on panel, 78.7 x 115 in. (200 x 115 cm.). St. Martin, Colmar.

8

St. Jerome in His Study (1492)

Once Dürer was in Basel, he made contact with publishers. He made drawings for 147 woodcuts for a new edition of the *Comedies* written by Terence, a Roman playwright around 180 BC. The book was never published because a similar book was published in Lyon, France, the following year.[1]

Dürer's first known woodcut was the title page of *St. Jerome's Letters*, published by Nicolaus Kessler in 1492. On the side of the woodblock he signed "Albrecht Dürer von Normergk" (from Nuremberg). St. Jerome in His Study was a common subject for many artists during the Middle Ages. Born in Stridon, (today's Bosnia) around 350 AD, Jerome was known for translating most of the Bible from the original Hebrew and Greek into Latin. The church used this version, referred to as the Vulgate. Dürer shows St. Jerome sitting, surrounded by three open books. One has Hebrew script, the second has Greek, and the third was in Latin. Dürer's woodcut was the first print depicting Jerome that included Hebrew script. Not all of the Hebrew letters are correct![2]

Both the clergy and the laity appreciated Jerome's encouragement to imitate Jesus and to be pious in order to "die well." Many humanists, who were enjoying the revival of classical ancient Greek and Roman texts, also admired Jerome's simple and holy life, as well as his mastery of languages. One professor of law in Nuremberg resigned from his teaching position in order to imitate St. Jerome by spending the "remaining time of his life reading holy Scriptures, especially the books of St. Jerome, which pleased him greatly, and also with prayer, celebration of the Mass, contemplation, and service to God."[3]

Sometime during his stay in Basel, Dürer made a drawing of *Love Couple* (or *Young Couple Walking)*. The couple is wearing courtly clothing, including long point-ed shoes. The young man resembles Dürer.[4]

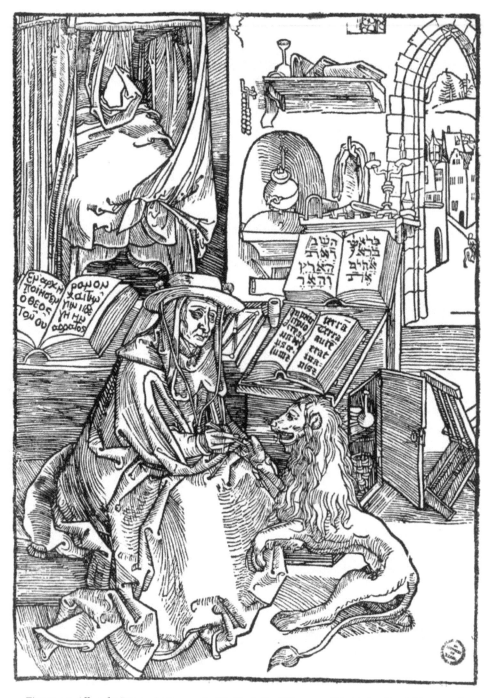

Figure 16. Albrecht Dürer, *St. Jerome in His Study* for title page of *Epistolae Beati Hieronymi*
(*Letters of St. Jerome*), Basel: Nicolas Kesler, 1492.
Woodcut, 7.48 x 5.24 in. (19 x 13.3 cm.). Kunstmuseum Basel.

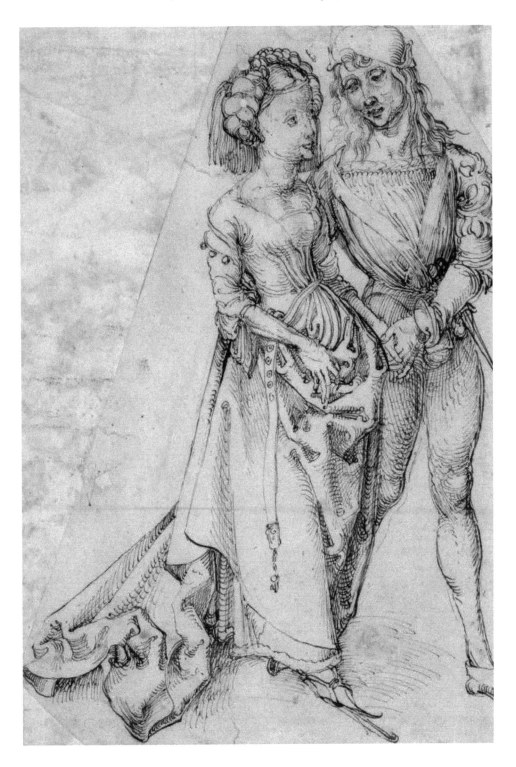

Figure 17. Albrecht Dürer, *Love Couple*. Undated, probably in Basel. Pen and brown ink on paper, 10.2 x 7.5 in. (25.8 x 19.1 cm.). Kunsthalle, Hamburg.

Figure 18. Albrecht Dürer, *Portrait of Agnes Frey Dürer* ("Mein Agnes"), 1494. Pen and black ink on white paper, 6.14 x 3.86 in. (15.7 x 98 cm.). Albertina, Vienna.

9

A Wedding

Dürer was called home from Basel to get married. His father arranged his son's marriage to the daughter of Hans Frey, a master craftsman from an old Nuremberg family. Frey worked in brass and hammered copper, casting and chasing (embossing) statues used in ornamental fountains. Frey was also known as a good singer and the best harp player in town.[1]

The Frey family owned two adjoining houses on the west side of the Hauptmarkt (market square) at the center of town. Frey's wife, Anna Rummel, came from Nuremberg's wealthiest family. One ancestor on her father's side was an internationally respected financier who made loans to emperors. When Anna married Hans Frey in 1472, she brought a dowry of eight hundred florins as a gift into the marriage. Hans and Anna had two daughters, Katharina and Agnes.[2]

Agnes, nineteen, brought a dowry of two hundred florins into her marriage with Dürer, equal to the price of a comfortable house. Albrecht and Agnes were married on July 7, 1494. The couple lived in one of their parent's households, as was customary for newlyweds. Dürer made a pen drawing of *My Agnes* showing her braid down her back.[3]

Figure 19. Albrecht Dürer, *View of Arco*, c. 1495. Watercolor on paper, 8.7 x 8.7 in. (22.1 x 22.1 cm.). Louvre Museum, Paris.

10

First Journey to Italy

Several months after Dürer married, he travelled to Italy to study art. Since he had already fulfilled his obligation to learn his craft by working for four years as a journeyman in Switzerland, this was unusual. Most craftsmen only spent one or two years as a journeyman. German artists usually went north to Bruges and Ghent to learn. He may have been the first German to go to Italy to study art. Maybe Dürer wanted to escape the plague, which came to Nuremberg in early September 1494, killing more than eight hundred people. Perhaps he was curious after seeing engravings by Italian artists and hearing businessmen speak about Venice, the wealthiest city in Europe.[1]

Traveling with an armed convoy of Nuremberg businessmen, Dürer probably left in late summer to avoid both the rains and snow on Brenner Pass, the easiest path across the Alps. At a comfortable pace, the trip took two weeks.[2]

A large and prosperous German community of tradesmen, bankers, and innkeepers lived in their own section of Venice. The businessmen dined, drank, and made deals on spices and silks at the German clubhouse. The house was only one bridge away from Rialto Square, where streets with shops for jewelers, tailors, and cloth dealers converged. Moneychangers exchanged many types of coins from across Europe and Asia.[3]

Though little is known about Dürer's time in Italy, the thirteen watercolors made on his return journey to Nuremberg were among the first pure landscape paintings of modern times. "The View of the Arco" in the province of Trentino shows that he took the southern route home, via Padua and Verona. The mountain dominates the scene with houses, walls, towers, olive trees, and vines in spring green below.[4]

The final travel watercolor was of Innsbruck, Austria, eighteen miles north of Brenner Pass. The painting shows the city walls with towers, boats on the flowing river, and the mountains with snow in the distance under a canopy of clouds. These watercolors reflect Dürer's new skills in using color and light learned during his time in Venice.[5]

Figure 20. Albrecht Dürer, *View of Innsbruck From the North*, c. 1495. Watercolor and body color over faint line drawing, 5 x 7.4 in. (12.7 x 18.7 cm.). Albertina, Vienna.

11

Setting Up His Workshop

At age twenty-four, Dürer returned home and set up his own workshop. Unlike his master Michael Wolgemut, Dürer did not wait until he received commissions, but began printing and building up a stock of engravings and woodcuts with a wide variety of subject matter. Then he sought a receptive audience.[1]

Dürer was fortunate to live in Nuremberg because the town had no guilds. Guilds usually helped their members by providing unemployment insurance and death benefits, a social life with other members of the guild, and collective political power. The guilds also had strict rules that kept artisans from experimenting with different designs and formats. However, in Nuremberg all social and political activity and all self-regulation of technical matters was banned after an artisan revolt in the mid-fourteenth century.[2]

Nuremberg was an ideal location for a graphic artist. A ready supply of fine paper was available in two grades from Germany's first paper mill. The mill, built in 1390, can be seen in Wolgemut's woodcut of Nuremberg in the lower right-hand corner of figure 5. Also, large crowds came to Nuremberg to enjoy fairs, markets, and religious festivals.[3]

Since Dürer wanted to sell his prints in other cities and countries, he hired an agent. The agent agreed to sell his works at the price given on a list, to remit the money to Dürer from time to time, and to not stay in places where the prints did not sell. In return, the agent received a weekly salary plus expenses. Dürer was the first painter to introduce fixed prices for his prints.[4]

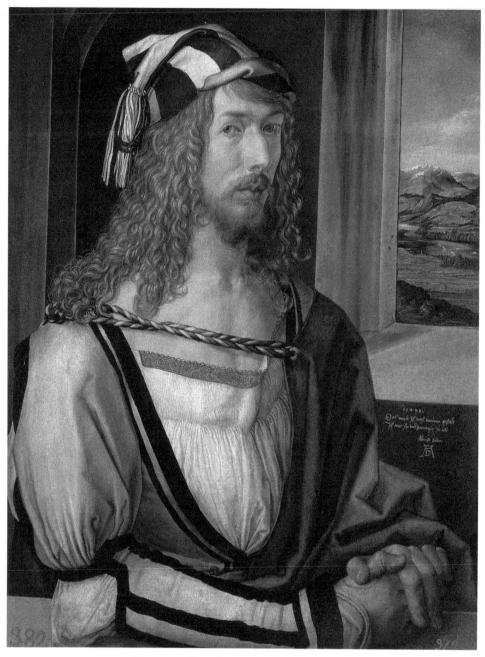

Figure 21. Albrecht Dürer, *Self-Portrait*, 1498.
Oil on panel, 20.5 x 16.1 in. (52 x 41 cm.). Prado, Madrid.

Figure 22. Albrecht Dürer, Dürer's Trademark, 1498. His name means "door" in Hungarian.

In the Middle Ages, painters were considered craftsmen, not artists, so they rarely signed their work. In contrast, Dürer invented the branded article. After several years of redesigning his mark, he settled on the capitol "D" under the capitol "A" that looks like a door. This symbol was appropriate since his name comes from the Hungarian word for "door." He was the first to sign and date most of his sketches and finished works.[5]

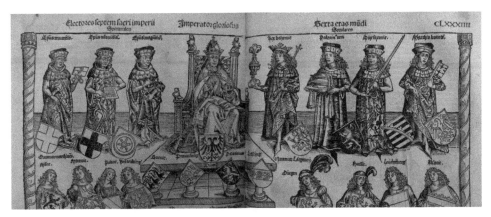

Figure 23. Attributed to Michael Wolgemut, *The Emperor and the Seven Electors*, 1493. Woodcut from *Nuremberg Chronicle*.

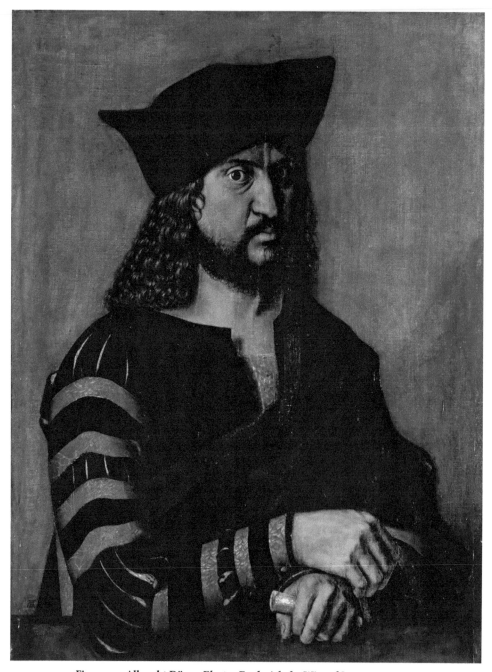

Figure 24. Albrecht Dürer, *Elector Frederick the Wise of Saxony*, c. 1496.
Oil on canvas, 29.9 x 22.4 in. (76 x 57 cm.). Gemäldegalerie, Berlin.

12

Frederick the Wise

From the thirteenth to the sixteenth century, seven electors had the power to choose the next Holy Roman emperor. Four were princes and three were archbishops (of Mainz, Trier, and Cologne). Frederick III, elector of Saxony (the eastern part of Germany), succeeded his father, Ernest, in 1486.[1]

Frederick lived in a castle with an attached church at the west end of Wittenberg, a town of 2000 that sat on the north shore of the Elbe River. The town was more than two hundred miles north of Nuremberg. Frederick's favorite residence was a hunting castle in Lochau, near Leipzig, about fifty miles to the southwest. During his lifetime, Frederick was given the nickname, "The Wise."[2]

After returning from a pilgrimage to the Holy Land in 1493, Frederick journeyed throughout Europe adding to his relic collection. Frederick wanted Wittenberg to become the "Rome of Germany" so pilgrims would visit the town to gain spiritual merit. He negotiated with kings and queens to exchange relics.[3]

When Dürer was twenty-five years old, he painted a picture of Frederick when he visited Nuremberg for four days. Dürer, like Leonardo da Vinci, was among the first artists who attempted to show the sitter's state of mind by their facial expressions in portraits. Dürer painted various powerful men with a slight frown, perhaps as a way of expressing the sitter's seriousness about fulfilling their civic duty.[4]

While sitting for his portrait, Frederick requested Dürer to make an altarpiece for him. Once this important patron discovered Dürer, leading families began to give him commissions. Two years later, Frederick sent a young boy to Nuremberg to be Dürer's apprentice and paid for the boy's instruction.[5]

In the same year, Frederick founded the University of Wittenberg. He wanted the new academy to rival the century-old University of Leipzig.[6]

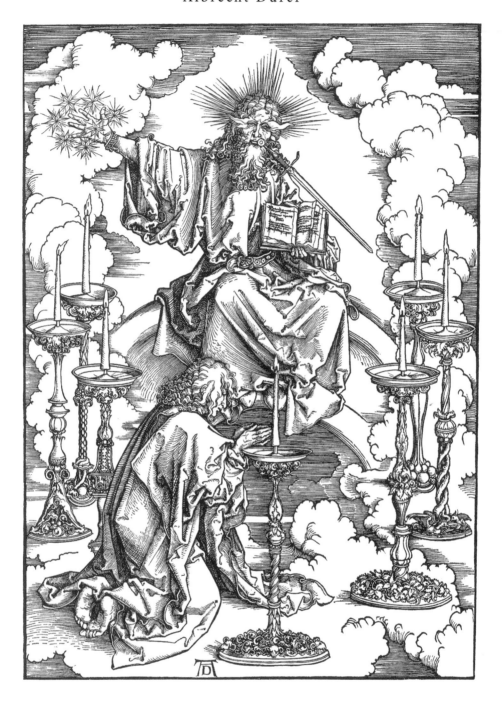

Figure 25. Albrecht Dürer, *St. John's Vision of God and the Seven Candlesticks*, 1497–98. Woodcut from the *Apocalypse*, 15.4 x 11 in. (39 x 28 cm.). Staatliche Kunsthalle, Karlsruhe.

13

The *Apocalypse* (1498)

During the two years after Dürer opened his own workshop, he made fifteen woodcuts called the *Apocalypse*. The prints were based on the book of Revelation, the last book of the Bible. The apostle John wrote the book to the seven early churches in western Turkey while he was exiled on Patmos, a small mountainous Greek island near Ephesus (now Kusadasi). The vision unveils the future return of Christ, the judgment of the corrupt and evil, and the establishment of the Kingdom of God.[1]

The Apocalypse was not an unusual topic. The oldest surviving illustrations date from the time of Charlemagne, the first Holy Roman emperor who was crowned by the pope in Rome in 800. Other artists provided images for the Cologne Bible of 1480 and the Nuremberg Bible, published by Koberger, in 1493.[2]

The Book of Revelation gave Dürer a great challenge. Though the book's descriptions were intensely visual, the Apocalyptic imagery and miracles were difficult to convey. Dürer's style was revolutionary. Crude woodblocks became fine art in his hands.[3]

In *St. John's Vision of the Seven Candlesticks*, John kneels before God, seated on a rainbow in the clouds (Revelation 1:12–20). A sword comes out of God's mouth and his hand holds seven stars. God is surrounded by seven candlesticks, each different in design, reflecting Dürer's apprenticeship as a goldsmith. The number "seven" represents perfection based on God resting on the seventh day (after creating the world) and Jesus's seven statements from the cross. The seven stars represent the angels of the seven churches to whom God wants John to speak both encouraging words and stern warnings. God expects the churches to be light in a dark world.[4]

In *The Four Horsemen of the Apocalypse*, Dürer merged the results of the Lamb opening the first four wax seals into one image (Revelation 6:1–8). Jesus is qualified to open the seals hanging from the scroll, because his death on the cross redeemed people from all over the world (Revelation 5:9), and he could explain the mysteries of life and death.[5]

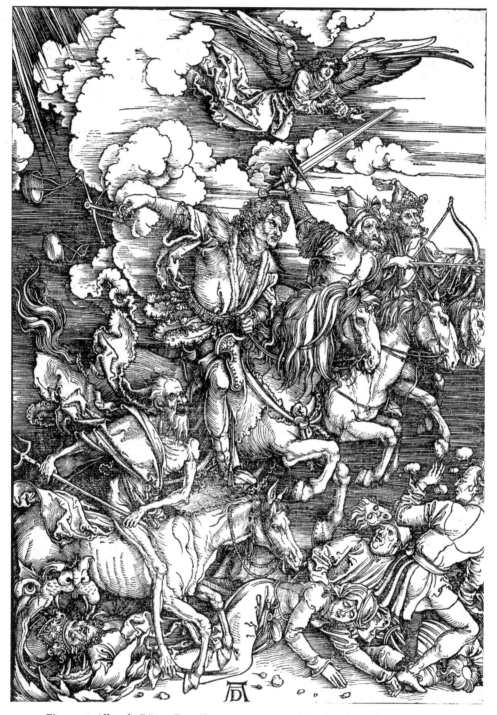

Figure 26. Albrecht Dürer, *Four Horsemen*, 1497–98. Woodcut from the *Apocalypse*, 15.4 x 11 in. (39 x 28 cm.). Staatliche Kunsthalle, Karlsruhe.

At the back of the image, the first rider, the Conqueror, rides on a white horse, holding a bow and arrow. The second rider, War on a red horse, charges forward with a raised sword. The third rider, Famine, rides on a black horse holding a balance in his hand. In the foreground, the boney fourth rider, Death, rides on a skinny "pale horse" holding a trident. In the lower left corner, Hell, in the shape of a monster, first swallows up an emperor. Across the bottom of the woodcut, others of all social classes are trampled despite their efforts to escape. The four horsemen ride throughout history and across the world, bringing conquest, strife, scarcity and death.[6]

The destruction portrayed in the *Four Horsemen* was counterbalanced by another woodcut. In *The Adoration of the Lamb*, people are worshipping the Lamb of God, Jesus, who was slain and rose again. The Lamb's blood flows into a goblet held by a bishop wearing a miter on his head. The large community worships God day and night: "Holy, holy, holy, is the Lord God Almighty, who was, and is, and is to come" (Revelation 4:8 New International Version). The martyrs in their robes, who died for the word of God, stand in the center. The twenty-four elders, each with a different shaped crown, are on both upper sides. The signs of the four writers of the gospels in the New Testament are around the Lamb: Matthew (winged man), Mark (winged lion), Luke (winged bull) and John (eagle). The risen Lamb and the four Gospel writers radiate mercy and grace toward the people.[7]

Dürer's design was innovative. The woodblocks were several times larger than usual, equal to a full page of a book. The images were first issued as single sheets that stood alone from the text. Dürer combined movement, multiple images, and intricacy into forceful compositions. His attention to detail and design went beyond the central figures. This was the first time that one artist designed, illustrated, and published a work. Dürer used his own press, but used his godfather Koberger's type for text.[8]

Dürer's woodcuts of the late 1490s were the most complex to appear on either side of the Alps. Following Wolgemut's and Schongauer's example, Dürer created woodcuts that had the qualities of copper-plate engravings. Instead of stiff lines and hatchings, he created more dynamic images with swelling and tapering contours.[9]

The woodblocks, unlike a painting, would remain in Dürer's possession for the rest of his life. Woodcut blocks were capable of yielding hundreds of good impressions. Dürer or an assistant could reprint at will and replenish stock. In comparison, engraved metal plates yielded fewer than one hundred impressions of the best quality.[10]

These woodcuts, presented as an integrated whole, commanded authority. Artists in Germany, Italy, France, and Russia carved their own woodblocks in order to make copies to sell. They transferred Dürer's images to paintings, reliefs, enamels, and tapestries. The *Apocalypse* was Dürer's first major work.[11]

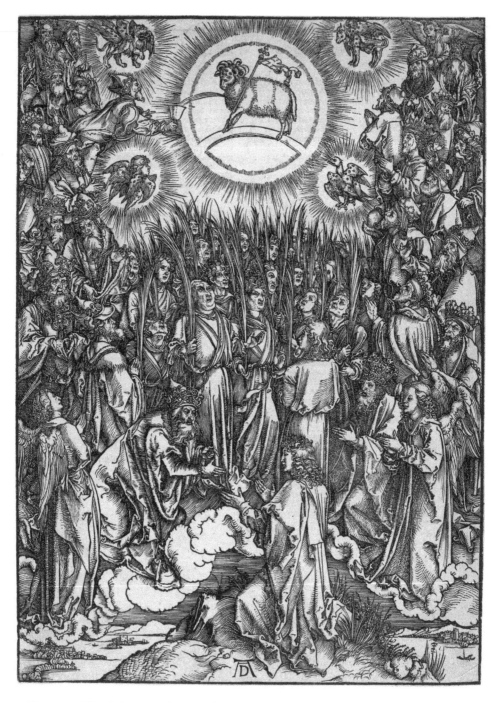

Figure 27. Albrecht Dürer, *Adoration of the Lamb*, c. 1496–98. Woodcut from the *Apocalypse*, 15.55 x 11.18 in. (39.5 x 28.4 cm.). National Gallery of Art, Washington, DC.

14

1500

Dürer's *Apocalypse* made its appearance just when people were worrying about the year 1500 approaching. News spread of strange meteorological phenomena, such as comets. When the Ottoman Turks won a battle in Croatia and started occupying significant forts in 1493, people worried if Vienna, the doorstep of Europe, was secure. Plagues appeared unexpectedly. People had a growing sense of foreboding.[1]

Many people felt insecure about their ability to get into heaven, so they tried various methods to gain salvation. Many thought that reliquaries or relics of holy people or from holy places (such as a piece of the cross) had power to heal and that the saints could share their extra merits with sinners.[2]

Since it was a holy year, Pope Alexander VI (born Rodrigo Borgia) promised special indulgences to those who visited approved pilgrimage shrines. Pilgrims bought certificates stating that they had seen the relics. The church taught that buying indulgences was a way to lessen the time in purgatory, the place where souls were purged of sin through suffering before they were let into heaven. Indulgences provided a way for the Church to raise money to build churches and finance wars.[3]

Figure 28. Reliquaries in Fulda Cathedral, Germany. The largest reliquary in the center contains the skull of St. Boniface, a missionary from England who evangelized the German tribes, and was martyred in 754.

Figure 29. Letter of Indulgence, 1455. Printed on parchment in Johannes Gutenberg's workshop in Mainz, issued by Johannes de Ytestein in Nuremberg.
The page has blank spaces where a name and the date were filled in by hand.

Medieval Christians also went on pilgrimages to show devotion, to be physically healed, and to see new places. Though visiting Jerusalem was a long and difficult trip, pilgrims could walk where Jesus and his disciples had walked. Other popular destinations were Rome (to see the bones of St. Peter and St. Paul), Canterbury Cathedral (where the English Archbishop Thomas Becket was martyred), and Santiago de Compostela, Spain (to see the bones of the apostle James, Jesus's disciple). Pilgrims wore special hats with pilgrim badges that displayed the holy sites they had visited. The badges were typically cast from metal, but Santiago's badge was a simple scallop shell.[4]

Figure 30. Pilgrim badges. Metal.

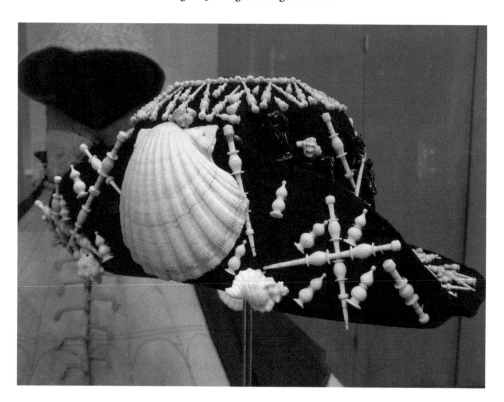

Figure 31. Pilgrim hat with a scallop shell from Santiago de Compostela.

Wealthy people donated land to the church or gave money to decorate private side chapels within churches with paintings, sculptures, and liturgical objects. Monks were assigned to offer ongoing private masses for souls of the family's deceased members so they could leave purgatory and go to heaven. These masses, said without a congregation, were held in side chapels endowed by these families.[5]

People were anxious: Was the end of the world near?

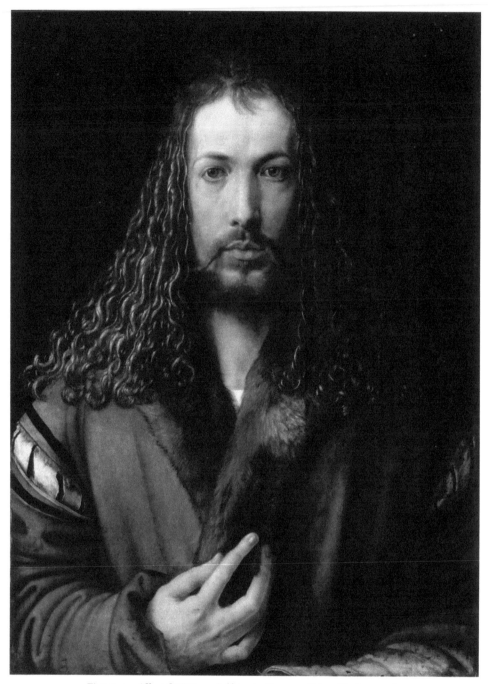

Figure 32. Albrecht Dürer, *Self-portrait*, 1500. Oil on lindenwood,
26 3/8 x 19 1/4 in. (67 x 49 cm.). Alte Pinakothek, Munich.

15

Self-portrait (1500)

Dürer's image fills the canvas as he looks directly at the viewer in his *Self-portrait* of 1500. The dark background offers no scenic distraction like his portrait of two years before (figure 20). Instead the dark emphasizes the light falling on his hair, face, and right hand. His fashionable coat, with a rich brown fur collar, with sleeves slashed to show the shirt beneath, was usually worn by noblemen.[1]

Is Dürer portraying himself as Christ? His hair is darkened and he holds his hand similarly to a form of Christ's blessing in Byzantine art. Does the emphasis on his hand represent that he, like Christ, is a creator? The hand is not gloved, but shows his veins. Perhaps Dürer had been influenced by popular devotional practices which encouraged people to imitate Christ. The Brethren of the Common Life, a reform movement in the Netherlands, combined devotion, virtue, and zeal. Thomas a Kempis's book, *The Imitation of Christ*, published in the mid-1400s, was the most influential book of the movement.[2]

The eyes represent the power of an artist's vision. Maybe Dürer was fascinated with human expression, reflecting the growing humanism inspired by studying Greek art during the Renaissance. Perhaps he is conveying a sense of wonder about humanity, or his own identity in particular.[3]

Dürer wrote the date on the left side, 1500, with his A.D. monogram below. The monogram usually meant "Albrecht Dürer," but it could also cleverly mean "Anno Domini" ("in the year of our Lord").[4]

On the right he wrote in Latin "Albertus Duerus Noricus," his name plus a variant of Nuremberg. The three-part name, similar to one an upper class ancient Roman would use, gave him both a classical identity and the weight of the past. The inscription, in the formal Antiqua script favored by the humanists, is translated: "I, Albrecht Dürer of Nuremberg painted myself thus, with undying colors, at the age of twenty-eight years." When he completed this picture, twenty-eight was considered the age

when one reached the peak of attractiveness and talent. The Latin word, "proprius" can mean "own" and "immortal." Did he hope that his colors, his image, and he himself would be immortal? He may have asked his friend, Willibald Pirckheimer, who knew Latin, to help him choose these words.[5]

This portrait, an exercise in light, texture, realism and self-creation, never left his house during his lifetime. Prospective clients and students could admire his painting ability. Unlike medieval artisans who painted traditional subject matter, Dürer insisted that a chief requirement for a good master was to "pour out new things which had never before been in the mind of any other man."[6]

16

Loving Fathers

———

In 1496 Dürer made a copperplate engraving of *The Prodigal Son*. The Gospel of Luke 15:11–32 records that Jesus told this parable in response to the religious leaders who were accusing him of being a friend of sinners.[1]

One of two sons of a successful farmer wasted all of his inheritance in a distant land as a young man, and now has to work with unclean pigs on a farm to survive. The barefoot man, with his rich gown tucked around his waist to keep it out of the mud, is surrounded by pigs of all sizes, some with bristles similar to that of wild boars. Due to a severe famine in the land, he is so hungry that he is tempted to eat the pigs' turnips and cornhusks.[2]

He realizes that his father's hired men have plenty to eat. When the son comes to his senses, he kneels in the farmyard, looking toward a chapel in the upper right. He decides to return home, hoping to be accepted as a hired man. When approaching home, his father runs to welcome him. His father gives a party to celebrate the younger son's return. The older son is angry and does not want to attend the celebration. The story could be called the Parable of the Two Lost Sons.[3]

Dürer placed his monogram below the son's praying hands and the bucket of swill. Was he saying that he, too, was sorry? Or was he asking, "Is your heart and house in order as the year of 1500 approaches?"[4]

The farmyard scene was typical near Dürer's hometown. This was the first time an artist showed the prodigal at the moment of repentance. The Italian painters, who admired the engraving for its rustic setting and soul-stirring message, copied the image in all sorts of media.[5]

Several years later, Dürer's father grew ill. The night his father died, the maid ran to wake him. He was grieved that he had not been with his father when he died. He wrote: "And he left my mother a sorrowing widow, having always praised her to me as a trusty wife. That made me resolve never to abandon her. O all of you my friends

and family, when you read of my honest father's passing, I pray you for God's sake, remember his soul with Our Father and Ave Maria, and also for your own soul's sake, by serving God, we may inherit a life in bliss through a blessed end."[6]

Dürer asked his friends to pray "Our Father" (the Lord's Prayer) and "Ave Maria" or "Hail Mary" (a prayer based on the angel Gabriel's first words to Mary about being chosen to bear the Son of God). He wanted to help his father's soul as well as give his friends spiritual benefits. Dürer expressed his deep belief that one needed to serve God in order to live and die well.[7]

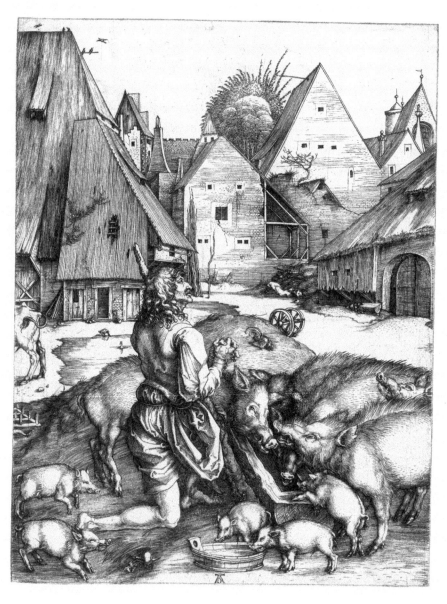

Figure 33. Albrecht Dürer, *The Prodigal Son Among the Swine*, c. 1496. Engraving, 9.7 x 7.5 in. (24.7 x 19.1 cm.). Rijksmuseum, Amsterdam.

17

Madonna with a Multitude of Animals (1503)

———

Dürer widened the setting of traditional religious pictures in a watercolor called the *Madonna with a Multitude of Animals*. Mary sits on a wooden bench in a garden holding Jesus who has turned from his mother to hold a strawberry sprig in his hands. The iris on the left is an emblem for the Virgin Mary's purity and humility. A parrot, a messenger of sacred tidings, and several other birds are near Mary. A crab and two stag beetles are joined in the foreground by a resting, yet watchful dog, a snail, a dragonfly, and a butterfly (a symbol of resurrection and eternal life). The Christ child has the power to overcome evil, symbolized by two owls (below Jesus, in darkness), a frog (sin) and a fox tied up to a stake.[1]

In the middle ground two swans (symbols of purity and courage) swim while an elderly Joseph stands with a crane that represents good works and devotion. In the background to the right, an angel announces Christ's birth to the frightened, yet worshipping, shepherds (representing the Jews). Above Jesus's head is a flock of sheep that represents Christ as the Good Shepherd. Just beyond them, a caravan of camels is coming through a pass. (The camel may be one animal that Dürer doesn't draw well!) On the left, a castle sits on a hill with a village below. The magi (representing the Gentiles) have landed their ships and are now riding their horses, with their banner flying in the wind, toward Mary and Jesus, to give homage and gifts to the King of Kings.[2]

No other artist had ever combined these subjects into one piece of art. The infant Jesus, the Lord of creation, brought harmony between humans and beasts in a garden, a metaphor for paradise.[3]

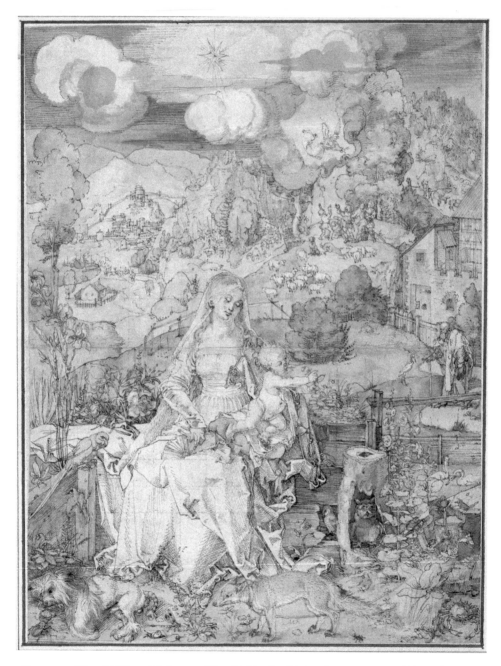

Figure 34. Albrecht Dürer, *Madonna with a Multitude of Animals*, 1503. Pen and blackish-brown ink on paper with watercolor, 12.56 x 9.49 in. (31.9 x 24.1 cm.). Albertina, Vienna.

18

Animals and Plants

The Hare, a watercolor painted in 1502, almost looks real with its glossy eye, long ears, furry folds, and twitching whiskers. The hare was often a symbol of Jesus's Resurrection because its coat changes color with the seasons. Known for having many offspring, it was also a symbol for life. After the artist Giovani Bellini in Venice saw the print, he begged Dürer to give him the paintbrush that created *The Hare*. He was surprised when Dürer showed him several paintbrushes just like those Bellini himself used.[1]

The Large Piece of Turf, painted in 1503, portrays a clump of common grasses and puddles from the side, not the top. At first, it appears to be a random picture with little color other than green and touches of yellow at the tips of the unopened dandelion buds. The tall grasses divide the picture and the leaves of recognizable plants provided a dynamic composition. The viewer is invited to contemplate the details and wonder in the commonplace. Dürer created a whole world from a southern German meadow in May.[2]

Dürer drew animals and plants to portray the beauty of the creation. Many years later, Dürer wrote, "Depart not from Nature . . . for art is rooted in Nature; whoever can pull it out, has it."[3]

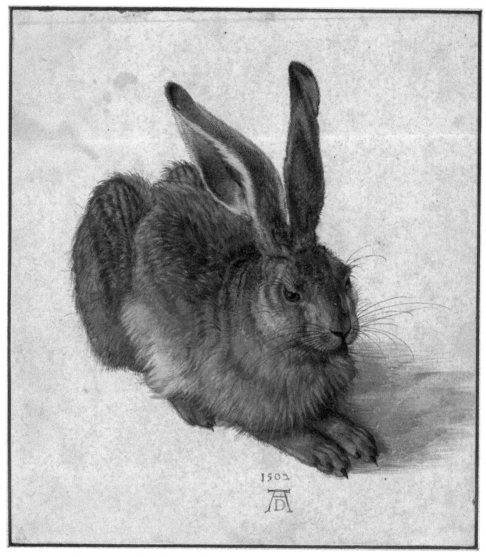

Figure 35. Albrecht Dürer, *The Hare*, 1502. Watercolor and body color,
9.84 x 8.86 in. (25 x 22.5 cm.). Albertina, Vienna.

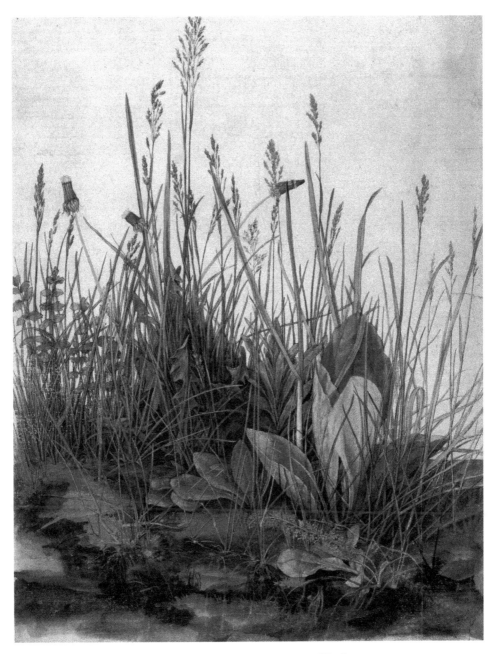

Figure 36. Albrecht Dürer, *Large Piece of Turf*, 1503.
Watercolor and body color on paper with brush, pen, heightened with white,
16.1 x 12.6 in. (41 x 32 cm.). Albertina, Vienna.

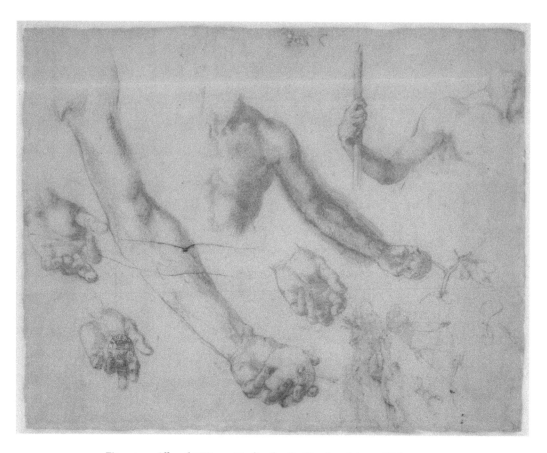

Figure 37. Albrecht Dürer, *Studies for the Hand and Arm of Adam*, 1504.
Pen with brown and black ink, 8.5 x 10.8 in. (21.6 x 27.5 cm.). British Museum, London.

19

Adam and Eve (1504)

When Dürer was thirty-three years old, the age of Christ's death, he made an engraving called the *Adam and Eve* (*Fall of Humanity*). Before he started making the engraving, Dürer made studies, including Adam's hand and arm.[1]

Since an engraving was made up of thousands of marks on a copper plate, Dürer inked and printed the incomplete plate to see his progress. This trial proof offers invaluable insight into his working method. Remembering that the print was a reverse of the plate, Dürer worked from right to left. He had already incised Eve's legs and left side of her body on the plate.[2]

In the finished print, Adam and Eve stand like statues, perfect in proportion, at the edge of a forest in the Garden of Eden. Like the *Madonna with a Multitude of Animals*, Dürer combines the two main figures with animals that Adam has named (Genesis 2: 19–20). A mouse and a cat with thick fur are peacefully near each other, with the cat's tail curled around Eve's foot. A rabbit, and an ox (a symbol of patience and strength) rest behind them, and a shaggy elk with antlers watches Adam and Eve anxiously. In the distance a mountain goat is balanced precariously on a rock.[3]

Adam holds onto a branch of the Tree of Life. Between Adam and Eve, a snake with a headdress hangs from the forbidden Tree of the Knowledge of Good and Evil, and offers Eve a piece of fruit (Genesis 3). A wise parrot, making eye contact with the viewers, sits above a sign hanging from the Tree of Life, which said "Albrecht Dürer Nuremberg 1504" in Latin.[4]

The future of the two people and the animals are in the balance. Will the beauty of this scene be broken? What will be the consequences for the couple and for the animals?[5]

Dürer created his Adam and Eve out of copper, ink, and paper. His sign, hanging from the branch held by Adam, suggests that in a sense, he, too, walked in the garden before the Fall. Dürer recognizes the consequences of sin and is invites the viewers to consider their own temptations.[6]

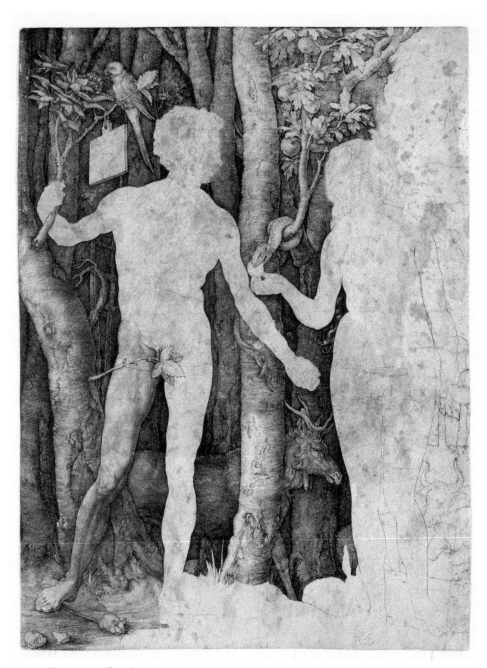

Figure 38. Albrecht Dürer, Trial proof for *Adam and Eve* (*Fall of Humanity*), 1504.
Engraving, 9.8 x 7.4 in. (24.9 x 18.6 cm.). British Museum, London.

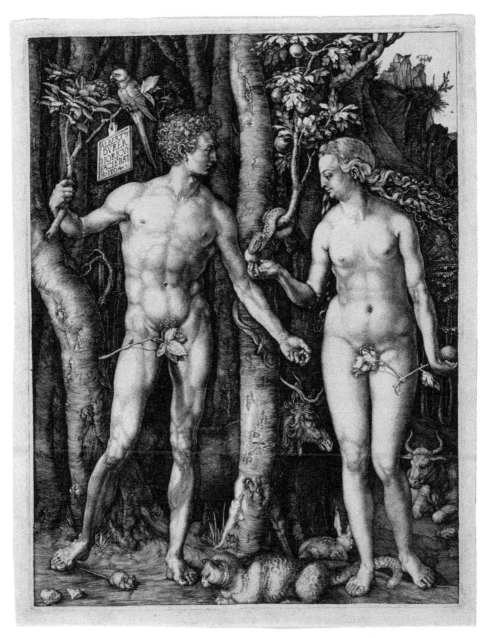

Figure 39. Albrecht Dürer, *Adam and Eve (Fall of Humanity)*, 1504.
Engraving, 10.4 x 8.2 in. (26.5 x 20.9 cm.). Morgan Library and Museum, New York City.

Figure 40. Albrecht Dürer, *Willibald Pirckheimer*, 1503.
Charcoal, 11.1 x 8.19 in. (28.2 x 20.8 cm.). Gemäldegalerie, Berlin.

20

Dürer's Friends

A group of men in Nuremberg began meeting to discuss the Greek and Roman classics. They also desired to change the image of Germany. Creating a small republic of learning called the Pirckheimer Society, they called each other by Latinized names and formidable titles, such as "Your Humanity."[1]

Wilibald Pirckheimer came from a rich family whose home was on the same side of the Nuremberg's market square as Agnes Dürer's family. After studying law and humanities at Padua and Pavia, Italy, he returned to Nuremberg. Dürer drew a sketch of his friend with charcoal.[2]

Konrad Celtis was crowned the first poet laureate of the empire in 1487 in Nuremberg by Holy Roman Emperor Frederick III, who reigned from 1452–93. Celtis was offended that university professors in Italy viewed the Germans as drunkards and savages. He challenged his countrymen to write a history of Germany and to make the classics available to Germans. Though he traveled throughout Germany, Celtis thought of Nuremberg as his home. He wrote four short poems about Dürer and Dürer designed illustrations for some of his books. Celtis died in 1508 in Vienna.[3]

Pirckheimer was a generous host to Celtis and other humanists who visited Nuremberg. He responded to Celtis's challenge by translating the writings of Greek authors into German and opening his private library, the finest in Germany, to the community. He also had connections to the religious community through his older sister, Caritas (meaning Love), a Latin scholar, who had become the Abbess of St. Clara's convent, the largest convent in Nuremberg, in 1503. One-tenth of the population of Nuremberg were priests, nuns, and friars, who lived in the eight monasteries and convents.[4]

Though Dürer was not as educated as Celtis and Pirckheimer, they asked Dürer to join the study group because they hoped he would reform German painting. They introduced Dürer to classical literature and humanist thinking. As an artist, Dürer

also benefitted from hearing the thoughts and wishes of the learned religious community. This group of men was interested in cultural, religious, and political reform. If the church was the only way to get into heaven, and the church was corrupt, how could anyone get to heaven?[5]

Figure 41. Peter Vischer, *Display of Relics at Nuremberg Heiltumsfest* **from** *Heiligthum und Gnade, wie sie jährlich in Nürnberg ausgerufen werden* **(Sanctum and grace, as they are called out annually in Nuremberg), 1487. Printer's ink on parchment, hand-colored, 8.27 x 5.5 in. (21 x 14 cm.).**

21

Returning to Italy

During the ten years since he had been in Italy, Dürer and his workshop produced numerous paintings and more than sixty engravings and woodcuts. In the late summer of 1505, Dürer returned to Venice. Pirckheimer loaned him the money for the trip. No one knows why Dürer went to Italy again. A plague had broken out again in Nuremberg, causing many of the city council, including Pirckheimer, to flee to Nordlingen, a walled city sixty miles to the northeast.[1]

Before Dürer left home, he gave his wife Agnes some money for household expenses for her and his widowed mother. Since women commonly had a role in sales, he expected his mother to sell his prints in Nuremberg on the holiday after Easter. For this festival, the city fathers built a scaffold in the marketplace and brought out the Imperial relics and treasures for viewing. People of high rank as well as common pilgrims came to the city. Relic viewers were promised that they would be released from purgatory, either for a minimum of 37 years and 275 days or 632 years. Agnes was also expected to take prints to Frankfurt to sell at the large fair in August. She was accompanied by her brother-in-law or Dürer's godfather.[2]

Dürer was now famous in Italy because his agent had been there selling his prints and engravings. One Italian artist was making exact copies of Dürer's engravings, signing them with Dürer's initials and selling them. Dürer filed a suit against the artist. It may be the first copyright infringement case in history.[3]

As a distinguished guest, he met "intelligent scholars, good lute-players, flutists, connoisseurs of painting and many noble minds." In order to find some privacy, he hid himself at times.[4]

Figure 42. Albrecht Dürer, *Young Venician Woman*, 1505.
Oil on elm wood, 12.8 x 9.65 in. (32.5 x 24.5 cm.).
Kunsthistorisches Museum, Vienna.

Dürer wrote to Pirckheimer on February 7, 1506:

> I have a lot of good friends among the Italians who warn me not to eat and drink with their painters. And many of them are hostile to me and copy my stuff in churches and wherever they can get hold of it; . . . But Sambelling [Giovanni Bellini] has praised me highly in the presence of many *czentillomen* [nobles]. He would like to have something of mine, and came to me himself and asked me to do something for him, he would pay well for it . . . He is very old yet still the best at painting.

Giovanni Bellini, age 75, was the younger brother of Gentile Belllini, who had painted the portrait of the Ottoman Sultan twenty-five years earlier (figure 4).[5]

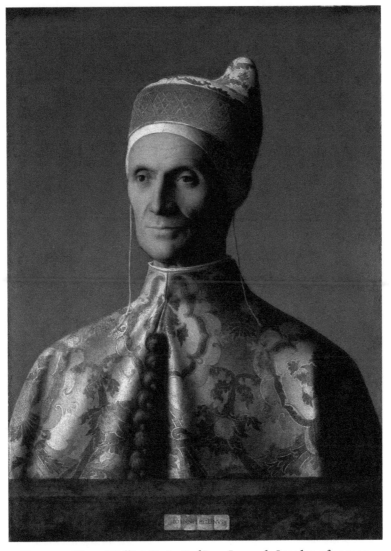

Figure 43. Giovani Bellini, *Portrait of Doge Leonardo Loredan*, after 1501.
Oil on poplar wood, 24.3 x 17.8 in. (61.6 x 45.1 cm.). National Gallery, London.

The German community asked Dürer to paint an altarpiece for the newly rebuilt German church in Venice, San Barolommeo. In *The Feast of the Rose Garlands*, Mary is crowned by two angels. The worshippers, who surround her, include Pope Alexander VI, Emperor Maximilian, St. Dominic, and some Germans, including Jakob Fugger, the banker and head of the German community in Venice.[6]

The theme of the composition was suggested by the rosary, a form of prayer encouraged by Dominicans. On a string of beads each "Hail Mary" is represented by a white small bead, while "Our Father" is a larger red bead. The white beads correspond to white roses and the Joyful Mysteries of the Virgin, while the red beads correspond to red roses and the Sorrowful Mysteries of Christ's Passion. The thread symbolizes the Christian Faith, which unites the Christian community.[7]

In the background of the painting, a strawberry blond Dürer stands by the tree on the right, holding a piece of a scroll written in Latin with his signature, the date and a note recording that the altarpiece took five months to paint. The actual time was at least six and one half months if preparatory studies and underdrawings on the panel are included. The picture reflects Dürer's study of Giovanni Bellini's style as well as earlier Northern artists.[8]

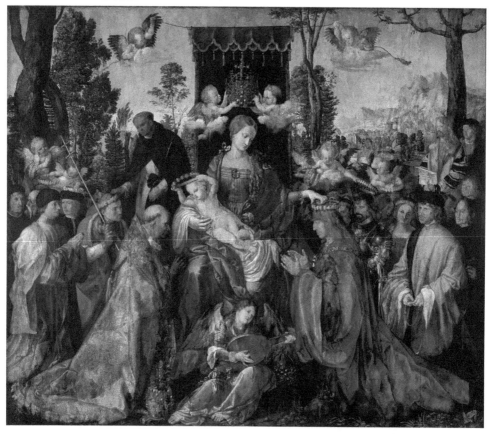

Figure 44. Albrecht Dürer, *Feast of the Rose Garlands*, 1506.
Oil on poplar, 63.8 x 76.6 in. (162 x 194.5 cm.). National Gallery, Prague.

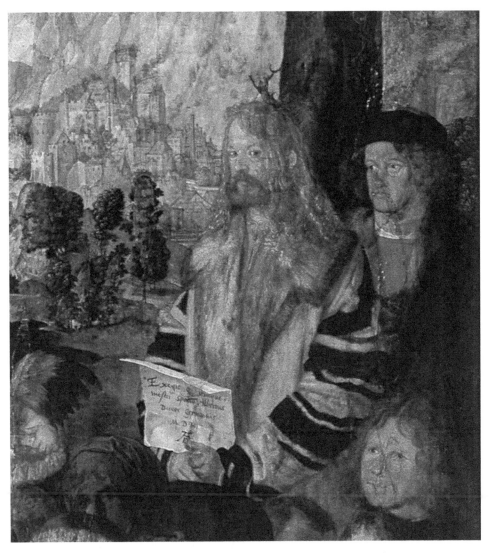

**Figure 45. Albrecht Dürer, Detail of *The Feast of the Rose Garlands*, 1506.
Oil on poplar. National Gallery, Prague.**

Pirckheimer and friends in Nuremberg saw the painting as a testament to Dürer's (and Germany's) genius in Italy. Dürer wrote Pirckheimer, "I have silenced all the painters who said I was a good engraver but didn't understand paint." Even the Doge and the Patriarch-archbishop of Venice came to see his altarpiece. The Venetian Senate offered Dürer a handsome salary if he would live there. He turned down the offer, but did stay on for an extra month or so to earn money.[9]

Dürer responded to one of Pirckheimer's letters telling him about the honors he had recently received. "I do urgently need to tell you of the great pleasure it gives me to hear of the great honor and fame which your manly wisdom and learning have brought you . . . It comes to you, however, as it does to me, by a special grace of

God. How pleased we both are with ourselves, I with my painting and you with your wisdom!" Later in the letter, Dürer wrote that he stopped taking dancing lessons. "To learn dancing I should have had to pay away all that I have earned, and at the end I should have known nothing about it."[10]

In his last three letters from Venice, Dürer told his friend that he was buying clothes for him. Dürer bought emeralds, crane feathers (for a hat) and oriental rugs. Dürer also bought new publications in Greek so Pirckheimer could translate them into German. Dürer also bought his friend pearls though they were forbidden in Nuremberg by the Council's sumptuary laws. The Council wanted to guard the towns-people against sins of pride, greed, covetousness and vanity. They tried to limit the showing of wealth in food, clothing, gifts and other luxuries from birth to death. They did not allow baptismal gowns of silk, embroidered with gold, silver or decorated with pearls. They only allowed small funerals without banquets and small memorial stones. When Dürer returned home at the beginning of 1507, he settled his debts with Pirckheimer.[11]

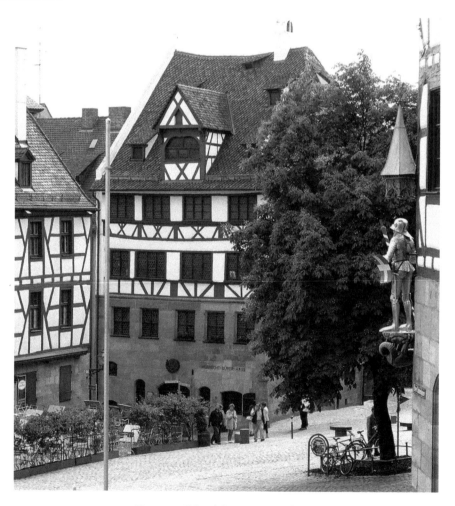

Figure 46. Dürer's Home, Nuremberg.

22

Moving to a New Home

Two years after paying off the mortgage on his father's house, Dürer purchased a large home near the city wall and imperial castle. The home had previously been owned by Regiomontanus (Johannes Müller of Königsberg), the most famous late Middle Ages astronomer and mathematician, and later by his pupil, Berhard Walther. The house had a third-floor balcony and windows for stargazing, and a print shop on the ground floor.[1]

In an undated note from the thirteenth year of his marriage (1507–8), Dürer wrote that he had paid off his debts from his trip to Venice and made a list of his possessions. "I possess fairly good household furniture, good clothes, some good tin vessels, good materials for my work, bedding, chests and cupboards and good colours worth 100 florins Rhenish."[2]

One of Dürer's neighbors was Lazarus Spengler, a lawyer who served as secretary for the City Council. Their friendship was cemented when Dürer became a member of Nuremberg's Greater Council, more an honor than a governing body. In 1511, Dürer was called in to consult on the inspection of the Schoner Brunnen, the fountain in the principal square of the city. (See figure 7.) Later they asked him to redecorate the Town Hall.[3]

Dürer and Spengler began exchanging comic poetry. Shortly afterward, Pirckheimer criticized Dürer's rhymes for being the wrong length. Dürer, who was sometimes mocked for his beard, first responded with a long poem, closing with these lines:

> I shall go on making verses,
> Must keep the pen-pusher laughing
> Quoth the long-haired bearded painter
> To the satirical town clerk.

Later, Dürer stopped writing poetry. Spengler became known as "a jurist among theologians and a theologian amongst the jurists."[4]

Elector Frederick requested a painting of *The Martyrdom of the Ten Thousand Christians*, based on Dürer's earlier woodcut (1496), to put in the Castle Church in Wittenberg. The prince had collected many relics from this battle. The Persian king, riding on a horse, is dressed as an Ottoman sultan. Dürer and the poet Celtis, who had recently died, are dressed in black in the middle of the painting. Dürer, holding a sign, "Albrecht Dürer the German made this in the year of our Lord 1508," takes on the role of a martyr (Greek for "witness") at the site.[5]

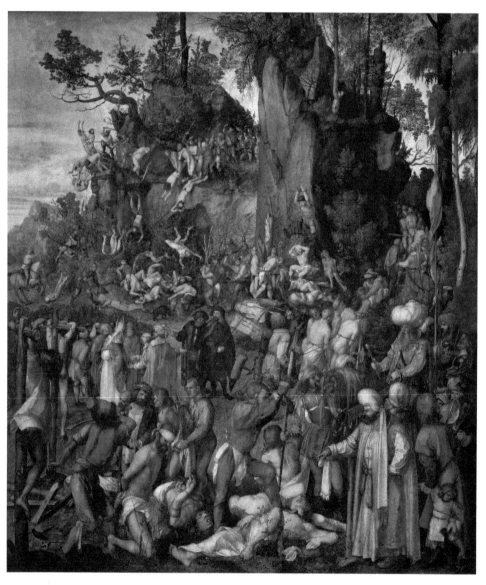

Figure 47. Albrecht Dürer, *Martyrdom of the Ten Thousand Christians*, 1508.
Oil on panel transferred on canvas, 39 x 34.3 in. (99 x 87 cm.).
Kunsthistorisches Museum, Vienna.

The Dominican church in Frankfurt am Main commissioned an altarpiece. Dürer wrote to the mayor, Jakob Heller, in August 1507, that he hoped to start soon on the piece, but that he needed to finish the piece that Frederick had ordered. He indicated that he had bought the wood panel for the altarpiece with the money provided and had given it to someone to prepare the wood for painting. He did not ask for any more money in advance, "for I don't like to begin too many things at once, so that I won't tire myself out."[6]

In two of his nine letters to Heller, Dürer explained that the piece was more expensive than he initially quoted because he was using the best blue color for the Virgin Mary's gown. Dürer bought ultramarine pigment, which was ten times more expensive, from specialty shops during his time in Venice because it was the one color not available in Nuremberg. The intense blue color, made from finely-ground lapis lazuli from Badakshan (modern Afghanistan), was mixed with nut oil. He would use azurite, a cheaper material found in lead and copper ore, for the under-painting, but use the ultramarine lapis lazuli for the top layer.[7]

After working on the altarpiece for a year, Dürer sent it to Heller and asked him to keep it clean and not sprinkle it with holy water because it often had salt added to it. He offered to come in a year or so and varnish it with some "excellent varnish" so it will last "100 years longer than it would before."[8]

Figure 48. Lucas Cranach, **Signature of Lucas Cranach the Elder**, detail from *Duchess Katharina, Spouse of the Duke Heinrich the Devout of Saxony*, 1514. Oil on panel transferred to canvas, 72.6 x 32.7 in. (184.4 x 83 cm.). Gemäldegalerie Alte Meister, Dresden.

23

Lucas Cranach's Relic Sampler

Though Elector Frederick commissioned various painters for particular works, he also had a court painter. He chose Lucas Cranach for this position in 1505 after being assured that Cranach was the closest to Dürer in talent and style out of the possible candidates. As the court painter, Cranach was expected to design and decorate rooms in several castles, plan festivals and celebrations, create altarpieces for the churches, and organize the jousting tournaments and seasonal hunts. He designed costumes and carnival masks, horse clothes for tournaments, coats of arms, and medals. His pay was the same as a professor at the University of Wittenberg.[1]

Because of royal backing, Cranach had at his disposal many pigments, some that were expensive, as well as metal leaves and powder. He also commissioned other painters, supervised their work, and arranged payment. In his spare time, he could create his own woodcuts and paintings. In 1508 Frederick gave a coat of arms to Cranach, a winged serpent that became Cranach's trademark.[2]

On April 8, 1510, Pope Julius II, the "Warrior Pope," endowed Frederick's relic collection with a generous indulgence. The pope said that those who came to see the relics in Wittenberg and prayed for themselves and the elector on All Saint's Day (November 1), would lessen their time in purgatory for themselves or others to the extent of 1,902,202 years and 270 days.[3]

Frederick asked Cranach to make an illustrated catalogue of some of his 5,005 relics. In previous years, people who viewed Frederick's relics and paid for indulgences could reduce their time in purgatory by 1,443 years. In order to encourage more people to come to Wittenberg, Cranach made woodcut images of one hundred and twenty relics, while the court poet, Georg Sibutus, a student of Celtis, provided poetic commentaries on some of them.[4]

Figure 49. Lucas Cranach the Elder, *Wittenberg Reliquary Book*, 1510. Woodcut engraving and letterpress on cream laid paper, 7.6 x 5.5 in. (19.3 x 14 cm.). Art Institute of Chicago.

The centerpiece of the collection was a thorn from the crown of Christ. Other relics from Christ included a piece from his swaddling clothes, thirteen pieces from his crib, one piece of gold brought by the Wise Men, one strand of Jesus's beard, and one of the nails driven into his hands. Frederick's relics from Mary included four hairs, three pieces of her cloak, and seven pieces from the veil sprinkled with the blood of Christ. His saints' relics included a tooth of St. Jerome and pieces of three other saints.[5]

By 1520 Frederick's collection had grown to 19,013 relics, the greatest collection in Germany. He traded some of Cranach's paintings for relics from the collection of the king and queen of France.[6]

24

The Life of the Virgin (1511)

After working on many woodcuts for a decade, Dürer published three books in 1511. Dürer dedicated one of the books, *The Life of the Virgin*, to Pirckheimer's sister, Caritas, the name she took when she was admitted to the Poor Clares at the age of sixteen. "Indefatigable abbess of watchful nuns the Latin works you avidly read make you treasured in the eyes of those like us who are devotes of the Muses. To you, virginal Caritas, I dedicate these pleasing lines which hymn the Virgin Mary, model of all virgins."[1]

One of the nineteen woodcuts, *The Flight into Egypt,* shows the peasants Mary, Joseph, and baby Jesus fleeing to the safety of Egypt. The Gospel of Matthew 2:13–16 tells that after King Herod heard from the wise men (magi) from the East that the King of the Jews had been born, he sent soldiers to Bethlehem to kill all the male children around that age so no rival king could grow up to take his place.[2]

The escaping family is surrounded by various palm trees while a crowd of angels watch from above. The lizards, in the bottom left, and the dragon's blood tree are suggestive of the bronze serpent that was raised on a pole in the desert to cure the Israelites, who had been bitten by snakes, if they would look upon it (Numbers 21:4–9). This foreshadows the healing promised to all who look to Jesus, who was lifted up on the cross. The grapevine in the middle may allude to Jesus's sacrificial blood.[3]

The cult of the Virgin Mary, the Queen of Heaven, portrayed Mary sharing the same throne as Jesus. She was glorified and elevated to the position of co-redemptrix and mediator with Jesus. The church also taught that she, like Jesus, was taken directly up into heaven, an event referred to as the Assumption of Mary.[4]

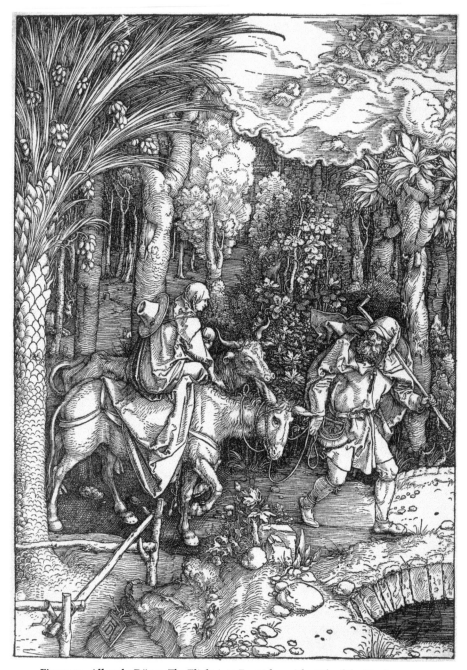

Figure 50. Albrecht Dürer, *The Flight into Egypt* from *The Life of the Virgin*, 1511.
Woodcut, 11.7 x 8.23 in. (29.7 x 20.9 cm.).
National Gallery of Art, Washington, DC.

25

The Small Passion
and *The Large Passion* (1511)

The other two large woodcut books Dürer published in 1511 were *The Small Passion* and *The Large Passion*. People bought a Passion to be reminded of the consequences of sin entering the world shown in Jesus's suffering and death on the cross.[1]

The title page of *The Small Passion* was a woodcut of Jesus as the Man of Sorrows. Benedictus Chelidonius, a Benedictine monk and schoolmaster in Nuremberg, wrote a plea in the voice of Jesus to accompany the woodcut:

> O cause of my many sufferings, despite my innocence,
> O Bloody cause of my cross, O of my death!
> O man, let it be enough that I endured all those things for you.
> O, stop crucifying me with your new crimes.

After viewing the pain that Jesus suffered because of their sin, the readers were expected to repent and change their lives.[2]

The Small Passion had thirty-seven woodcuts. The first scenes were the Fall of Man and the expulsion from Paradise. The next pages were the Annunciation, the Nativity, and Christ leaving his mother. The following set showed Christ's entry into Jerusalem and Christ expelling the money-changers from the temple. Most of the woodcuts focused on the events between the Last Supper and Jesus's death on the Cross. The next group included the entombment, the resurrection, Christ appearing to his mother, Mary Magdalene, the disciples at Emmaus, and to St. Thomas. The final set was the Ascension, the descent of the Holy Spirit and the Last Judgment.[3]

Though the book had no text, it could be bound together with handwritten prayers to form a personalized devotional volume. *The Small Passion* became Dürer's most widely circulated collection of woodcuts. This work, like the *Apocalypse*, the *Life of the Virgin*, and *The Large Passion*, included a brief statement warning those who

were considering making copies that Emperor Maximilian would confiscate their goods.[4]

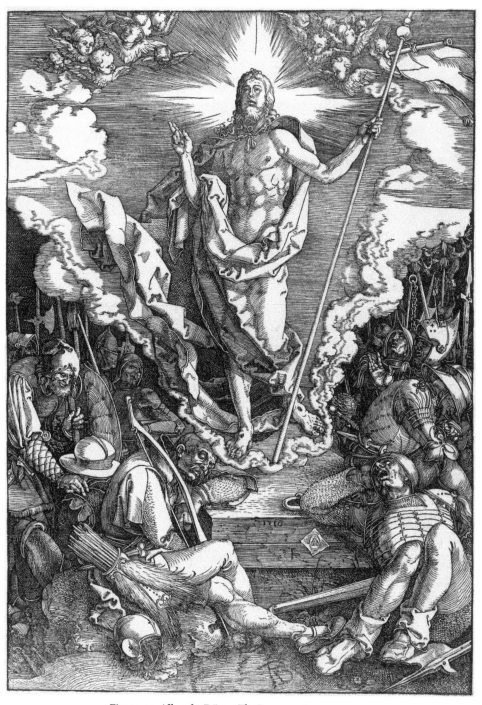

Figure 51. Albrecht Dürer, *The Resurrection*, 1510–11.
Woodcut from the *Large Passion*, 15.3 x 10.87 in. (38.9 x 27.6 cm.).
British Museum, London.

The Large Passion had only twelve woodcuts, but they were larger than usual. The mistreatment of Christ was condensed into two scenes, *Christ Taken Captive* and *Christ Scourged*. *The Resurrection* fused the Resurrection with the Ascension, with Christ suspended above the grave while the Roman soldiers, who are supposed to be guarding the tomb, are sleeping. This woodcut influenced Matthias Grünewald's Isenheim Altarpiece, painted a few years later, in which the resurrected and transformed Christ ascends above frightened soldiers in the midst of a rainbow of colors.[5]

Dürer also made *The Green Passion*, a set of eleven drawings on green paper, in 1504, and *The Engraved Passion*, a set of fifteen engravings, in 1512. Elector Frederick interspersed the engravings with texts to create a prayer book. The Passion was Dürer's main subject, both as individual pieces and as cycles. Could these portrayals of Christ's Passion help to bring transformation to an individual's heart and to the church at large?[6]

Figure 52. Matthias Grünewald, *The Resurrection,* from the middle position, right wing Isenheim Altarpiece, c. 1515. Oil on a panel, tallest height 8.8 x 4.7 ft. (2,69 x 1,43 m.).
Unterlinden Museum, Colmar, France.

Figure 53. Giotto, *Dream of Innocent III*, 1297–99.
Fresco, 106.3 x 90.5 in. (270 x 230 cm.).
Upper Church, San Francesco, Assisi.

26

Reform Movements within the Church

———————

Throughout 1500 years of church history, various orders or groups rose within the church to reform it. Though priests and nuns made vows of poverty, chastity, and obedience to their superiors, some were attracted to the wealth, power, and prestige of the church rather than living simple lives in monasteries or pastoring people in a village church. Other common reforms were against simony (the buying and selling of church positions) and nepotism (giving positions to relatives and friends).[1]

The Desert Fathers lived in the deserts of Egypt and Syria in response to the ease of being a Christian after Constantine legalized Christianity in AD 313. The Cluniac monasteries, established in 910, were a reaction to the corruption of the Benedictine monasteries at the time. The Cistercian order, begun in 1098, was a reaction to the corruption in the Cluniac monasteries.[2]

When Francis of Assisi (in Italy) and eleven followers went before Pope Innocent III in Rome in 1210, the pope was at first hesitant to endorse the new movement. However, the pope had a dream where the St. John Lateran Church (the oldest church building in Rome) was falling over and a man, dressed as a peasant, was straightening it up again. The pope heard a voice, "Rebuild my church." The pope gave Francis his endorsement to start a new order, the Franciscans. The Poor Clares, the women's branch of the Franciscans, was formed after Clara, a daughter of a nobleman in Assisi, wanted to follow Francis.[3]

The Augustinians, named after Augustine, the bishop of Hippo in North Africa (d. 430), became an order in 1243. The Franciscans and Augustinians wanted to renew the church by calling it to service, simplicity and holiness.[4]

Figure 54. Lucas Cranach the Elder, *Hans Luther* and *Margrethe Luther*, 1527.
Oil and tempura on beech, 15.4 x 10.2 in. (39.1 x 26 cm.) and 15.4 x 10.2 in. (39.2 x 25.8 cm.).
Wartburg-Stiftung, Eisenach.

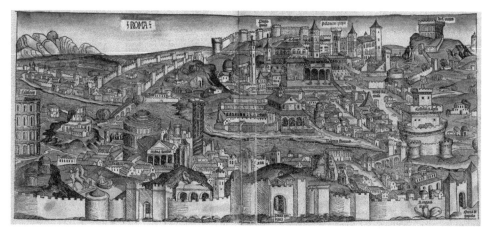

Figure 55. Attributed to Michael Wolgemut, *Rome*, 1493.
Woodcut from the *Nuremberg Chronicle*. St. Peter's Basilica was not yet built.

27

Martin Luther

Elector Frederick invited the Franciscans and the Augustinians to send three new teachers to the University of Wittenberg. Johann von Staupitz, the vicar-general of the Reformed Congregation of the Augustinians, sent Martin Luther, an Augustinian monk, to teach theology in 1511.[1]

Luther, the son of Hans, a copper-shale miner, and Margrethe Luther, was born twelve years after Dürer in Eisleben, a remote town in central Germany. Soon after Luther's birth, the family moved to Mansfeld where his father became part-owner of a mine, allowing him to have enough money to send Martin to school. Luther enrolled at the University of Erfurt in 1501, where his father hoped he would study to become a lawyer. Erfurt was founded by Boniface, the missionary monk to Germany (figure 28).[2]

Before he graduated, Luther was caught in a thunderstorm. Fearing for his life, he vowed to Saint Anne, the patron saint of miners, that he would become a monk. In 1507, he was ordained as a priest into the Augustinian order, known for its strictness. His days were filled with fasting, praying, and working, and his nights were spent in prayer vigils.[3]

When Luther was called to Wittenberg to teach, he was suffering from a lack of certainty about his faith. He knew he was impure in the presence of the Holy God. The more sins he confessed, the more sins he thought he needed to confess.[4]

Soon after Luther arrived, he and another friar had the privilege of being sent as representatives on a mission to the headquarters of the Augustinian order in Rome. After passing through Chur, Switzerland, they crossed the Alps through the Septimer Pass, and arrived in Rome, a route of almost 900 miles.[5]

Rome was the heart of western Christianity. The St. John Lateran Church, the first church in the West built by Constantine, stood near the south gate of the ancient city. Other churches held precious relics, including the entire bodies of St. Peter and St. Paul. Though Rome was thought to be a pilgrim's paradise, Luther was shocked and disgusted by the Italian clergy's ignorance, levity and immorality.[6]

Figure 56. Albrecht Dürer, *Portrait of Erasmus*, 1520.
Black chalk on paper, 14.7 x 10.7 in. (37.3 x 27.1 cm.). Louvre Museum, Paris.

28

Erasmus of Rotterdam

Desiderius Erasmus was educated in part by the Brethren of the Common Life, a reform movement in the Netherlands that encouraged lay people to holiness and devotion. Erasmus was one of many followers who did enter a monastery, but never forgot those who were not called to monasticism. After living in an Augustinian monastery in the Netherlands for seven years, he moved to Paris, Oxford, and then Cambridge between 1498 and 1514. Pope Leo X released Erasmus from his vows and gave him an official blessing to produce a new translation of the New Testament. Erasmus eventually settled in Basel, Switzerland. He wrote in 1518, "My home, in my opinion, is wherever I keep my library."[1]

In 1511, his satire, *In Praise of Folly*, was published. He poked fun at philosophers, princes, poets, and merchants. His strongest rebukes were toward the church leaders and followers. He told how the church authorities were more interested in worldly business than in taking care of the flock entrusted to them. Directed to "instruct, exhort, comfort, reprehend, admonish, compose wars, resist wicked princes and willingly expend not only their wealth but their very lives for the flock of Christ," it seemed to these leaders that: "To work miracles is old and antiquated, and not in fashion now; to instruct the people, troublesome; to interpret the Scripture, pedantic; to pray, a sign one has little else to do; to shed tears, silly and womanish; to be poor, base; to be vanquished, dishonorable and little becoming him that scarce admits even kings to kiss his slipper; and lastly to die, uncouth; and to be stretched on a cross, infamous."[2]

He also rebuked the laity, who substituted external acts of prayers and indulgences for a genuine change of heart and life. They "hug themselves with their counterfeit pardons; that have measured purgatory by an hourglass."[3]

Erasmus encouraged those who truly wanted to live a holy life to imitate the lives of saints or the Virgin Mary. "[T]he best way to get quit of sin is to add to the money you give, the hatred of sin, tears, watchings, prayers, fastings and amendment of life; such or such a saint will favor you, if you imitate his life." He said there was no need to burn candles to the Virgin Mother at noonday. "But how few are there that study to imitate her in pureness of life, humility and love of heavenly things, which is the true worship and most acceptable to heaven!"[4]

Erasmus closed *In Praise of Folly* by describing people currently judged as "foolish" people "whom the zeal of Christian religion has once swallowed up."

> So they waste their estates, neglect injuries, suffer themselves to be cheated, put no difference between friends and enemies, abhor pleasure, are crammed with poverty, watching, tears, labors, reproaches, loathe life, and wish death above all things; in short, they seem senseless to common understanding, as if their minds lived elsewhere and not in their own bodies, which, what else is it than to be mad? For which reason you must not think it so strange if the apostles seemed to be drunk with new wine, and if Paul appeared to Festus to be mad.

Erasmus concluded that these "fools for Christ" were wise in the sight of God, experiencing a "small taste of future happiness." His paradox reflects the apostle Paul's discussion in his First Letter to the Corinthians 3:18–19. "Do not deceive yourselves. If any one of you thinks he is wise by the standards of this age, he should become a "fool" so that he may become wise. For the wisdom of this world is foolishness in God's sight."[5]

The book became a bestseller. Forty-two Latin editions were printed during his lifetime. It was translated into many languages and has never been out of print.[6]

Erasmus wanted people to be able to read the Bible in their own languages. While scholars in the Middle Ages focused their research and commentaries on the Old Testament, Erasmus studied the New Testament, primarily using five ancient Greek manuscripts. In January of 1515, he wrote to his friend Willibald Pirckheimer in Nuremburg, "I have corrected the whole New Testament and added notes."[7]

In 1516 Erasmus's New Testament was published. This new translation challenged the Vulgate, St. Jerome's translation used by the Catholic Church. One of Erasmus's corrections was of Jesus's preaching in Matthew 4:17: "Repent, for the kingdom of heaven is near" (NIV). The Vulgate translated the Greek word, *metanoeite*, as "Do penance," while Erasmus translated the word as an active verb, "Repent" or turn and have an inner conversion.[8]

As soon as the first edition was published, Erasmus started the next edition. He devoted half of his life to studying the New Testament. He believed that Christians

needed to know what the scripture said and understand what it means in order to reform both themselves and the Church.[9]

Figure 57. Albrecht Dürer, *Nativity,* 1504. Engraving, 7.2 x 4.72 in. (18.3 x 12 cm.).
Staatliche Museem, Berlin.

29

Dürer's Thoughts on God and Art

Dürer also studied the New Testament and wrote down phrases. These quotes were written before 1513. Some of the more common phrases were: "From God we received all things." "God is perfect in goodness." "The more we learn, the more closely do we resemble the likeness of God, who knoweth all things."[1]

Dürer also wrote about training apprentices. The youthful apprentice was to be "brought up in the fear of God and taught to pray to God for the grace of quick perception and to honour God." He believed that an artist should be pure because "nothing so blunts the understanding as immorality."[2]

Dürer believed that great artists were God-inspired and God-honoring. "God only knoweth what is the perfect figure of a man, and he knoweth it likewise to whom He revealeth it." "Painting is a useful art when it is of a godly sort and employed for holy edification. It is useful because God is thereby honoured, when it is seen how he hath bestowed such genius upon one of His creatures, in whom is such art." "Work well done is honouring to Him."[3]

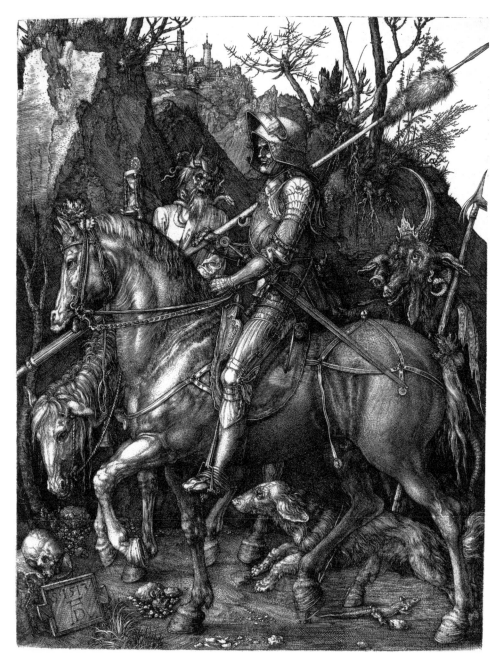

Figure 58. Albrecht Dürer, *The Rider* or *Knight, Death and the Devil*, 1513.
Engraving, 9.7 x 7.5 in. (24.8 x 19 cm.).

30

The Rider (1513)

In 1503, Erasmus's *Handbook of the Christian Soldier* was printed in Latin. Like a pastor speaking to a congregation, he combined themes from the Apostle Paul's letters, works by the Church Fathers, such as Jerome and Augustine, as well as the best-seller, the *Imitation of Christ*. In Ephesians 6:10–18, Paul encouraged the new Christians in Ephesus with the opening phrase "Put on the full armor of God so that when the day of evil comes you may stand against the devil's schemes." He then describes the armor, including the belt of truth, the breastplate of righteousness, feet covered with the gospel of peace, the shield of faith, the helmet of salvation, and the sword of the Spirit.[1]

The *Handbook* focused on the role of baptism in living a new life. "Are you not aware, O Christian soldier, that when you were initiated into the mysteries of the life-giving font [baptized], you enrolled in the army of Christ, your general, to whom you twice owed your life, since he both gave it and restored it to you, and to whom you owed more than to your very self."[2]

Erasmus encouraged Christians to study the Scriptures so they could live in peace. "Therefore if you dedicate yourself entirely to the study of the Scriptures, if you meditate day and night on the law of the Lord, you will have no fear, day or night, but you will be protected against any attack of the enemy."[3]

The *Handbook* was first reprinted in 1509, but as its popularity grew, it was reprinted six more times between 1515 and 1516. It was translated into nine European languages, first in Czech, then German, English, Dutch, Spanish, French, and Italian. The German edition by Froben in 1518 was widely read. Though Dürer could not have read Erasmus's *Handbook* in Latin, the humanist study group in Nuremberg may have eagerly discussed the book.[4]

Dürer's engraving, *The Rider*, shows a serene and strong knight in armor, holding a spear, riding on a powerful horse through the rocky wilderness. A faithful dog runs besides him, keeping up with his master. A skull and a lizard (a symbol of spiritual insight) are at the horse's feet. The man and dog do not seem aware of Death, sitting on an old, tired horse, who hopes to frighten the knight by holding an hourglass to remind the knight that he will die. The devil, a terrible monster with a long horn on top of his head, stands nearby with a spear. The towers of a distant city on a hill, the heavenly city, are visible between the trees.[5]

Dürer turns his research on the anatomy and proportions of horses into a commentary on life by illustrating Erasmus's *Handbook*. "All those spooks and phantoms which come upon you in the very gorges of Hades must be deemed for naught." The Rider goes on his way, "fixing his eyes steadily and intensely on the thing itself" rather than on the phantoms around him.[6]

31

Mother and *Melancolia I*

Dürer experienced two sad events in 1513 and 1514. His godfather, Anton Koberger, died in the fall of 1513 at the age of seventy-three. He had helped Dürer publish some of his early works, such as the *Apocalypse*.[1]

His mother, who had lived with Albrecht and Agnes for nine years, became seriously ill and died in spring of 1514. Dürer wrote in his journal: "[She had] spent most of her time in church, and scolded me if I did not do right . . . And if I went out or in, she always said 'Go in the Name of Christ!' And she constantly and diligently gave us pious warnings, and she always had great concern for our souls' health. And I cannot praise enough her good works and the compassion she showed to everyone, and her good character."[2]

Later in the journal entry, Dürer wrote about her last hours: "[She] gave me her blessing and wished me peace with God and exhorted me with beautiful words to keep myself from sin . . . She feared death very much, but she said that she was not afraid to come before God. Also, she died hard, and I noticed that she saw something frightening . . . I have such sorrow from this, that I cannot express it. God be merciful to her . . . [H]er greatest delight was always to speak of God and she liked to see God honored."[3]

Dürer was troubled when his mother, whom he believed had lived a blameless life, saw something that terrified her in the last minutes of her life. People believed that dying without agony demonstrated that the person was right with God. The mourning bell tolled at St. Sebald's Church for Barbara Dürer.[4]

In the same year, Dürer made an engraving called *Melancolia I*. A winged woman in a long, flowing gown and a crown of leaves is seated. Her head leans on one hand while the other hand holds a compass. Her keys and purse strings are twisted. She is surrounded by scattered tools of architecture, carpentry, geometry, mathematics and

astronomy. Dürer, who was familiar with metal objects since his youth, often included compasses, hourglasses, balances, and astrolabes in his drawings.[5]

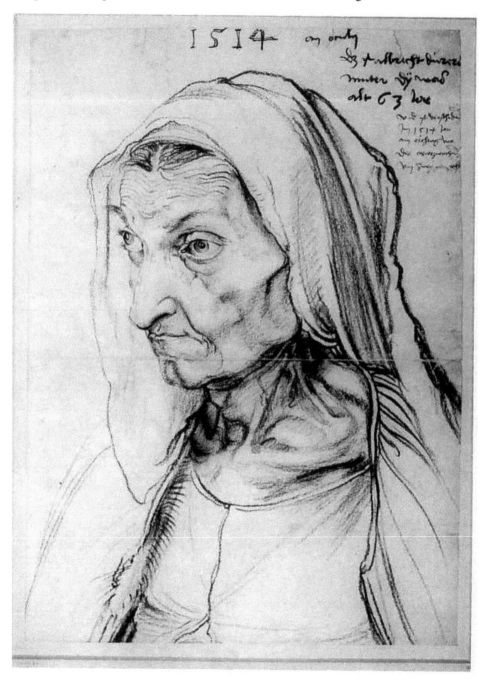

Figure 59. Albrecht Dürer, *Portrait of the Artist's Mother at the Age of Sixty-three*, 1514. Charcoal drawing on paper, 16.57 x 11.93 in. (42.1 x 30.3 cm.). Gemäldealerie, Berlin.

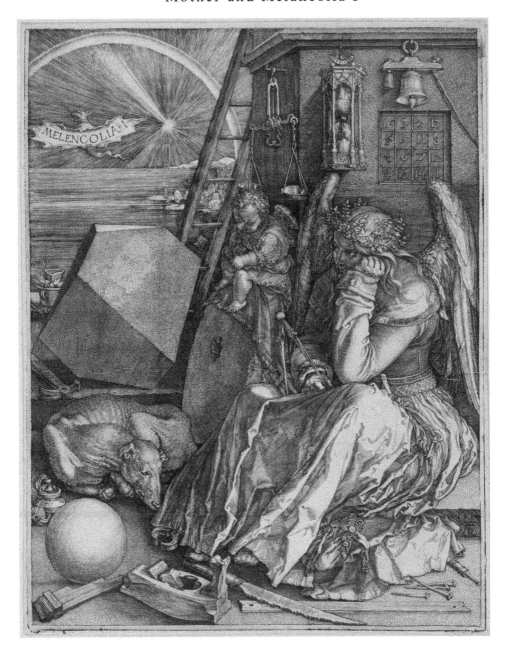

Figure 60. Albrecht Dürer, *Melancolia I*, 1514. Engraving, 9.45 x 7.36 in. (24 x 18.7 cm.).
National Gallery of Art, Washington, DC.

A curly-headed putto (small angel) sits on the edge of a millstone, scrawling on a tablet. Death is symbolized by an old dog with its ribs showing, an hourglass, and the setting sun. Jesus's Passion is alluded to by a hammer and nails and a ladder (used to take Jesus down from the cross).[6]

What was the winged woman contemplating? The Greek philosopher Aristotle said that all truly outstanding men suffer from melancholy, a feeling of sadness, not

attributable to any one source. Some argued that this type of despair was caused by pride. Why is the title of the engraving on the wings of a bat? What does the "I" mean in the title? People have written books discussing the possible themes of this one print! For three centuries it was popular across Europe, being mythologized, reinterpreted, transformed, and romanticized.[7]

32

St. Jerome in His Study (1514)

Dürer created more images of St. Jerome, the Bible translator, than any other saint. He made woodcuts, engravings, and drypoints of the saint through the years.[1]

In 1512, Dürer's woodcut placed St. Jerome in the wilderness. The saint sits in a rocky grotto, with a large rock as his desk. He looks through a large hole out to the water, contemplating Christ on a cross in the distance.[2]

In a 1514 engraving, St. Jerome sits in the back of a simple, peaceful, sunlit room (of a German home?). The Holy Spirit is present in the form of the halo around the saint's head and a candle on the shelf. An hourglass and a skull remind St. Jerome and his viewers of the shortness of life. Detailed shadows of the small round windows fall on the walls next to the window seats. St. Jerome shows his devotion to Jesus through translating the Bible. If he raises his head, his gaze will fall on the crucifix on the table. The sleeping dog, near his master's slippers, and the lion are next to each other. Viewers feel as if they can step into the room.[3]

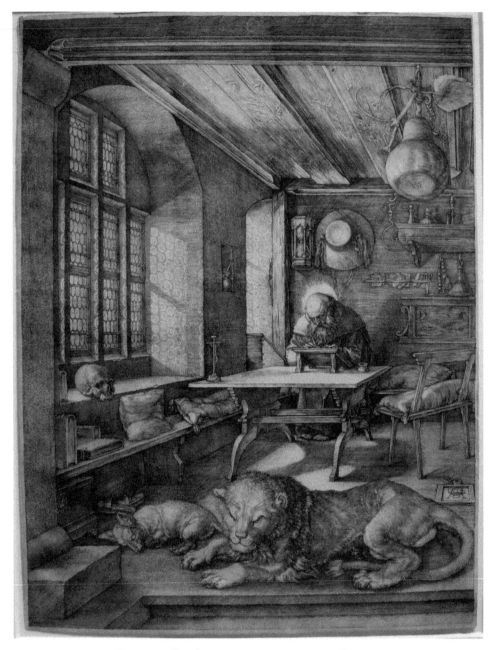

Figure 61. Albrecht Dürer, *St. Jerome in His Study*, 1514.
Engraving, 10.2 x 7.91 in. (25.9 x 20.1 cm.). Staatliche Kunsthalle Karlsruhe.

This contemplative scholarly life complements the bold, active life portrayed in Dürer's *The Rider*. In medieval times, these two extremes were thought to be the two halves of a human soul.[4]

33

The Rhinoceros (1515)

During this period many people, including Dürer, were greatly interested in unusual objects. Explorers were bringing new items from far off lands to Europe. Unlike most of his paintings that were done after careful observation, Dürer never saw a rhinoceros, but he had read about one.[1]

The ruler of Gujarat, Sultan Muzafar II, gave a rhino to the governor of Portuguese India. The governor sent the animal by ship to King Manuel I in Lisbon, the capitol of Portugal. After it arrived in May 1515, the king arranged for the rhino to fight with an elephant. He wanted to see if the natural animosity between the two animals described in Pliny the Elder's *Natural History* (written in AD 77) was true. The elephant fled.[2]

The king then shipped the rhino from Lisbon to Rome as a gift to Pope Leo X. On the way, the ship hugged the coastline and then dropped anchor at Marseilles where King Francis I of France and his queen came to see the rhino. The ship sunk along the Italian coast before reaching Rome.[3]

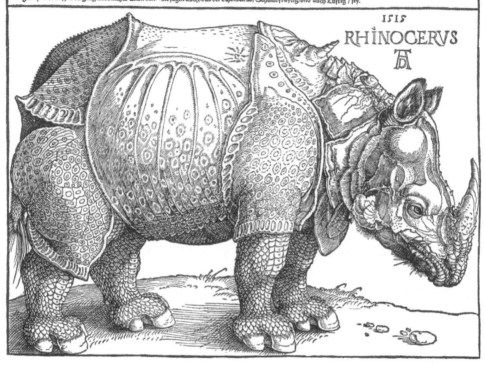

Figure 62. Albrecht Dürer, *The Rhinoceros*, 1515.
Woodcut and typography, 9.76 x 12.48 in. (24.8 x 31.7 cm.).

34

Johann von Staupitz

Johann von Staupitz, who sent Luther to the University in Wittenberg, was a child-hood friend of Elector Frederick. After completing his theological education, Staupitz served as a prior of the Augustinian house in Munich. Frederick called him to become professor of Bible at the newly founded University of Wittenberg, as well as the first dean of the theological faculty. Soon afterwards, Staupitz was also called to be the Vice-General of the German Congregation of Augustinians. He was busy teaching and supervising Augustinian monasteries.[1]

When Luther came to Wittenberg, Staupitz became his confessor. After hearing Luther's fears about a holy God, Staupitz encouraged Luther to be confident of God's love and to love God. "Don't you know that God commands you to hope?" Staupitz finally counseled Luther to preach and to take Staupitz's position as chair of Bible at the University in 1512.[2]

Though Luther did not feel like someone who could guide people to know God, he began studying the book of Psalms in 1513 in order to give lectures. Two years later, he began teaching Paul's Letter to the Romans. Erasmus's new translation of the *New Testament* reached Luther when he was lecturing on the ninth chapter of Romans. In his first letter to Erasmus, Luther called him, "Our delight and our hope." Studying God's word brought Luther peace because he discovered that the righteousness that God required of him was found in Christ, not in his own acts.[3]

Staupitz' warmth and knowledge of cures for spiritual ailments helped Luther. Luther later said, "If it had not been for Dr. Staupitz, I should have sunk into hell."[4]

On one of his visits to Nuremberg as the Vice-General, Staupitz spoke in 1512 at the Augustinian cloister. When he returned to the city in 1516 and 1517, Staupitz gave a series of sermons. "On True Repentance" emphasized God's infinite capacity for the forgiveness of sins and the Passion of Christ as the only true key to salvation. Pirckheimer's group, which met regularly in the Augustinian monastery, was part of

the audience. The group was so impressed that they began calling themselves the Staupitz Society.[5]

Dürer paraphrased one of Staupitz' sermons on a slip of paper from memory. City Secretary Lazarus Spengler's transcriptions of the 1517 sermons fill in two of the gaps from Dürer's memory.

> Item: As through the disobedience of sin we have succumbed to eternal death, there was no other way by which we might be helped than that the Son of God became Man, so that through his guiltless suffering he superabundantly paid our debt to the Father and redeemed all our guilt, in order that God's justice would be satisfied. For he repented of the sins of the whole world, atoned for them, and obtained eternal life for us from the Father. Thus Jesus Christ is the Son of God, the highest power who can do all things and he is the eternal life. Every one into whom Christ enters is born again and himself lives in Christ. Therefore all things are good things to Christ. In us there is nothing good unless it is made good in Christ. Thus whoever seeks to justify himself is not justified. We can will what is good, provided Christ wills it in us. No human repentance is so great that it can be sufficient to [expunge] a deadly sin, [although even this human repentance is such] that it can bear [living] fruit.[6]

This scrap of paper reflects the influence of Staupitz' sermon on Dürer's new understanding about the extent of sin, the power of Christ's death on the cross to save all people, and the goodness found in new life in Christ. Dürer gave Staupitz some prints or one of his biblical books, such as a Passion, as a gift.[7]

35

Emperor Maximilian

In 1508, Maximilian was elected the Holy Roman emperor. He was a courageous, impulsive, and generous man who liked to think of himself as a direct descendant of Osiris, an Egyptian god of the dead. He also imagined himself as King Arthur of England. He was interested in learning everything—from archeology to fishing, from mining to fashion designing.[1]

The emperor awarded Dürer a special copyright to protect all of his work in 1511. He probably hired Dürer to organize a team including the court historian and astronomer, as well as many artists, to create a triumphal arch when he was in Nuremberg for almost two weeks in 1512. The 192 separate woodcuts (totaling 11' x 10') represented a colossal arch like those built by conquering soldier-emperors in Ancient Rome.[2]

The arch celebrated Maximilian's life and the Hapsburg family's deeds. "Egyptian" hieroglyphs are mingled with classical mythology and medieval heraldry. The woodcuts include about one hundred and fifty lions in all shapes and sizes, mostly on shields of his ancestors and allies. Seven hundred copies of the *Arch* were printed and sent throughout the empire. Maximilian knew about the power of print.[3]

Dürer also drew forty-five pictures in red, olive-green, and violet pen in the margins of nine pages of the emperor's personal *Prayerbook*. The imaginative and humorous drawings included biblical, classical, and medieval themes: animals and birds, branches and tendrils, knights and dragons, saints and scenery, musicians and dancers. The drawings were not only to decorate the pages but also illustrate the content. Since Dürer was busy with the *Arch*, the remaining pages were handed to Lucas Cranach of Wittenburg and four other artists with instructions to complete the volume following the pattern Dürer had set. The Gothic letters and the drawings imitated a handwritten, hand-decorated manuscript. The *Prayerbook* was not meant for the emperor's private use, but was presented as gifts to a select group of noble subjects.[4]

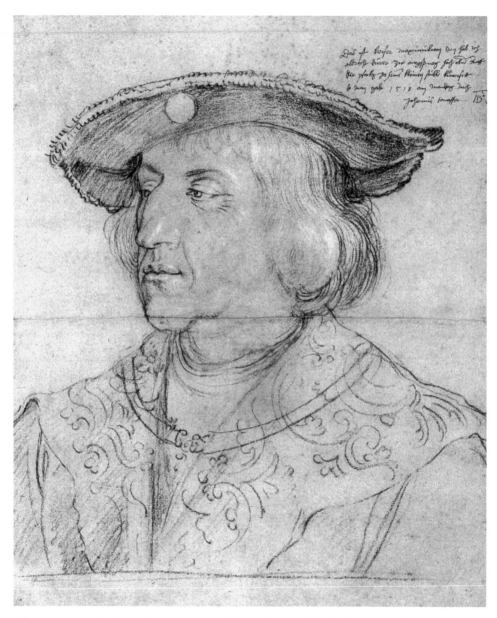

Figure 63. Albrecht Dürer, *Preparatory Sketch for the Emperor Maximilian's Portrait*, 1518. Charcoal and red, yellow and white chalk on paper, 15 x 12.56 in. (38.1 x 31.9 cm.). Albertina, Vienna.

The large, intricate arch to honor Maximilian and the small, delicate illustrations in the emperor's *Prayerbook* reflected Dürer's "decorative" phase in his stylistic development.[5]

Figure 64. Albrecht Dürer and workshop, *Triumphal Arch of Emperor Maximilian I,* **Finished 1518. 42 woodcuts and 2 etchings, 139 3/8 x 117 1/2 in. (354 x 298.5 cm.). National Gallery of Art, Washington, DC. One hundred and seventy blocks survive in the Albertina, Vienna.**

Despite all of his work for Maximilian, the emperor did not pay Dürer. At the end of July 1515, Dürer wrote to Nuremberg's ambassador to the Imperial Court, asking that he tell the emperor that he had served him for three years as supervisor of the woodcuts of the Arch.[6]

Figure 65. Albrecht Dürer, *Maximillian's Prayerbook*, 1515. Red, olive-green and violet ink, 11 x 7.7 in. (28 x 19.5 cm.). Bayerishce Staatsbibliothek, Munich. This page quotes Psalm 100:1–2: "Shout for joy to the LORD, all the earth. Worship the LORD with gladness; come before him with joyful songs." (NIV)

Just over a month later Maximilian responded:

> We Maximilian, by the Grace of God [titles] do declare publicly with this document for ourselves and our Imperial successors, and make known to all, that we have regarded and taken cognizance of the art, skill and intellect for which our and the Empire's trusty and well-beloved Albrecht Dürer has become renowned at our court, likewise the pleasing, loyal and useful service which he has oft and gladly rendered, still daily renders, and henceforth may and shall render, to us and the holy Empire and also in sundry ways to our own person.

Maximilian directed the City Council of Nuremberg to pay Dürer one hundred guilders from the city tax they were expected to send to the emperor each year.[7]

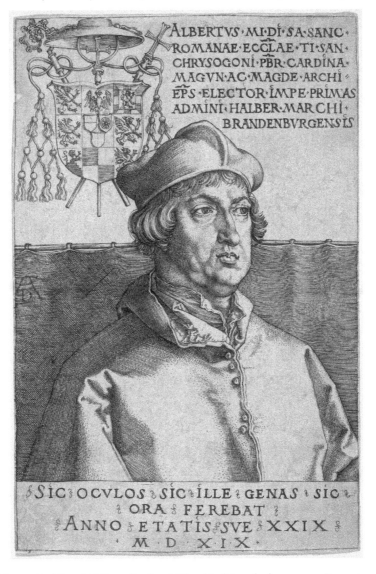

Figure 66. Albrecht Dürer, *Cardinal Albrecht of Brandenburg*, 1519. Engraving, 5.8 x 3.8 in. (14.7 x 9.6 cm.). Victoria and Albert Museum, London.

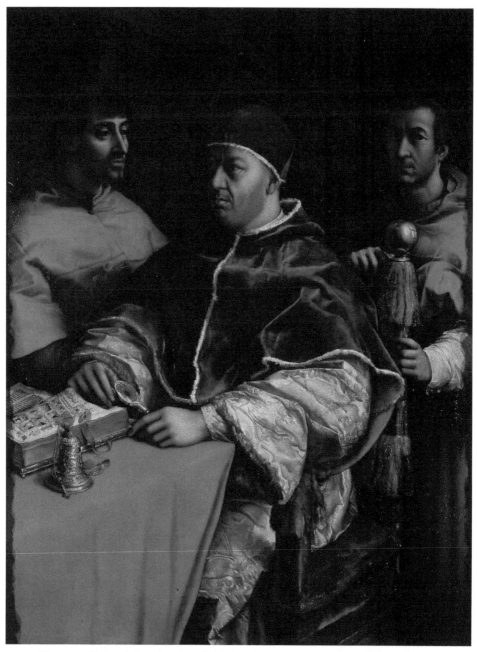

Figure 67. Raphael, *Pope Leo X with Cardinals Medici and Rossi*, 1518. Oil on panel, 61.2 x 57 in. (155.5 x 119.5 cm.). Uffizi Gallery, Florence. Pope Leo X was pope from 1513 to 1521. His cousin, on the left, became Pope Clement VII from 1523–34.

36

When the Coin Rings

In 1517, Cardinal Albrecht of Brandenburg was in trouble. He wanted money to buy the position of archbishop of Mainz, one of the three archbishops who served as electors. But Albrecht already held two positions, bishop of Halberstadt and Magdeburg—one too many. He was also too young to become a bishop, much less an archbishop. After taking a loan (29,000 florins) from the Fugger banking family, Cardinal Albrecht needed to raise money to pay back the loan.[1]

In 1513, Giovanni di Lorenzo de Medici, a member of the Medici banking family in Florence, became Pope Leo X. He also had money problems. He liked spending money on carnivals, gambling, and war. He wanted to complete the building of the new St. Peter's Basilica in Rome that the previous pope had begun.[2]

Pope Leo gave Cardinal Albrecht the privilege of selling indulgences for eight years, to raise money to complete St. Peter's. Albrecht sent out Johann Tetzel, a Dominican priest, to sell indulgences. Tetzel told the German villagers that if they would pay, they would enjoy the forgiveness of all of their sins and not have to spend any time in purgatory. Any relatives already in purgatory would not have to confess their sins. Tetzel went from village to village giving sermons. Standing in the market place he would end with a song:

As soon as the coin in the coffer rings,
The soul from purgatory springs.[3]

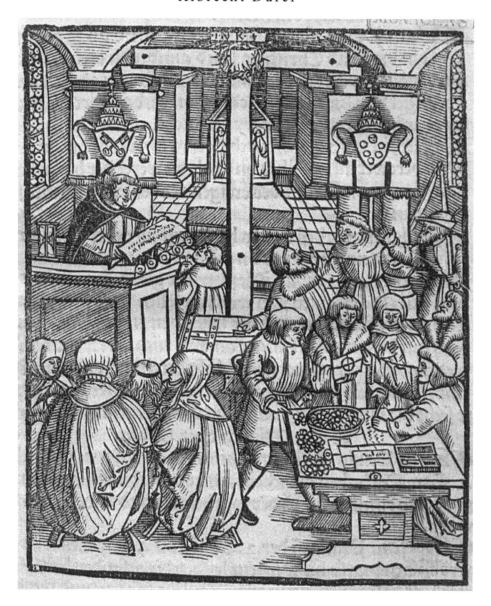

Figure 68. Indulgence selling in a church, from title page of *On Aplas von Rom kan man wol selig warden* (Without Indulgence from Rome One Can Still be Saved), Augsburg, 1521. Bayerische Staats Bibliothek, Munich.

Elector Frederick prohibited indulgence salesmen from coming to Wittenberg because he wanted any indulgence money to support his Castle Church and the University of Wittenberg.[4]

37

Ninety-Five Theses

―――――――――――

Martin Luther, who preached three times against indulgences in 1516, heard from members of his congregation about Tetzel selling indulgences in a nearby town. Luther was indignant when he heard that Tetzel was promising the people a free pass to heaven because it gave people a false sense of security. Each year on All Saints Day (November 1), Frederick displayed his relics and sold indulgences. Would Luther criticize the hand that fed him?[1]

On the eve of All Saints, October 31, 1517, Luther wrote ninety-five theses of questions and statements, a common way of starting a debate within a university setting. He had written other theses before and would do so again. He wrote the document in Latin and addressed it to Pope Leo X. Luther directed his attack on Cardinal Albrecht and Tetzel's sermon to the villagers. He rejected the idea that the church had a treasury filled with the merits of Christ and the saints that could be purchased through indulgences. Instead, he asserted that the poor were the treasure of the church.[2]

Luther mailed a copy to Archbishop Albrecht with a cover letter complaining that Albrecht gave people false assurance. "For all these souls you have the heaviest and constantly increasing responsibility." While Luther was calling for an academic debate on the topic of indulgences, Albrecht's advisors told the cardinal to send the ninety-five theses to the pope because they challenged the pope's authority to define the benefits of indulgences.[3]

Figure 69. Castle Church or All Saint's Church, Wittenberg. The tall bronze doors (120 in.; 304.8 cm. height) in the lower left corner have the original Latin text of the Ninety-five Theses (1858).

Pirckheimer's humanist group in Nuremberg got a copy of Luther's theses. Kaspar Nützel, a member of the group, translated it into German so the group, including Dürer, could read it. As a member of the City Council at Nuremberg, Nützel had already written to the church authorities in Bamberg and Rome that the city refused

to permit the sale of indulgences for the building of St. Peter's. The translations of Luther's theses were printed in several other towns and began to spread across Germany. Would this outcome be any different than the one experienced by Jan Hus, the Bohemian priest?[4]

The pope directed the new head of the Augustinians to "quench a monk of your order, Martin Luther, by name, and thus smother the fire before it should become a conflagration."[5]

Figure 70. Martin Luther, Ninety-five Theses as a placard, Nuremberg, 1517. Printed paper, 15.1 x 10.5 in. (38.4 x 26.7 cm.). Berlin State Library.

38

Luther Says Thank You

In March of 1518 Luther wrote a letter to Christoph Scheurl, a Nuremberger by birth. He had been a counselor and diplomat for Elector Frederick, as well as the rector or chancellor of the University in Wittenberg. Since 1512, Scheurl served as a legal advisor for Nuremberg's City Council. He was another member of Pirckheimer's humanist group.[1]

In the letter, Luther thanked Scheurl for his recent gifts: Nützel's German translation of the Ninety-five Theses and Dürer's prints "Meanwhile, I ask you to commend me to the best of men Albrecht Dürer and assure him of my gratitude and remembrance. Truly I beg of you and of him, that you will abandon your exaggerated opinion of me, and expect no more from me than I can perform. In truth I can do nothing and am at bottom nothing, and day by day I become even more nothing." Though unspecified, it seems likely that Dürer's gift was a group of prints.[2]

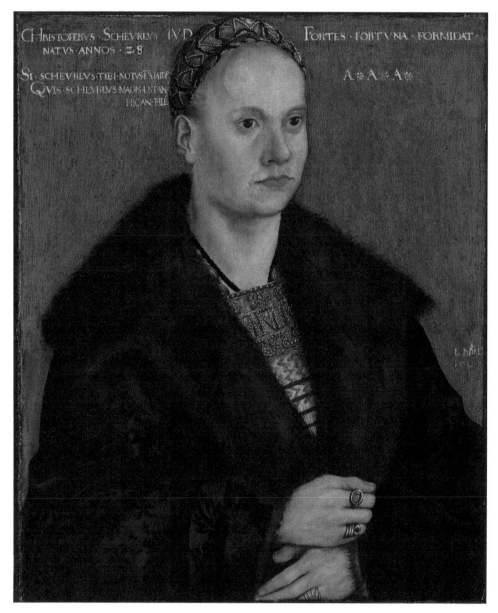

Figure 71. Lucas Cranach the Elder, *Christoph von Scheurl*, 1509. Oil on lime, 19.1 x 15.9 in. (48.5 x 40.5 cm.). Germanishes Nationalmusuem, Nuremberg.

39

The Diet of Augsburg (1518)

The pope wasn't the only one angry at Luther. Emperor Maximilian wrote Pope Leo on August 5, 1518, "to set a stop to the most perilous attack of Martin Luther on indulgences lest not only the people but even the princes be seduced." That same month, Luther was summoned to a hearing in Rome before the pope and given sixty days to arrive.[1]

Elector Frederick negotiated with the pope for Luther to speak on German soil with the pope's representative, Cardinal Thomas Cajetan, the former general of the Dominican order. He also asked the emperor to give Luther safe conduct. So Cardinal Thomas Cajetan invited Luther to a private hearing at the end of the next diet held in Augsburg, Germany. The diet attracted ambassadors, delegates, scholars, and businessmen from all over Europe.[2]

Dürer was also at Augsburg, making a preparatory sketch in charcoal for the emperor's portrait (see Figure 63). Dürer wrote on the final painting: "This is Kaiser Maximilian, who I, Albrecht Dürer, portrayed at Augsburg in his little room, high up in the Palace, in the year reckoned 1518 on Monday after John Baptist's" (June 24). In the upper left is the shield with the double-headed eagle of Austria, surrounded by the collar of the Golden Fleece. Instead of holding the imperial orb, the emperor holds a pomegranate, whose exterior is not beautiful, but the interior has both a pleasant scent and is filled with seeds that will bear fruit. The writing at the top of the portrait reads: "The most almighty, most invincible Emperor Maximilian, who in reason, decorum, wisdom, and manliness / surpassed the multitude / Also practiced remarkable great deeds and accomplishments." Dürer also sketched portraits of Cardinal Albrecht, a count, and another cardinal who was attending the diet.[3]

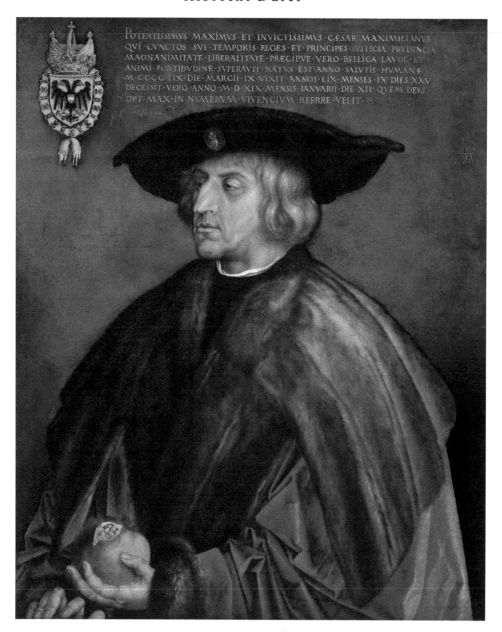

Figure 72. Albrecht Dürer, *Emperor Maximilian I,* **1519. Oil on linden wood, 29.1 x 24.2 in. (74 x 61.5 cm.). Kunsthistorisches Museum, Vienna.**

While representing the Nuremberg City Council at the Diet of Augsburg, Nützel and Spengler, and their friend Dürer, received a letter from Caritas Pirckheimer, abbess of the convent of St. Clara. She was responding to a letter they had written to her that caused her eyes to fill with tears of laughter. She answered with a "playful letter" that included a request for Dürer, "who is such a genius and master at drawing," to give advice on remodeling her church so that the choir's "eyes may not be quite blinded."[4]

The Diet of Augsburg (1518)

Cardinal Cajetan's main purpose for calling the diet at Augsburg was to raise money to fight the Ottoman Turks. The church hoped that the Bohemian heretics would be reconciled so that they, too, would join the church in the fight. Emperor Maximilian was decorated with a helmet and dagger as the Protector of the Faith.[5]

The German princes, who were not eager to raise money or join the fight, presented their grievances. "German money in violation of nature flies over the Alps. The pastors given to us are only shepherd in name. They care nothing but fleece and batten on the sins of the people. Endowed masses are neglected, the pious founders cry for vengeance. Let the Holy Pope Leo stop these abuses."[6]

Cajetan failed to achieve his main goal of the diet.[7]

Would he succeed with Luther? Pope Leo X gave him instructions to either reconcile Luther to the church if he recanted or to send him bound to Rome.[8]

Figure 73. Anonymous, *Luther before Cardinal Cajetan* from Ludwig Rabis, *Historien der heyligen Außerwolten Gottes Zeugen* (Histories of the Holy Witness), Strasbourg, 1557. Colored woodcut, 2.6 x 4.2 in. (67 x 107 cm.).

40

Cardinal Cajetan Interviews Luther

Several months later, Luther, accompanied by two of Elector Frederick's advisors, came through Nuremberg on October 5, 1518, on their way to the Diet at Augsburg. Luther, suffering from a stomachache that made riding in a wagon impossible, walked from Wittenberg. He met with Dürer's neighbor, Lazarus Spengler, the secretary to the Nuremberg Council. Luther then continued south to Augsburg on foot, for a total of twelve days.[1]

Five days after arriving in Augsburg, Luther was escorted from the monastery where he was staying to the home of the Fuggers, the banking family who lent Cardinal Albrecht the money to pay Rome for his archbishop's hat. A year before, Dürer's designs had been used in part of the Fugger Chapel in St. Anne's church in Augsburg. It is thought to be the oldest Renaissance building in Germany.[2]

Luther entered and prostrated himself before the pope's representative. Cardinal Cajetan asked him to stand, saying, "You shook Germany with your theses on indulgences; if you wish to be an obedient son and please the pope, then recant. Nothing bad will happen to you, for I hear that you are a doctor of theology with many disciples."[3]

Luther did not recant. Instead, he offered to remain silent if his attackers would also refrain. That offer was rejected, so Luther asked to be shown his errors. The first error was Luther's denial that the treasury of the church from which indulgences drew their power contained the merits of Christ and the saints. The second was Luther's assertion that faith brought certainty of forgiveness even before the penitent person received absolution from a priest. Both "errors" denied the church's role in the process of forgiveness.[4]

Luther defended himself by appealing to scripture. Cajetan countered by appealing to papal decrees and to papal authority. The talks began to turn into a debate. Staupitz, Luther's former confessor, arrived to lend support to Frederick's advisors.

Over dinner, Cajetan urged Staupitz to make Luther recant, but Staupitz said that was Cajetan's job, not his. When Luther submitted his written defense on the third day, Cajetan bluntly said, "Either recant or do not show your face again."[5]

With the pope, the emperor, and Cardinal Cajetan against him, could Luther escape the stake?[6]

41

Fleeing by Horseback

Staupitz released Luther from his vow of obedience to the Augustine order and found him a horse. Because the city gates were being guarded, Luther concealed his monastic habit under a borrowed hat and cloak and rode out into the night with a single bodyguard.[1]

Though Luther was not an experienced horseman, the two men rode back to Nuremberg. They stayed as guests in Pirckheimer's home. Luther was shown Pope Leo's instructions to Cardinal Cajetan to arrest Luther and excommunicate his followers. Luther returned home to Wittenberg exactly one year after writing the Ninety-five Theses.[2]

Luther thought he should leave Wittenberg because he was causing Elector Frederick too much trouble. Staupitz, who did not want to speak against Luther, left his positions at the University and with the Augustinians and moved to Salzburg. He wrote Luther in December asking him to join him there. "Leave Wittenberg and come to me that we may live and die together. The prince [Frederick] is in accord. Deserted let us follow the deserted Christ."[3]

At his farewell dinner in Wittenberg, Luther received a note from Frederick's representative, Spalatin, that Frederick wanted Luther to stay in Wittenberg.[4]

Figure 74. Golden Rose, 1330. Gold, gilded silver, colored glass, champlevé enamel over silver,
24 in. (60 cm.) height. Pope John XXII gave this rose to Rudulph III of Nidau,
Earl of Neuchatel in 1330.

42

Frederick Feels the Squeeze

Pope Leo wrote a letter to Elector Frederick exhorting him to deliver up Luther:

> Beloved son, the apostolic benediction be upon you. We recall that the chief ornament of your most noble family has been devotion to the faith of God and to the honor and dignity of the Holy See. Now we hear that a son of iniquity, Brother Martin Luther of the Augustinian eremites [hermits] hurling himself upon the Church of God, has your support . . . We call upon you to see that Luther is placed in the hands and under the jurisdiction of this Holy See lest future generations reproach you with having fostered the rise of a most pernicious heresy against the Church of God.[1]

However, the political situation changed dramatically when Emperor Maximilian died on January 12, 1519, in Wels, Austria. Five years before, the emperor had fallen from a horse and mangled his leg. Wherever he traveled, he brought an empty coffin with him.[2]

Before his death, Maximilian had advocated that his young grandson, Charles V, who was already King of the Netherlands and Spain, be elected the next Holy Roman emperor. Though the seven electors were mostly German and would have preferred a German ruler, no German had an army capable of enforcing the peace throughout the empire. The choice was between Francis I of France and Charles V of Spain.[3]

Back room political negotiations increased after the emperor's death. Since the pope supported Frederick in order to keep a balance of power, he did not want to alienate the Saxon elector despite his problem monk. Cajetan assigned Frederick's relative, Carl von Miltitz, to gain the favor of the elector and keep Luther quiet until the election was settled.[4]

The pope offered Frederick the special privilege of selling indulgences that would decrease the days in purgatory for those who viewed Frederick's relics. The privilege

would bring more pilgrims to Wittenberg and more money to Frederik's church and university.[5]

Pope Leo also sent Frederick a gift of great honor, a golden rose consecrated by him, along with a letter:

> Beloved son, the most holy golden rose was consecrated by us on the fourteenth day of the holy fast. It was anointed with holy oil and sprinkled with fragrant incense with the papal benediction. It will be presented to you by our most beloved son, Carl von Miltitz, of noble blood and noble manners. The rose is a symbol of the most precious blood of our Saviour, by which we are redeemed. The rose is a flower among flowers, the fairest and most fragrant on earth. Therefore, dear son, permit the divine fragrance to enter the innermost heart of Your Excellency, that you may fulfill whatever the aforementioned Carl von Miltitz shall show you.[6]

When the delivery of the rose was delayed, Frederick said, "Miltitz may refuse to give me the golden rose unless I banish the monk and pronounce him a heretic." A cardinal who knew this to be true, exclaimed, "You are a pack of fools if you think you can buy the monk from the prince."[7]

As Miltitz stayed at inns on his way to Wittenberg, he discovered that many more people supported Luther than the pope. When he arrived at Frederick's court, he asked Luther if he would agree to the new papal decree on indulgences. Luther replied that the decree did not have a word in it from Scripture. Luther did agree to refrain from debate and publishing if his opponents did likewise.[8]

Tetzel, having been made the scapegoat for the controversy, retired. When Luther heard Tetzel was ill, he wrote him not to blame himself for the debate over indulgences since the "child had many parents." Tetzel died in August 1519 in Leipzig.[9]

43

"Dürer Is in Bad Shape"

The death of Maximilian I ended a political era for the Holy Roman Empire. For Dürer, it possibly meant losing his yearly pension of one hundred florins, since the Nuremberg City Council might nullify it. Dürer was also in the midst of a spiritual crisis.[1]

Scheurl, the legal advisor for Nuremberg's City Council, wrote to Nikolaus von Amsdorf, a professor at Wittenberg, in April 1519 asking him to send five copies of a book on prayer compiled from Luther's sermons. He told of Dürer's particular interest in having the Sermon on Penitence translated. Several months later, Scheurl thanked Amsdorf for the translation. "I and my friend Albrecht Dürer, so pre-eminent among painters for his intellect and judgement, are immeasurably pleased by your translation . . . Privately, however, you would earn our thanks if you would send us anything at all, and even the slightest bits and pieces, from Luther's press. By the same token you will certainly be doing Dürer a favour." Once more, Dürer is hampered by his lack of formal education.[2]

Pirckheimer knew that something was disturbing his friend. He noted on a letter he had received from a fellow-humanist two weeks after the emperor's death, "Dürer is in bad shape."[3]

When the young Dutch artist Jan van Scorel came to Nuremberg to learn from Dürer in 1519, he found Dürer preoccupied with the "teachings by which Luther had begun to stir the quiet world." Since the teachings had been declared heresy, Scorel left Dürer and went on to another part of Germany, later entering the service of Pope Adrian VI, the only Dutch pope, from 1522–23.[4]

Figure 75. Martin Luther, *On the Babylonian Captivity of the Church*, Wittenberg: Melchior Lotter the Younger, 1520. Lutherhalle, Wittenberg.

44

Luther Debates Eck and Writes Tracts

In July 1519 the formidable professor of theology Johann Eck invited Luther to speak in Leipzig, Wittenberg's rival university. Two hundred students from Wittenberg came with battle-axes to hear the debate that lasted eighteen days. The debate resembled a university "prize fight" with both sides supporting their champion.[1]

Eck got Luther to admit that Hus, the Czech priest condemned and burned at the stake one hundred years before, was not heretical. The debate ended in a draw, but Eck was able to charge Luther with following Hus. Eck could now ask the pope to write a bull of excommunication for Luther. Eck called Luther's followers *Lutherani*.[2]

After Luther returned to Wittenberg, visitors from Prague gave him a book about Hus. After reading it, Luther wrote his mentor Staupitz: "We are all Hussites without knowing it." Luther began wearing a Hussite badge with pride. The chalice design represented both clergy and laity sharing the communion cup.[3]

Previous reformers, such as Peter Waldo in Lyon, France, declared as a heretic in 1215, or John Wycliffe in England, declared a heretic in 1415, or John Hus in Bohemia declared a heretic in the same year, did not have the benefit of the printing press to easily spread their teachings.[4]

Luther wrote three tracts during 1520. "On the Babylonian Captivity of the Church" questioned the seven sacraments of the church: baptism, Eucharist (communion), confirmation, penance, marriage, ordination, and last rites. He reduced them to two: baptism and the Eucharist. In the second tract, "On the Nobility of the German Nation," Luther addressed the German nobles and attacked the structure and theology of the medieval church. Following the German princes' lead, he, too, asked why all the church money went to Rome. When the tract was published in August of 1520, the first printing of 4,000 copies sold out in a few days. The third tract, "Freedom of a Christian," argued that Christ frees people in their spirit, but that they need to live under the rules of society. The book spoke about faith and love. "A Christian

is perfectly free, sovereign over all, subject to none; a Christian is a perfectly dutiful servant of all, subject to all."[5]

In 1520, Cranach, the court painter, and Christian Doring, the elector's private goldsmith and a fellow Wittenberg councilman, agreed to buy a printing press. They invited Melchior Lotter, Jr., a printer from Leipzig, to join them. The team of Cranach-Doring-Lotter published all three tracts of Luther, now a best-selling author.[6]

Luther's thirty publications probably sold well over 300,000 copies between 1517 and 1520. Luther described the printing press as "God's highest and extremest act of grace, whereby the business of the Gospel is driven forward." Elizabeth Eisenstein, a historian of the printing press, wrote: "For the first time in human history a great reading public judged the validity of revolutionary ideas through a mass-medium which used the vernacular languages together with the arts of the journalist and the cartoonist."[7]

Erasmus's works greatly influenced Luther between 1511 and 1521. The two men wrote letters to each other. In March 1519, Luther wrote about Erasmus's "wonderful spirit" that "has so much enriched me and all of us." Two months later, Erasmus wrote from Louvain to Luther, "No words of mine could describe the storm raised here by your books."[8]

45

Dürer's List and Letter

A t some point, Dürer made a list of sixteen of Luther's early pamphlets. The last one was written in 1520. The pamphlets included one against indulgences, two sermons on penance, interpretations of various Psalms, tracts on confession, and the meaning of Christ's Passion and the Lord's Prayer.[1]

In early 1520, Dürer wrote to George Spalatin, who had grown up in Nuremberg. Spalatin had been tutor to Elector Frederick's son, Prince Johann Frederick I. Spalatin later oversaw the University's library located inside the Wittenberg castle, and then he became Elector Frederick's court chaplain and secretary.[2]

Dürer asked Spalatin to thank the elector for sending him copies of Luther's pamphlets and to request that Frederick protect Luther.

> Therefore I ask your Honour to be so good as to convey my humble thanks in highest measure to His Grace, the Prince Elector, and to beg His Grace in all humility that he deign to protect the praiseworthy Dr. Martinus Luther, for the sake of Christian truth, which is more to us than all wealth and power of this world, that utterly perish with time, whilst truth alone endures eternally. And if with God's help I should come to Dr. Martinus Luther, I will use my skill to sketch his portrait and engrave it in copperplate as a lasting memorial of this Christian man, who has rescued me out of deep anguish. And I ask Your Honour, when Dr. Martinus publishes something new in German, please to send it to me and I shall pay you.[3]

Philip Melanchthon, a professor at the University of Wittenberg and great supporter of Luther, wrote about Dürer's reaction to Luther's writings: "Albrecht Dürer, painter of Nurnberg, a shrewd man, once said that there was this difference between the writings of Luther and those of other theologians. After reading three or four paragraphs of the first page of one of Luther's works he could grasp the problem to be

worked out in the whole. This clearness and order of arrangement was, he observed, the glory of Luther's writings."[4]

ANNO · ETATIS · 26 ANNO · DOMINI · 1509

Figure 76. Lucas Cranach the Elder, *George Spalatin*, 1509. Oil on wood transferred to canvas, 13 x 11.2 in. (33 x 28.5 cm.). Museum der bildenden Künste, Leipzig.

Luther's words of hope, peace, and purpose broke through Dürer's fear and sorrow that plagued him since his mother's death six years earlier. After closely following the controversy surrounding Luther, Dürer found shelter in the center of the storm.[5]

46

The Papal Bull

On June 15, 1520, the papal bull against Luther and his followers was published. The letter, written on a thick animal skin, was validated by the pope's seal of lead or *bulla*. Eck, who debated Luther in Leipzig the previous summer, was allowed to name other heretics in the bull.[1]

Eck listed three men from Nuremberg, including two men from the humanist study group. George Spengler, Dürer's neighbor, read everything Luther printed in Wittenberg. He felt Luther's teachings reflected scripture, gave peace and consolation, and also served as a guide to purposeful life. He angered Eck by joining Erasmus of Rotterdam in defending Johannes Reuchlin, a Hebrew scholar, against the Dominicans of Cologne. Eck also named Wilibald Pirckheimer. Eck was angry at a brilliant, yet anonymous satire written against him. Though Pirckheimer denied writing it, Eck thought he did. Both men went through humiliating and delicate negotiations with Eck, who granted them absolution or freedom from their sin.[2]

Eck also named three heretics from Wittenberg, including Andres Karlstadt, who also debated Eck at Leipzig. Once Karlstadt returned home to Wittenberg, he wrote an attack on Eck.[3]

Even after the negotiations, Pirckheimer and Spengler's names were still listed on the one hundred bulls carried north from Rome by Eck and another envoy of the pope, Jerome Aleander. They were to deliver copies of the bull to Emperor Charles and to the princes, bishops, universities, and all major cities in the Holy Roman Empire. After the new emperor received the bull, he ordered that Luther's books in Holland and Belgium by destroyed.[4]

Figure 77. Pope Leo X, *Bulla Contra errores Martini Lutheri et sequacium* **(Papal Bull against Luther and his Followers) Rome: Jacobus Mazochius. 1520.**

The bull was supposed to take effect in each archdiocese in Germany as soon as it was posted on the cathedral door, but Eck and Aleander met with more opposition than they expected. In Leipzig, Eck hid for his life in a cloister. In Erfurt, students threw copies of the bull into the river. Eck did not dare to enter Saxony, so he sent one copy by courier to the University at Wittenberg. Aleander described many of Cardinal Albrect's advisors as "radical Lutherans who spoke out against Luther like enemies but treated him like a friend."[5]

47

Cranach's *Luther in a Monk's Niche* (1520)

In his letter to Spalatin, Dürer expressed the desire to draw an image of the reformer Luther for posterity. He also included two copies of a recent copper engraving he had done of Archbishop Albrecht in 1519. At the moment, Albrecht was not popular in Wittenberg.[1]

Since Dürer was preoccupied at the time and could not come to Wittenberg, Spalatin gave the letter and the engravings to Frederick's court painter, Cranach. He instructed Cranach to make an official court portrait of Luther. Cranach's first engraving made Luther look like an angry reformer. Frederick did not want the new emperor to see that picture at the upcoming diet.[2]

So Cranach made another drawing. Luther, confined within a traditional saint's niche, is holding an open Bible. This "image of a holy man, with an open mind, obedient will, and god-fearing heart" became Luther's official court portrait. The elector renewed his pledge to protect Luther.[3]

Figure 78. Lucas Cranach the Elder, *Luther in a Monk's Niche*, 1520. Engraving, 66.5 x 45.7 in. (16.9 x 11.6 cm.). British Museum, London.

48

Traveling to the Netherlands

One month after the papal bull was published, which threatened Luther and two of Dürer's friends in Nuremberg with excommunication, Dürer took a trip to the Netherlands with his wife, Agnes, and her maid, Susanna. He carried two small books, a journal of expenditures and impressions, and a sketchbook. Dürer's journal, where he recorded his finances, his insights on art and life, and his interactions with various people, is a unique document of a Renaissance artist.[1]

The Dürers began their trip by visiting the bishop in Bamberg, the cathedral city for the diocese. The bishop gave Dürer a travel pass so that he would not have to pay tolls along the Rhine River. He also gave him three signed letters of introduction that would help him move within society. In exchange, Dürer gave the bishop a painting of the Virgin Mary, engravings, and a copy each of the *Apocalypse* and the *Life of the Virgin*.[2]

In those days, long distance travel included paying tolls, using many kinds of currency, and the ever-present threat of being robbed or kidnapped for ransom. The three sailed down the Main River from Bamberg to Frankfurt as part of a convoy. Each night they went ashore to stay at an inn or guesthouse.[3]

The Dürers presented their toll pass at every station along the way. They stopped at various castles along the Rhine River, including Rudesheim, Schloss Ehrenfels, Bacharach, Kaub, and St. Goar. At the Trier tollbar, Dürer wrote under his signet ring seal that he did not have any common merchandise. (Nothing he ever drew was common!) Finally, they sailed to Bonn and arrived six days later in Cologne, the oldest and largest city in Germany.[4]

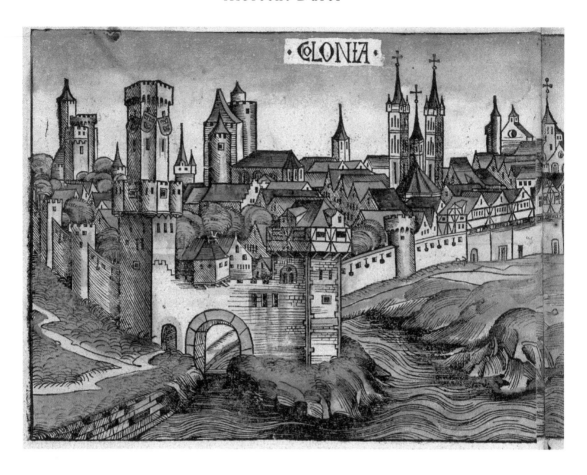

Figure 79. Attributed to Michael Wolgemut, *Cologne,* 1493. Woodcut from the *Nuremberg Chronicle.* The cathedral, center, begun in 1248, was halted in 1473. A crane sat on top of the unfinished cathedral for centuries. It was finished in the nineteenth century.

The Dürers spent a few days in Cologne visiting Albrecht's cousin, a goldsmith who once lived in Nuremberg. His cousin had been kidnapped while carrying five thousand florins worth of gems, and the Nuremberg City Council had ransomed him. After reimbursing the Council, his cousin moved to Cologne, impoverished.[5]

The final part of the journey was over land to Antwerp. They spent three days traveling on horseback, stopping for meals and lodging, arriving on Thursday, August 2, 1520.[6]

Figure 80. Albrecht Dürer, *Antwerp Harbor*, 1520. Pen and brown ink,
8.4 x 11.1 in. (21.3 x 28.3 cm.). Albertina, Vienna.

49

Antwerp, A City of Wealth and Power

In the prior fifteen years, Antwerp had overtaken Venice as the center of world commerce. Portuguese sailors who brought spices from Southeast Asia and gold and goods from the New World transformed the town. Bankers and merchants relocated their headquarters to Antwerp.[1]

The Dürers stayed at Jobst Planckfelt's inn that lay between the harbor and the main market. He gave Dürer a tour of the city, including a visit to the home of mayor, so elegant that Dürer had never seen anything like it in Germany.[2]

Dürer was entertained by the painters' guild, which was so rich that it owned its own set of silver dishes. Many painters bowed to Dürer and wished him goodwill. After an evening of socializing, the painters accompanied Dürer, his wife, and maid with lanterns, back to their inn.[3]

On the feast day of the Assumption of the Virgin (August 19), the guilds in Antwerp staged a great procession. Members of every guild dressed in their best clothes and walked down the streets with signs identifying their guilds. People carried expensive pole candles. Noisy musicians played trumpets, pipes and drums. Dürer recorded the event in his journal:

> There were the goldsmiths, the masons, the painters, the embroiderers, the
> sculptors, the joiners, the carpenters, the sailors, the fishermen, the butchers,
> the leatherers, the clothmakers, the bakers, the tailors and the shoemakers—
> indeed, workmen of all kinds, and craftsmen and dealers who work for their
> living. Also the shopkeepers and merchants and their assistants of all kinds
> were there . . . After these came the shooters with guns, bows, and crossbows,
> and the horsemen and the footsoldiers also. Then followed the Watch of the
> Lords Magistrates. Then came the fine troop all in red, nobly and splendidly
> dressed.[4]

Figure 81. Denys van Alsloot, *The Ommeganck in Brussels on 31 May 1615 the Senior Guilds* (right side), 1615. Oil on canvas, 46.5 x 67.3 in. (118 x 171 cm.). Victoria and Albert Museum, London.

Before them, however, went all the religious orders and the members of some Foundations very devoutly, all in their different robes. A very large company of widows also took part in this procession. They support themselves with their own hands and observe a special rule . . . Last of all there came the Chapter of Our Lady's Church with all their clergy, scholars, and treasurers. Twenty persons carried the [statue of] Virgin Mary with the Lord Jesus, adorned in the costliest manner to the honor of the Lord God.[5]

Dürer then described wagons decorated as ships, and others with scenes from the New Testament and from saints' lives. The procession lasted more than two hours. "And so many things were there that I could never write them all in a book, so I let it alone."[6]

Due to his friendly reception, he sold or exchanged his prints for luxury items, including a green parrot for Agnes, sugar cane, marzipan, and other candies. The print he gave away or sold most often was his engraving of *St. Jerome in His Study* (figure 61). He also made money by drawing portraits in charcoal. The members of the Antwerp City Council hoped Dürer would immigrate to their city. They offered him tax-free status, an annual salary, and rent-free housing.[7]

50

Losing His Sight

Dürer was forty-nine years old in the fall of 1520. In the same letter that he wrote to Spalatin, asking Frederick to protect Luther, he also shared about his health. "As I am losing my sight and freedom of hand my affairs do not look well." For an artist known for precision and detail, this was a terrible loss. He purchased three pairs of eyeglasses during his trip to the Netherlands.[1]

One of Dürer's main reasons for coming to the Netherlands was to ask the new emperor Charles for an extension of his old-age pension that Emperor Maximilian had promised in 1515. Dürer hoped that several high-placed backers, including Margaret of Austria, Maxmilian's daughter who ruled the Netherlands, would support his request. Dürer went to Brussels to gain an audience with the new emperor, who had been born and raised in the Netherlands, and was soon to be crowned in the cathedral in Aachen.[2]

While in Brussels, Dürer visited the Royal Palace and its zoo. He also went to the first exhibition of pre-Columbian art ever held in Europe. Captain Hernando Cortes had brought these objects back from Mexico, the "new Land of Gold." Dürer thought they were of high quality—a gold sun "a good six feet across," a silver moon, shields, weapons, ceremonial hangings made of colorful bird feathers, beds, and "very strange" clothing. He wrote in his diary: "All the days of my life I have seen nothing that has gladdened my heart so much as these things, for I saw amongst them wonderful works of art, and I marveled at the subtle *Ingenia* [ingeniousness] of men in foreign lands."[3]

Dürer returned to Antwerp in time for the Triumphal Entry of Charles V. Dürer bought a copy of the *Condemnation of Martin Luther*, written by the theological faculty of the University of Cologne. He also bought some Luther broadsheets.[4]

In early October 1520, Dürer left Antwerp for Aachen to be there in time for the coronation. He traveled on horseback for three days with the Nuremberg delegation, who paid his travel expenses.[5]

Figure 82. Anonymous artist after Jakob Seisenegger, *Charles V,* after 1532. Oil on canvas, 80.7 x 50 in. (205 x 127 cm.). Royal Palace of La Almudaina, Palma, Majorca.

51

Coronation at Aachen

Charles V was to be crowned in Aachen because all of the kings of Germany had been crowned there since 936, after Charlemagne (Charles the Great) chose Aachen as his imperial city.[1]

Dürer had carefully researched Charlemagne in 1512, after the Nuremberg Council asked him to paint a pair of portraits of two Holy Roman emperors, Charlemagne and Sigismund (figure 5). The painting of the tall emperor, wearing a mantle of heavy brocade, combines fairy-tale grandeur and historic study. Dürer painted the shields of Germany (left) and France (right) above him. Sigismund was the emperor who moved the collection of imperial clothing, swords, and relics to his hometown Nuremberg in 1424 to keep them from being captured by the Hussites. The portraits of the two emperors were placed in the same room as the imperial relics in Nuremberg. This served to remind people of the political and religious importance of their city.[2]

Because Charlemagne wanted to be known as ruler of the Holy Roman Empire, he built an eight-sided palace chapel in Aachen similar to those built by Roman emperors in Ravenna, Italy, around 500. A throne, made out of large plain cut stone, was also in the palace chapel. In the midst of the celebration of enthronement, the new emperor would see Jesus, the King of kings, watching from the ceiling of the dome opposite the throne. This was to remind the new sovereign that Jesus was the ultimate and eternal ruler.[3]

Dürer also visited Aachen Cathedral's treasury of the holy relics, including one shaped as the bust of Charlemagne that held his skullcap. Dürer bought a rosary, which he gave to one of his Nuremberg companions who would not accept monetary payments for his trip's expenses.[4]

Figure 83. Albrecht Dürer, *Emperor Charlemagne*, 1510–13. Oil and tempura on lime, 84.6 x 45.3 in. (215 x 115 cm.). Germanisches Nationalmuseum, Nuremberg.

Figure 84. Albrecht Dürer, *Aachen Cathedral,* **1520.**
Silverpoint, 5 x 7 in. (12.6 x 17.7 cm.). British Museum, London.

Charles V, who ruled more territory than any other European ruler since the ancient Roman Empire, was crowned on October 23, 1520. Dürer wrote, "There I saw all manner of lordly splendor, the like of which no man now alive has ever seen."[5]

Still waiting to hear about the emperor's decision regarding his petition for his pension, Dürer went back to Cologne with the Nuremberg businessmen. He visited the church of St. Ursula, where the relics of the martyred Romano-British princess and her eleven thousand ladies-in-waiting were kept. He bought another pamphlet of Luther's and a second copy of the University of Cologne's *Condemnation of Luther.* News of Charles V confirming his pension and Luther's books being burned in Cologne as ordered by the papal bull came on the same day, November 12, 1520.[6]

After thanking his hosts, Dürer left Cologne and sailed down river toward Antwerp. Upon arrival, he learned that his wife's purse had been cut off by a pickpocket in the Church of Our Lady. Dürer also heard that a large whale washed ashore in Zeeland, a cold and windy place on the North Sea. In early December he rode there, but by the time he arrived, the whale had been washed back to sea. He became chilled and had the first attack of a sickness that would trouble him the rest of his life.[7]

Figure 85. Throne of Charlemagne in Palace chapel, Aachen, Germany, 800. Marble with bronze clamps. Thirty-one German kings ascended to the throne after being crowned between 936 and 1531.

When Dürer's ship was landing at Arnemuiden, another large ship bumped its side. Most of the passengers had already disembarked when the rope which tethered the ship broke and a strong wind blew it back out to sea. Dürer, who was still on board, wrote about the event in his journal:

Thereupon the skipper tore his hair and cried aloud, for all his men had landed and the ship was unmanned. Then we were in fear and danger, for the wind was strong and only six persons in the ship. So I spoke to the skipper that he should take courage and have hope in God, and that he should consider what was to be done. So he said that if he could haul up the small sail he would try if we could come again to land. So we toiled all together and feebly about half-way up, and went on again towards the land. And when the people on shore, who had already given us up, saw how we helped ourselves, they came to our aid and we got to land.[8]

On Dürer's twenty-sixth wedding anniversary, he drew Agnes wearing a Nether-landish headdress that he had purchased on their travels.[9]

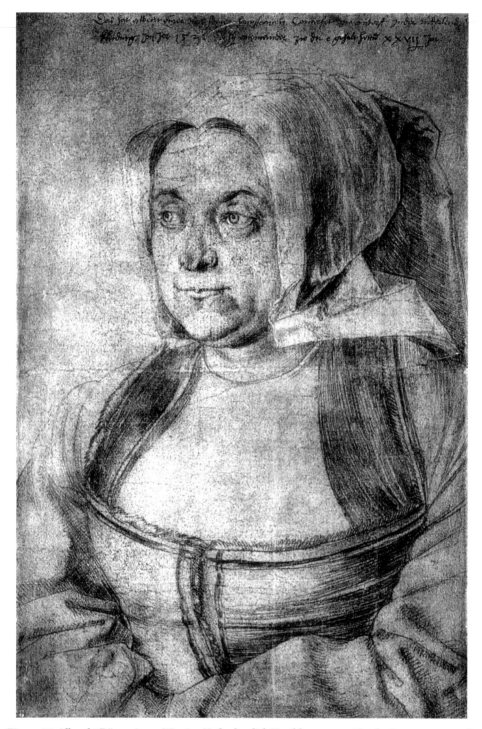

Figure 86. Albrecht Dürer, *Agnes Wearing Netherlandish Headdress*, 1521. Metalpoint on gray-purple primed paper, 16 x 10.7 in. (40.7 x 27.1 cm.). Staatliche Museum Kupferstichkabinett, Berlin.

52

Frederick Interviews Erasmus

While Elector Frederick was at the emperor's coronation, he met twice with Charles V to lobby that Luther be able to present his case before the delegates at the upcoming diet. The pope's envoy, Aleander, argued that it was not necessary to invite Luther since he was already considered a heretic by the church. Frederick responded that Luther should have a chance to answer accusations.[1]

Since Luther was so popular, the young emperor ran a political risk by condemning him without giving him a hearing. After the coronation, Charles V went to speak with Elector Frederick, who was suffering from gout in Cologne.[2]

The next day, November 5, Frederick summoned Erasmus for an interview. The first question Frederick asked was if Luther had erred. Erasmus replied, "Luther has erred in two points—in attacking the crown of the pope and the bellies of the monks." Erasmus also said that Luther had been too violent and Spalatin, the elector's secretary, promised to talk to Luther. Frederick commented about Erasmus to Spalatin, "An amazing fellow! You never know what to expect of him."[3]

At Frederick's request, Erasmus followed up the interview with "22 Axioms on Behalf of Luther" that might settle the conflict. "That the origin of the persecution [of Luther] was hatred of learning and love of tyranny; that the method of procedure corresponded with the origin, consisting, namely, of clamor, conspiracy, bitter hatred and virulent writing; that the agents put in charge of the prosecution were suspect; that all good men and lovers of the Gospel were very little offended with Luther; that certain men had abused the easy-going kindness of the pope."[4]

Having heard and read Erasmus's opinion, Frederick refused the demands of Eck and Aleander to side with the pope. When Aleander invited Erasmus to dinner to gain his support, Erasmus declined, fearing he might be poisoned. The following year, Aleander called Erasmus "the great cornerstone of the Lutheran heresy."[5]

Erasmus wrote five personal letters to Luther encouraging him to be milder. In a letter dated November 8 to Johannes Reuchin, the Hebrew scholar, Erasmus wrote that he prayed that the outcome would "tend to the glory of Christ and profit the truth of the Gospel. I would rather be a spectator of this play than one of the actors; not that I refuse to undergo some risks for Christ's sake, but because I see clearly enough that the business is too big for a small man like me . . . The truth must win."[6]

On November 28, the new emperor wrote to Frederick that Luther would receive a hearing on German ground: "Beloved Uncle Frederick: We are desirous that you should bring the above-mentioned Luther to the diet to be held at Worms that there he may be thoroughly investigated by competent persons, that no injustice be done nor anything contrary to law."[7]

53

The Diet of Worms

While Dürer was in the Netherlands, he was not out of touch with the theological storm brewing in Germany. He had bought copies of Luther's works, and on the very day he bought the *Condemnation of Martin Luther* in Cologne, Luther's books were being burned in the city. After Luther publically set fire to the papal bull and books of church law in Wittenberg in December 1520, the pope reiterated his excommunication of Luther on January 3, 1521.[1]

As the new ruler of the Holy Roman Empire, Charles V planned to hold his first diet in Nuremberg, as was the custom. In anticipation of the diet, the Nuremberg city council commissioned Dürer to design a medal of Charles. Pirckheimer advised him about the heraldic imagery included in the design, which showed some of the lands ruled by the emperor, and Hans Kraft executed its production. Since Dürer had never met Charles, he had to rely on prints, drawings, and oral descriptions. A large "N" was included in the border on the reverse side. The large silver medal was to display the city's artistic and technical achievements. The city fathers also renovated the private and public quarters of the castle in preparation for the emperor's arrival.[2]

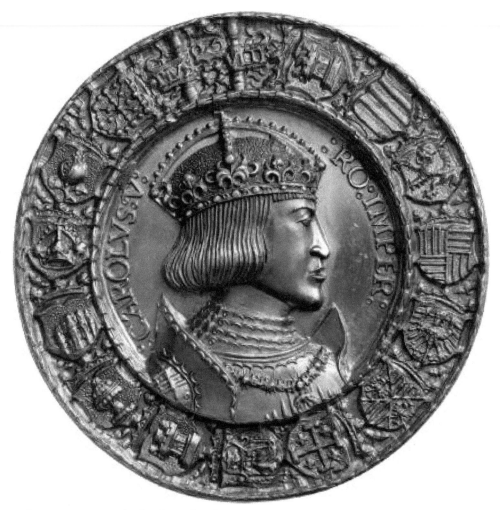

Figure 87. Hans Kraft, after design by Albrecht Dürer, Willibald Pirckheimer, Lazarus Spengler, and Johann Stabius, *Portrait Medal of Charles V*, 1521. Silver, 2.75 in. (7 cm.) diameter. State Mint Collection, Munich.

However, Nuremberg was experiencing a plague. So the first diet of Charles V was held in Worms ("vorms" rhymes with "forms") about 30 miles south of Mainz. The Diet of Worms opened on January 27, 1521. The town, a city of 7,000 people, doubled in population during the diet, which lasted several months. Spengler and Nützel were two of the envoys representing the city of Nuremberg. They were to deliver at least eleven of the hundred silver medals to the new emperor. However, most were later melted down.[3]

54

Final Months in Antwerp

In the Spring of 1521, Dürer was still in Antwerp, busy drawing portraits, coats of arms, and other artwork. He received gifts of quince jam and sandalwood, both thought to reduce fevers.[1]

As he began thinking about returning home, he bought gifts to take to his friends, neighbors, and their wives. He purchased sashes, borders, and gloves for Agnes's aunt, the wives of Kaspar Nützel, Hans Imhoff, Lazarus Spengler, and others. For Pirckheimer, he bought a large beret, an inkstand made of buffalo horn, a medal commemorating the coronation, one pound of pistachios, and three sugarcanes. For Nutzel, he bought a great elk's foot and ten large pinecones with pine nuts. In mid-March he sent his excess baggage home, packed in barrels by the Imhoffs, a family whose boat-shaped carts with canvas roofs lumbered along the great roads.[2]

Since Antwerp was the fashion capital of Europe, tailors and furriers eagerly took people's measurements to make clothing using the famous Netherlands' cloth. Dürer drew some cloak designs for his wife and mother-in-law. His own cloak was made from pelts of Spanish fur with velvet and silk trim.[3]

Dürer made a trip to Bruges and Ghent in early April. He saw Rogier van der Weyden's "splendid paintings" and Michelangelo's alabaster Madonna in the Notre Dame Church in this northern city of canals. In Ghent he saw Jan van Eyck's Altar in morning light. His wrote: "It is a most precious painting, full of thought, and the Eve, Mary, and God the Father are specially good."[4]

After returning to Antwerp, he experienced another attack of fever, nausea, and headache, and began spending money on doctors and medicines. Because of the reoccurring symptoms, some have speculated that he was suffering from malaria.[5]

Dürer made his first drawing of Erasmus in August 1520. He gave both Erasmus and his secretary copies of a *Passion*. In the spring of 1521 Dürer had dinner with Erasmus again in Antwerp. Dürer did not finish his painting of Erasmus until 1526.[6]

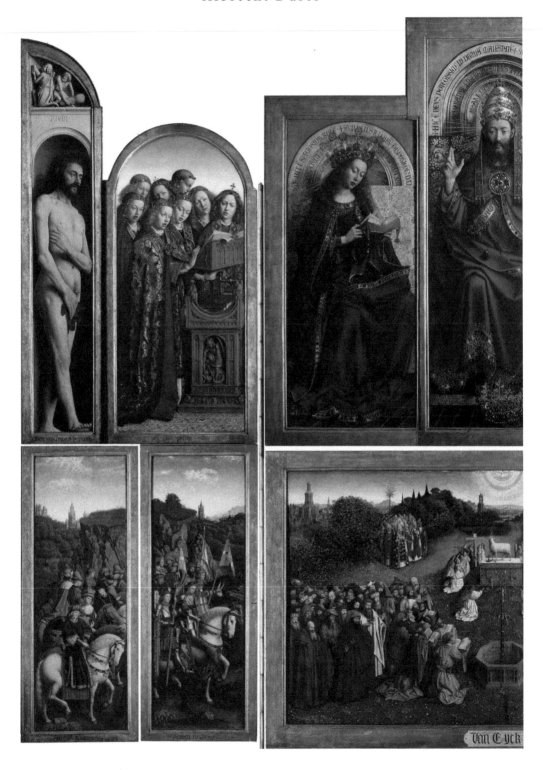

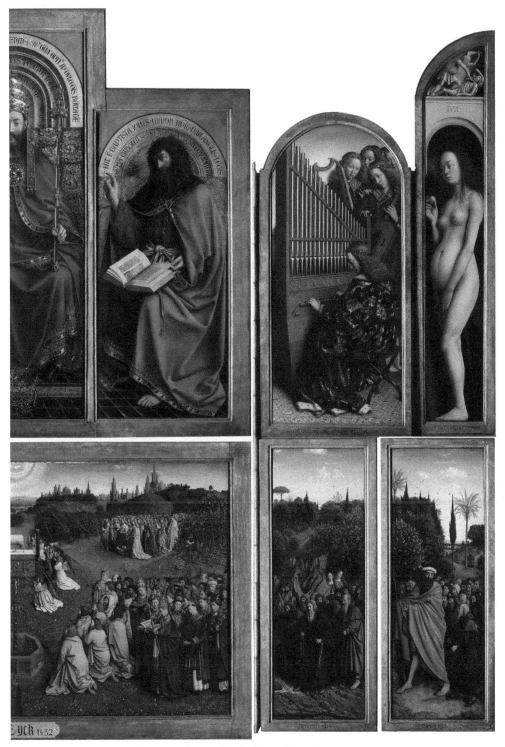

Figure 88. Jan van Eyck, *Ghent Altarpiece,* open, 1432.
Oil on oak panel, 137.8 x 181.5 in. (350 x 461 cm.).
Saint Bavo Cathedral, Ghent.

Figure 89. Anonymous, *Luther in Worms* from Ludwig Rabis, *Historien der Heyligen Außerwölten Gottes Zeugen* (Histories of the Holy Witness), Strasbourg, 1577. Colored woodcut, 3 x 4.4 in. (7.8 x 11.1 cm.). The emperor sits on the throne surrounded by the electors. Martin Luther stands next to the emperor's spokesman. Two cardinals in red hats and robes stand behind.

55

Blood

In March, Charles V ordered Luther to come to the Diet of Worms to stand before the assembly. Luther's books were burnt in the river town of Mainz on the same day. When Frederick asked Luther if he was willing to go, Luther's reply referenced the three Israelite youths who were rescued from the fire after the Babylonian king Nebuchadnezzar's verdict in Daniel 3. "I will go even if I am too sick to stand on my feet . . . I commend my cause to God. He lives and reigns who saved the three youths from the fiery furnace of the king of Babylon, and if He will not save me, my head is worth nothing compared with Christ. This is no time to think of safety. I must take care that the gospel is not brought into contempt by our fear to confess and seal our teaching with our blood."[1]

Luther wrote to Staupitz, his former confessor, in Salzburg: "I am afraid you hesitate between Christ and the pope, though they are diametrically contrary . . . If you will not follow, permit me to go . . . You seem to me to be a very different Staupitz from the one who used to preach grace and the cross."[2]

Luther and a group from Wittenberg reached Worms on Tuesday, April 16. Many people wanted to meet Luther, so Spalatin, the elector's secretary, made sure they came to Luther's quarters, in order to keep him safe. Spalatin joked that Luther received more visitors than the nobility who were attending the Diet.[3]

On the next morning, Luther learned that he would appear before Charles V that afternoon in the bishop's residence. The emperor, the electors, their advisors, and a few delegates were present. The emperor's spokesman asked Luther if the books published under his name were his. Luther's counsel demanded a list of titles be read aloud. The spokesman's second question was: Did he stand by the content of those writings, or did he wish to recant anything in them? Luther asked for time to prepare an answer. He was given twenty-four hours.[4]

On the second day, Luther was led again to the bishop's residence, but this time to a crowded larger hall. When he was asked to give his answer, Luther spoke first in German. He was then asked to repeat in Latin, for about ten to fifteen minutes. He said that his writings could be divided into three categories: those that explained the Christian life and faith that were not controversial, those that criticized the papacy, and those that replied to his adversaries. When the emperor's counsel asked him to make a concise answer, Luther replied, "Unless I am convinced otherwise by evidence from scripture or incontestable arguments, I remain bound by the scriptures I have put forward. As long as my conscience is captive to the word of God, I neither can nor will recant since it is neither safe nor right to act against conscience. God help me. Amen."[5]

Luther was dismissed. The emperor would decide his fate. Frederick summoned his secretary Spalatin to say that Luther had spoken "wonderfully," but "he was too daring for me."[6]

The emperor asked for the electors' opinions, but they requested time. So, he read from a paper he had written out beforehand in French. He did not want to depart from his ancestors' faith. "They were all faithful to the death to the Church of Rome, and they defended the Catholic faith and the honor of God. I have resolved to follow in their steps. A single friar who goes counter to all Christianity for a thousand years must be wrong. There I am resolved to stake my lands, my friends, my body, my blood, my life, and my soul." Charles said that he would proceed against Luther as a "notorious heretic" and asked the electors to agree. On the next day, four of the six electors signed the paper. Elector Frederick of Saxony and Elector Ludwig of the Palatinate (southwest Germany) did not.[7]

During the night, placards were posted on the door of the town hall and elsewhere in Worms. The placards were stamped with the sandal clog of a workingman, the symbol of a peasants' revolt. The poster implied that if Luther was condemned, the peasants would rise. No one knew who put up the posters.[8]

Albrecht, now archbishop of Mainz, who was also one of seven electors, rushed to Charles to warn him, but the emperor laughed. Albrecht and his brother, Joachim, an arch opponent of Luther, petitioned the emperor to examine Luther again. The emperor refused to do this himself, but told them that they had three days if they wanted to examine him. A committee met with Luther, but they reported back to the emperor that the meeting failed to reconcile Luther to the Church.[9]

Frederick's advisors told Luther that his safe conduct had been extended, but he should leave Worms immediately. Once Luther heard that Frederick would shelter him, Luther and two of Frederick's men departed for Wittenberg on April 26.[10]

One month later, Charles V published the Edict of Worms that Aleander had prepared. Luther and his supporters were declared outlaws. No one was to offer shelter, food, drink, protection or any other kind of help to them. People were urged to seize him and hand him over. The edict was published three and a half years after Luther wrote the Ninety-five Theses, and was in force even after Luther's death.[11]

Erasmus, who did not attend the Diet of Worms, kept up with the news in Louvain and Antwerp. After the Diet closed, Charles V returned to the Netherlands with the pope's envoy Aleander to stamp out heresy. Fearing possible arrest in Antwerp, Erasmus moved south to Anderlecht.[12]

56

Luther Is Kidnapped

The news of Luther's disappearance reached Dürer in the Netherlands about three weeks later. On May 17, 1521, he wrote in his journal:

> On Friday before Whitsunday in the year 1521 the news came to me in Antwerp that Martin Luther had been so treacherously taken prisoner near Eisenach. "There came 10 horsemen and they treacherously carried off the pious man, betrayed into their hands, a man enlightened by the Holy Ghost, a follower of Christ and the true Christian faith. And whether he is still alive, or whether they have murdered him, which I know not.[1]

Dürer reflected on why Luther was thought to be a threat and asked God for help:

> He has suffered this for the sake of Christian truth and because he rebuked the unchristian Papacy, which strives with its heavy load of human laws against the redemption of Christ; and because we are so robbed and stripped of our blood and sweat, and that the same is so shamefully and eaten up by idle folk, while the poor and sick die of hunger . . . Ach, God of Heaven, pity us! O Lord Jesus Christ pray for Thy people![2]

Dürer continued his lament and told of his desire to serve God.

> Oh God, never hast Thou so heavily oppressed a people with human laws as us poor folk under the See of Rome, who daily long to be free Christians, ransomed by Thy blood. O highest, heavenly Father, pour into our hearts, through Thy son Jesus Christ, such a light, that by it we may know what messenger we are bound to obey, so that with good conscience we may lay aside the burden of others and serve Thee, eternal, Heavenly Father, with light and joyful hearts.[3]

Dürer revealed his knowledge of the past, his understanding of people from various parts of the world gained from his travels, and laid out his hope for the future world.

> And if we have lost this man, who has written more clearly than any that has lived for 140 years, and to whom Thou hast given such a spirit of the Gospel, we pray Thee, O Heavenly Father, that Thou wouldst again give Thy Holy Spirit to another, that he may gather Thy church anew everywhere together, that we may again live united and in Christian manner and so, by our good works, all unbelievers as Turks, Heathen, and Calicuts [Indians], many of themselves turn to us and embrace the Christian faith.[4]

He considered the impact of Luther's death on people's ability to hear the good news clearly.

> May every man who reads Dr. Martin Luther's books see how clear and transparent his teaching is when he sets forth the Holy Gospel. Wherefore his books are to be held in great honor and not to be burned; . . . O God, if Luther is dead, who will henceforth deliver the Holy Gospel to us with such clearness? Ach, God, what might he not still have written for us in ten or twenty years? O all ye Christian men, help me to weep without ceasing for this man, inspired of God, and to pray Him to send us another such enlightened man.[5]

Dürer called upon Erasmus to be the warrior he described in his *Handbook of the Christian Soldier*.

> Behold how the wicked tyranny of worldly power, the might of darkness, prevails! Hear, thou knight of Christ! Ride on by the side of the Lord Jesus! Guard the truth. Attain the martyr's crown! You are such an aged little man. I have heard from you myself that you have but two years wherein you may still be fit to accomplish something. Turn them to good account for the good of the gospel and the true Christian faith, and make yourself heard . . . O Erasmus, take your stand here so that God Himself may be your praise, even as it is written by David. For then may you accomplish something, and truly you may overthrow Goliath.[6]

Dürer had experienced the light of Jesus within his heart and he hoped that others around the world have the same experience.

On July 12, 1521, the Dürers started their journey back to Nuremberg. They had been in the Netherlands just over a year. Though he had seen many wonderful things and received many honors, Dürer never recovered physically from his fevers.[7]

They sailed up the Rhine River into the storm that would overtake his city, his country, and beyond.

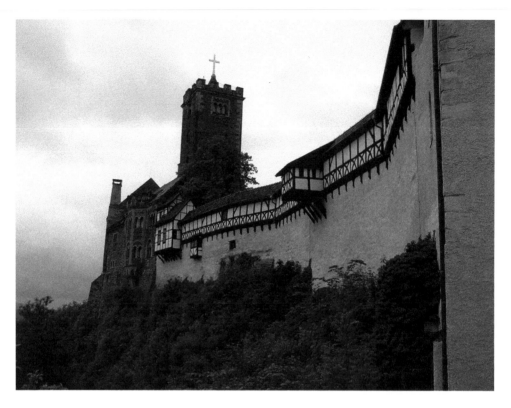

Figure 90. Wartburg Castle near Eisenach.

57

Wartburg Castle

Frederick the Wise knew that Luther's life was in danger. He also knew that many people under his rule in Saxony were followers of Luther and that there would be an uprising if Luther was murdered. One hundred years earlier the death of the reformer priest Hus caused a decade of strife across Bohemia and beyond.[1]

Luther was kidnapped near Eisenach—by Frederick's men. Two court officials made arrangements in order to keep Frederick ignorant of what was happening so that when authorities asked the elector about Luther's whereabouts, he would not have to lie. The officials brought Luther to Wartburg, a castle within Saxony, where one official and two serving boys hid him and cared for him.[2]

During the first few weeks, Luther stayed in a room where his food was brought to him. Later, he wandered around the courtyard. He exchanged his monk's robes for the clothes of a knight. He grew out his hair and a beard and became known as "Junker Jörg" or Knight George.[3]

Locked inside the castle, Luther suffered from loneliness, constipation, insomnia, and inner battles. So many questions: What was he going to do? He was no longer a monk or a professor at the University. Where would he live if he moved back to Wittenberg? If he did leave, where could he go, since the edict was enforced throughout the whole empire? He would have to wait in "Wait Castle."[4]

The best cure for his problems was to work on various writing projects. Luther began to translate the New Testament into German. Using the second edition of Erasmus's Greek New Testament, Luther completed the translation in less than four months.[5]

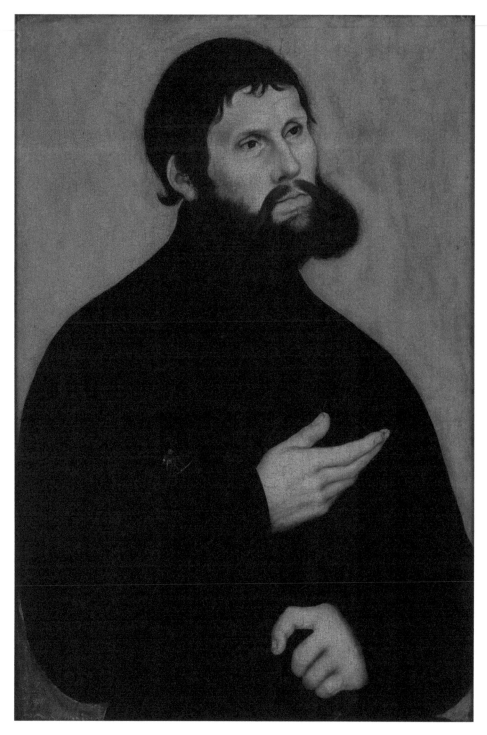

Figure 91. Lucas Cranach the Elder, *Martin Luther as Junker Jörg* 1521–22. Mixed technique on beech wood, 20.8 x14.7 in. (52.8 x 37.3 cm.). Klassik Stiftung, Scholssmuseum, Weimar.

58

Philip Melanchthon

While Luther was hiding in Wartburg, Philip Melanchthon and Andres Bodenstein von Karlstadt, led the reform movement in Wittenberg.[1]

Back in 1518, at the young age of 21, Melanchthon had come to teach Greek at the University of Wittenberg. In his inaugural lecture on educational reform, this prodigy encouraged the students to give extra effort to their study in Greek so they would be able to understand the original New Testament on their own.[2]

Luther, who was in the audience, told the elector's secretary, Spalatin, that as long as he lived, he desired no other Greek instructor. Luther asked Melanchthon if he would instruct him. Melanchthon joined with Luther because he agreed with Luther's interpretation of the apostle Paul's letters in the New Testament. He accompanied Luther to Leipzig in 1519 when Luther debated Eck.[3]

On November 25, 1520, Melanchthon married Katharina Krapp, the daughter of a cloth merchant who had been the mayor of Wittenburg. Melanchthon was generally a gentle man, but he had a terrible temper, a master of many subjects, yet he trusted in astrology.[4]

After Melanchthon heard that Luther's books had been burned in Cologne on November 20, 1520, he invited the faculty and students in Wittenberg to burn the papal constitutions, the canon law, and works of scholastic theology.[5]

Melanchthon became the systematizer of Luther's works and words. In 1521, he published a book on Lutheran theology covering practical topics for believers. He wanted to give precise definitions so that Luther's ideas would not be misunderstood. He clarified the Christian's ethical responsibility—to live a holy life.[6]

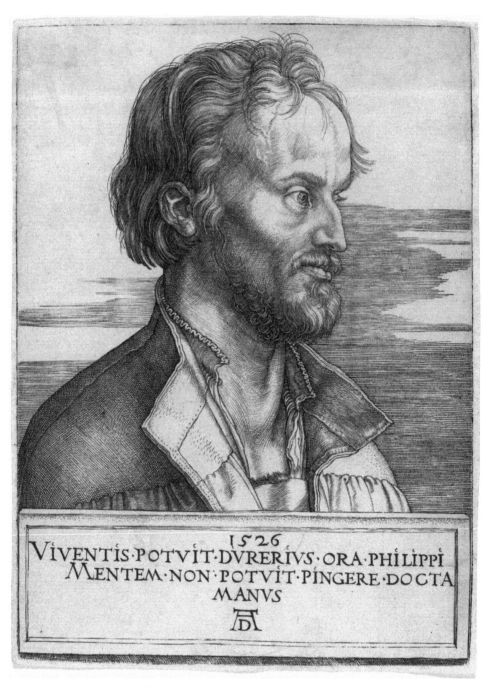

Figure 92. Albrecht Dürer, *Philipp Melanchthon*, 1526. Engraving, 6.75 x 4 15/16 in. (17.2 x 12.6 cm.). The copper engraving plate is in the Schlossmuseum, Gotha.

59

Andres Bodenstein von Karlstadt

The other leader of the reform movement in Wittenberg was Andres Bodenstein von Karlstadt, archdeacon at the Castle Church, who was two years older than Luther. He was Luther's sponsor when he received his doctorate at Wittenberg. He also debated Eck in Leipzig in 1519. Eck named him as one of the six heretics besides Luther in the 1520 papal bull.[1]

While Luther was in the Wartburg castle, Karlstadt took the first steps toward change in Wittenberg. Priests and nuns were leaving their cloisters. Some were marrying. Priests who did not agree with the changes moved to other cities. The mass was changed from the reenactment of the sacrifice of Jesus to a commemoration of the Last Supper when Jesus shared the Passover meal with his disciples and gave his last teaching and promises before he died.[2]

In 1521 Karlstadt wrote a book advocating that the people receive both the bread and the wine at communion. He dedicated the pamphlet to "Respected and Esteemed Albrecht Dürer of Nuremberg, my dear patron . . . thereby to render due service to you and the whole of Christendom. For your many kindnesses oblige me to serve you insofar as I can. May God protect you." This suggests that Dürer spoke in defense of either Luther or Karlstadt or the activities in Wittenberg, though there is no direct evidence of Dürer's links with Karlstadt except for a letter from Scheurl to Karlstadt in August 1519 that included thanks for sending a woodcut by Cranach.[3]

Dürer's woodcut of *The Last Supper* is the first time an artist portrays the scene *after* Judas has left the meal to help the high priests identify Jesus so they can arrest him. The chalice of wine sits prominently on the table, while a wine jug, a basket of bread and a platter were on the floor. Jesus then gives a new commandment to his faithful friends: "Love one another. As I have loved you, so you must love one another" (John 13:34 NIV).[4]

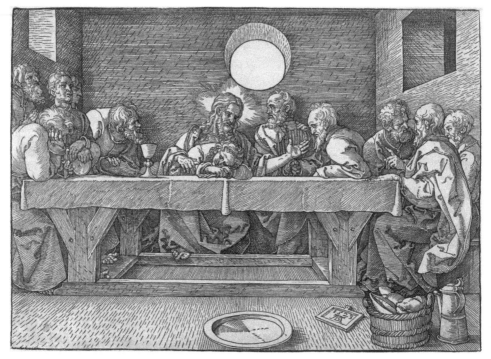

Figure 93. Albrecht Dürer, *The Last Supper*, 1523. Woodcut, 8.4 x 11.9 in. (21.3 x 30.1 cm.). National Gallery of Art, Washington, DC.

Luther and his colleagues faced challenging decisions and did not agree on everything. How fast should the reformers expect people to change? Would they force people to adopt new ways or give them time to adjust? What if people did not want to take both bread and wine? What if people still wanted to worship at altars and statues? Knowing that it was difficult to predict or control circumstances, Luther wrote to Melanchthon in August 1521 to take action even if the proper actions resulted in imperfect results. "As long as we are in this world we have to sin. This life is not the dwelling place of the righteous."[5]

In December 1521 Luther heard that Archbishop Albrecht had arrested two married priests. Luther wrote to Albrecht, who kept several women, warning him that the people would rise up and demand that bishops get rid of their women.[6]

Karlstadt heard that the elector's advisors were going to block his service in the Castle Church on January 1, 1522, because he was advocating more reform than Frederick desired. So he moved the service back to Christmas Day 1521. Karlstadt wore his academic gown instead of clerical vestments. He celebrated the Lord's Supper in German and distributed both the bread and the wine chalice into the hands of each person. Many people from Wittenberg, including the town leaders, attended the service.[7]

In January 1522, Gabriel Zwilling, a former Augustinian monk, led a group to destroy sacred objects. Wooden altars, pictures, statues, and vessels were set out in the Augustinian cloister yard and burned. They chopped off the heads of statues of saints

or defaced paintings because they believed the saints did not bring people closer to God.[8]

Some people found it difficult to change from praying to saints at altars to believing the images were only for decoration and inspiration. Karlstadt argued that pictures and statues should be removed from the Town Church. In 1522 he published a pamphlet, "On the Abolition of Images," stating that visual images in the churches could not be Christian because they transgressed the Second Commandment of making "graven images" (Exodus 20:4–6).[9]

Dürer vehemently opposed Karlstadt on this issue for this threatened the artists' profession as well as some of his greatest paintings, including those in Wittenberg. In his dedication letter to Pirckheimer for his *Course in the Art of Measurement* (1525), Dürer wrote: "[I]n our land and in our time the art of painting is by some despised and accused of serving idolatry. For any Christian is as little likely to be drawn into superstition by a painting or sculpture as a decent man into murder simply because he carries a weapon at his side. That must truly be an ignorant man who would pray to painting, wood or stone. Indeed a painting promotes betterment rather then injury if it is fashioned well, honestly and with art."[10]

On February 13, Elector Frederick issued his own rules to the university and the Castle Church. "We have gone too fast. The common man has been incited to frivolity, and no one has been edified. We should have consideration for the weak. Images should be left until further notice . . . Karlstadt should not preach anymore."[11]

60

Luther's New Testament in German

While Luther was hiding in the castle he heard that Archbishop Albrecht of Mainz was still selling indulgences in Halle. He wrote Albrecht, "I beg you, show yourself not a wolf but a bishop. It has been made plain enough that indulgences are rubbish and lies." Luther warned him to stop the trafficking or he would publish a tract against him. Albrecht wrote him that it had stopped and confessed that he was a "stinking" sinner, ready to receive correction.[1]

When Luther also heard about a new law in Wittenberg making reforms compulsory, he decided it was time to return to pastor his congregation. Elector Frederick did not want Luther to return because he did not know if he could protect him. Since Luther believed that he served Christ alone, he felt he was no longer obligated to obey his prince. He wrote Frederick, "I say you have done too much, and you should do nothing but leave it to God. You are excused if I am captured or killed."[2]

After eleven months, Luther arrived in Wittenberg on March 6, 1522. The elector allowed Luther and another monk to stay in the nearly deserted Augustinian cloister.[3]

On the first Sunday back, wearing his monastic clothes, Luther began to preach the first of eight sermons in a series on steps to reform. He stated that five traditional practices should remain optional: clerical celibacy, monastic vows, sacred statues and pictures, fasting, and private confession. "Do not make what is free into a must." Luther defined a Christian by their faith and love, rather than by following rules of conduct governing eating, drinking, and clothing. His sermons slowed down the pace of reform.[4]

When Luther returned, he brought his translation of the New Testament. The translation combined simplicity and directness with fresh language. Luther asked Melanchthon to check his work. In May 1522, when the first sheets of the manuscript were ready to be printed, Luther called it a "taste of our new Bible." Their New Testament in German was first published in September 1522.[5]

Luther later contrasted himself to Melanchthon: "I am rough, boisterous, stormy and belligerent. I am born to fight against innumerable monsters and devils. I must remove stumps and stones, cut away thistles and thorns, and clear wild forests; but Master Philip comes along softly and gently, sowing and watering with joy, according to the gifts which God has abundantly bestowed upon him."[6]

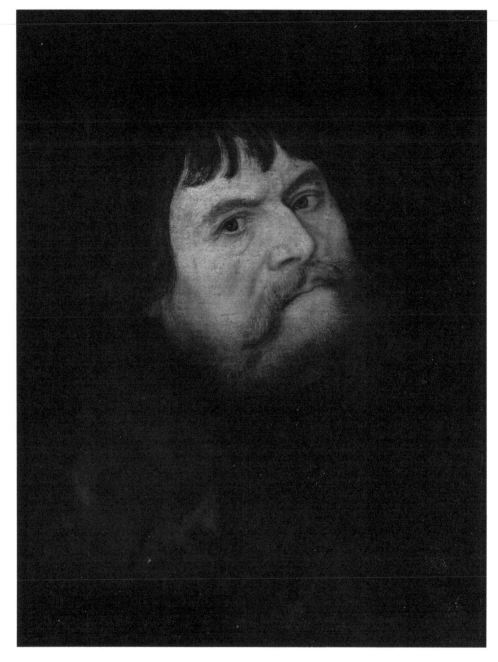

Figure 94. Lucas Cranach the Elder, *Self-Portrait*, 1531. Mixed technique on red beech, 17.8 x 14 in. (45.2 x 35.5 cm.). Schloss Stolzenfels, Koblenz.

61

Cranach, the Artist and Publisher

Lucas Cranach, Frederick's court painter who had also published Luther's tracts, had become an important man in Wittenberg. He moved out of the castle to live in a home in the city. He served on the town council, including three terms as the city's bürgermeister (mayor).[1]

He ran an active workshop with hired assistants, apprentices, and journeymen as well as gold-platers, cabinetmakers, illuminators, glaziers, goldsmiths, silk sewers, and tailors. The goal of a workshop was to not be able to see the difference between the master's work and that of the assistants.[2]

Since he co-owned the only pharmacy in town, he had a monopoly on selling items, such as paint, spices, oil, sugar, wine, and imported beer. Other merchants could sell these items only during annual fairs in the city.[3]

Luther and Cranach knew each other well. Luther was the godfather of the Cranach's fifth child, Anna. When Luther was translating Revelation 21: 19–20, he had difficulty knowing which stones decorated the wall of the New Jerusalem. Cranach gave him access to Elector Frederick's gem collection so he could match the colors with the names.[4]

Cranach made a series of woodcuts for the book of Revelation to accompany Luther's translation of the New Testament. Luther asked Cranach to illustrate only that book because he thought that readers could easily be confused because of its allegorical language. Luther wanted the images to agree with the details of the text. Cranach took images from Dürer's fifteen woodcuts of the *Apocalypse* and divided them into twenty-one blocks that kept closer to the text.[5]

John's Revelation, chapters 17 and 18, told of a proud and beautiful harlot wearing purple and scarlet, sitting on a seven-headed monster that had strength and authority. She had grown rich because the nations had drunk the wine, made from the blood of the saints, from her golden goblet.[6]

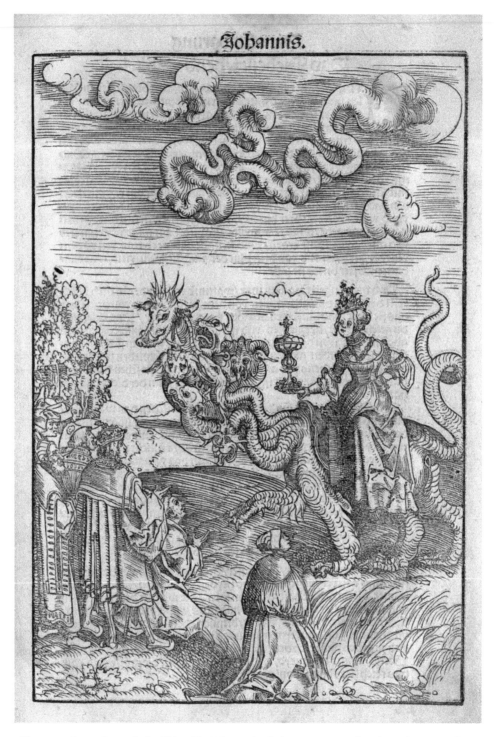

Figure 95. Lucas Cranach the Elder, *The Whore of Babylon***, 1522. Woodcut from the September New Testament. Württembergische Landesbibliothek Stuttgart.**

Cranach's illustration of *The Whore of Babylon* caused controversy. The powerful city that opposes God and his Gospel is not historical Babylon, set between the Tigris

and Euphrates Rivers, but contemporary Rome. He shows the Harlot wearing a papal tiara with the Vatican and the Castel Sant'Angelo in the background. After Elector Frederick's rival Duke George of Saxony complained, Frederick commanded Cranach to cut off the tiara on the block in the next printing.[7]

The first run of the September New Testament was three thousand copies. The second run of five thousand copies came out in December. The price of an unbound copy was half a gulden and bound copies were a full gulden (the price of a slaughtered pig).[8]

Paul Johnson, a historian, wrote: "The smell of printer's ink [was] the incense of the Reformation."[9]

62

Luther as Teacher and Reformer

Luther realized that a new foundation was needed for relationships between church, state, and society. By liberating people from anxiety about themselves and their future, they could redirect their concern to others. What could society look like with this new freedom and hope? In *Freedom of a Christian*, Luther had written in 1520: "When God in his sheer mercy and without any merit of mine has given me such unspeakable riches shall I not then freely, joyously, wholeheartedly unprompted do everything that I know will please him? I will give myself as a sort of Christ to my neighbor as Christ gave himself for me." Luther also wrote: "Good works do not make a man good, but a good man does good works."[1]

Luther's major job was being a pastor in Wittenberg. He preached on the Ten Commandments, the Lord's Prayer, and ancient creeds. He often preached three times on Sunday on one passage and then three or four times during the week on different books in the Bible. Luther also worked with his team of translators on the Old Testament for twelve years, wrote books (*Personal Prayer Book*, etc.), and kept up correspondence.[2]

Because Luther's works were being pirated, he asked Elector Frederik if he could have a patent to protect his works. Luther did not like that the pirated copies of the Bible were badly produced with small, blurry illustrations including fantasies and monsters. At first, in 1524, Luther chose a Lamb of God holding a flag with a red cross as his patent. The blood of the Lamb is falling into a chalice sitting on grass.[3]

He also traveled to nearby towns to oversee churches. He often took with him one theologian and three lawyers to help settle matters. After he stayed at Leisnig for several days, he returned and wrote a letter about how to organize and finance churches. Instead of an indulgence chest where the money would "fly over the Alps to Rome" to finance buildings or wars, a common chest in each town would distribute funds to pay pastors and teachers, maintain church property, and provide for the poor

and needy. Some common chests had four locks so that all four directors (one each from nobility, council, town and peasant) had to be present to open the chest.[4]

Around Easter 1523, twelve nuns escaped in a grocery wagon from a convent near Leipzig. While three of the nuns joined their families in Torgau, the wagon driver brought the others to the cloister in Wittenberg where Luther was staying. At that time it was a capital crime to help nuns escape. They arrived, still dressed in habits, with no money. One of the older nuns was Magdalena Staupitz, sister of Luther's former confessor, Johann Staupitz. Two sisters and Katherina von Bora moved in with Lucas and Barbara Cranach, who owned the largest house in town. Luther tried to help the nuns find husbands.[5]

By the end of 1524, Luther was no longer a monk wearing monastic clothes, but a teacher and reformer. In his eyes, the Lutherans were not splitting from the Roman Catholic Church, but returning to the early church practice of the "priesthood of all believers" (1 Peter 2:5). He believed that the Roman church had betrayed this design by building a hierarchical structure that distanced people from God.[6]

He wrote to Staupitz, who had become the abbot of St. Peter's Benedictine monastery in Salzburg. He chided his old friend for taking that role and defended himself against various rumors that were circulating. Staupitz took two years to reply. "We owe you thanks, nevertheless, for bringing us back from the husks of the pigsty to the green pastures of life and the words of salvation . . . If only we could sit together for just one hour and share the secrets of our hearts." Staupitz died soon afterwards and was buried in Salzburg.[7]

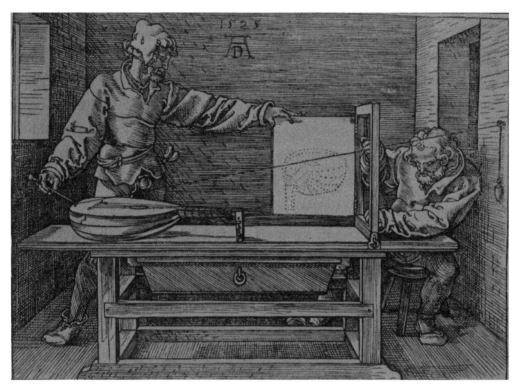

Figure 96. Albrecht Dürer, *A Man Drawing a Lute* from the *Painter's Manual A Manual of Measurement of Lines, Areas, and Solids, by Means of Compass and Ruler, by Albrecht Dürer, for the Use of All Lovers of Art with Appropriate Illustrations,* 1525. Woodcut, 5.1 x 7.2 in. (13 x 18.2 cm.).

63

Books on Art Theory

A s Luther was trying to bring order to a new society in German towns by his teaching, Dürer was challenged to bring order to art by writing the first books on art theory in German.[1]

As a young man, Dürer had contact with Italian artists and learned some of their theories. Perspective was a way to create an illusion of depth or space on a two-dimensional surface. In 1506, he had traveled over one hundred miles to learn the secret of perspective in Bologna, although his teacher remains unknown. Dürer told his friends that the saddest event of his life was when he travelled quickly to Mantua at Andrea Mantegna's invitation to come and learn scientific knowledge and principles. Mantegna, who had been ill, died before Dürer arrived.[2]

The first draft of his theory books that he dated was in 1512. He realized that some would laugh at him for his attempt. "With God's help I will set down what little I have learned, even though many will despise it. That does not bother me, for I well know that it is easier to criticise than to produce something better. I shall present these things as understandably and transparently as I can."[3]

Later in the passage he wrote, "This great art of painting has been held in high esteem by the mighty kings many hundred years ago. They made the outstanding artists rich and treated them with distinction because they felt that the great masters had an equality with God, as it is written. For, a good painter is inwardly full of figures, and if it were possible for him to live on forever he would always have to pour forth something new from the inner ideas of which Plato writes." He wrote fourteen drafts at this phase. He abandoned his grand project of an all-inclusive handbook on painting, turning to focus on a treatise on human proportions.[4]

Dürer was sad that the Greek manuals of art had been destroyed or lost "as a result of war, or expulsion of people, change of state or religion." He both wanted to replace the lost ancient books and influence future artists. Dürer knew how important

theory books were. He had borrowed Vitruvius's book, *de architecura*, on architecture of the Roman Empire from Pirckheimer for guidance in drawing human figures and was still searching for a copy of *Euclid's Elements of Geometry and Optics* in German in 1524.[5]

In 1522, Dürer returned to work almost exclusively on the *Four Books on the Theory of Human Proportion*. He was preparing the manuscript to be published, but he kept rewriting the introduction on his philosophy of art.[6]

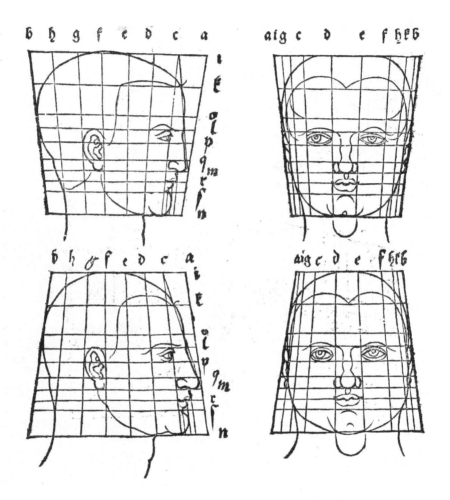

Figure 97. Albrecht Dürer, Face Transformations from *Four Books of Human Proportions*, Nuremberg: Agnes Dürer, 1532, 1534.

Dürer demanded verisimilitude, believing that the smallest details should be included so the piece of art would look real. Though he longed for beauty, he did not follow the Italian theories of embellishment to reach this ideal. He believed that perfect or absolute beauty transcends the human mind and was known only to God, the "Master of all Beauty." The rule of harmony, all parts in relation to the whole, became his leading theory of beauty. At the end of the third book, he wrote:

There are many different kinds of men in various lands; whoso travels far will find this to be so and see it before his eyes. We are considering about the most beautiful human figure conceivable, but the Maker of the world knows how that should be. Even if we succeed well we do but approach towards it somewhat from afar. For we ourselves have differences of perception and the vulgar who follow only their own taste usually err. Therefore I will not advise anyone to follow me, for I only do what I can, and that is not enough even to satisfy myself.

By the mid-1520s Dürer no longer likened the artist to God, but merely credited the artist with a "power given by God."[7]

After Pirckheimer wrote a preface to Dürer's book on proportion, Dürer responded with various comments. Dürer knew that his book would be helpful to more than painters. "For this Doctrine of Proportions, if rightly understood, will not be of use to painters alone, but also to sculptors in wood and stone, goldsmiths, metal-founders, and potters who fashion things out of clay, as well as to all who desire to make figures."[8]

In his preface to the *Course in the Art of Measurement*, published in 1525 and dedicated to Pirckheimer, Dürer wrote: "And since geometry is the right foundation of all painting, I have decided to teach its rudiments and principles to all youngsters eager for art . . . I hope that this my undertaking will not be criticized by any reasonable men, for . . . it may benefit . . . all those who have to rely on measurement."[9]

At the end of the third book on measurement, he shared another "secret"—how to geometrically construct Roman letters. The book was published four years before a similar volume written by Geoffry Tory, a French engraver.[10]

Since Dürer's last section of the *Course* was the first literary document about the representational problem in scientific terms written by a Northerner, Dürer needed to create German terms for the art and math concepts. Erwin Panofsky, an art historian, compares Dürer and Luther's influence on the German language:

> Thus Dürer, like Luther had to create a German language of his own. Like Luther, he took a more or less standardized chancery style as a basis and infused life into it . . . by listening to the man in the street . . . and by tapping the sources of religious prose. For abstract mathematical concepts he used graphic expressions which had been handed down from generation to generation of artisans . . . In the end the "poor painter" not only managed to describe complicated geometrical constructions more briefly, more clearly and more exhaustively than any professional mathematician of his time, but also expressed historical facts and philosophical ideas in a prose style no less "classic" than Luther's translation of the Bible.[11]

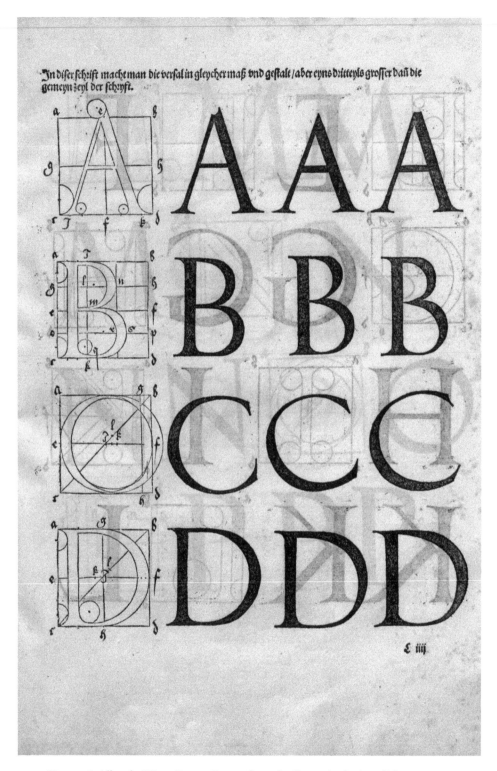

Figure 98. Albrecht Dürer, Roman Letters from the *Course in the Art of Measurement*,
Nuremberg, 1525. Saxon State and University Library Dresden (SLUB).

These theory books, like Dürer's giant woodcuts that sailed into the world with his initials "A.D.," brought even more celebrity and literary immortality. They were not always appreciated. One of Pirckheimer's sisters who lived in a convent on the Danube, wrote to her brother, "A book has now come to us about art and measurement, which Dürer has dedicated to you . . . We enjoyed it, but Sister Painter reckons she has no use for it because her art is accurate enough without it."[12]

Dürer desired to help others learn what he had studied despite knowing that some would judge him harshly.

> Also, not having been born for myself alone, and lest all this, like blossoming seeds sown in thorny, sterile land, be disregarded by one and all, I now communicate this my studiously experiences, long and whole-hearted labor and care to all artists present and future, hoping to tie them to myself externally— although I am unknown to them—by true good-will, love and friendship. But while the penetrating, deadly poison of slandering, pointed tongues is always ready to flow forth whereby all works, however good and useful they may be, are commonly polluted and blown up, yet I am confident that this my little book may escape such deadly injury by the scatheless, poison-chasing unicorn of more and fairer judges.[13]

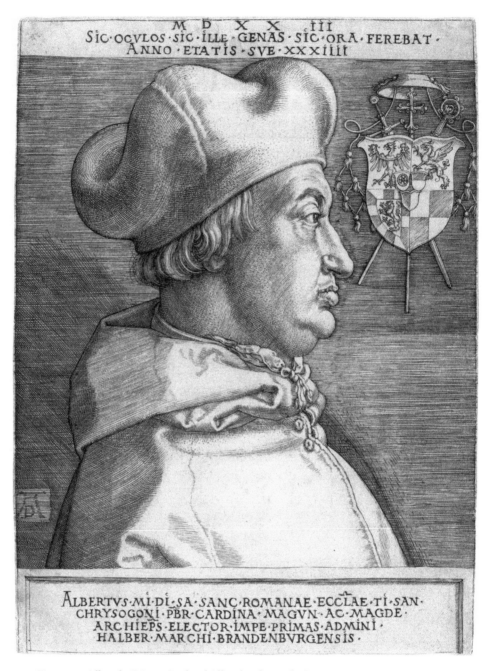

Figure 99. Albrecht Dürer, *Cardinal Albrecht of Brandenburg*, 1523. Engraving, 6.7 x 5 in. (16.9 x 12.6 cm.). National Gallery of Art, Washington, DC.

64

The "Roman" Engravings

Though Dürer was never able to make an engraving of Luther as a "lasting memorial" as he had hoped, he made engravings of five of the most important men of this period in the form of ancient Roman army gravestones that were being excavated in Germany. The ancient memorials were usually made from rectangular tablets in stone or bronze with Latin inscriptions. Though the five men were still alive, the form leant a sense of timelessness and honor.[1]

Dürer's first image in this style was Albrecht of Brandenburg, the cardinal whose desire to buy an archbishopric set the process of Luther's church reform into motion. Though he sent Luther's Ninety-five Theses to the pope and had given permission to burn Luther's writings in 1520, he did not sign the Edict of Worms that declared Luther an outlaw. Albrecht now ruled over the largest church province in Europe. The writing at the bottom of the portrait says: "Albrecht by Divine Mercy Presbyter Cardinal of the Holy Roman Church, Titular of St. Chrysogonus, archbishop of Mainz and Magdeburg, Primate Elector of the Empire, Administrator of Halberstadt, Margrave of Brandenburg."[2]

Dürer wasn't the only artist working for Albrecht. The cardinal asked Cranach to come from Wittenberg and develop a master plan for the construction and decoration for his church and private residence in Halle. Cranach and his workshop filled the church with Catholic art and sculpture.[3]

Dürer softened the tone of the other four "Roman" portraits by changing them from profile to three-quarters profile, from an angle of authority to one of contemplation.[4]

Dürer's next portrait was of his long-time friend, Willibald Pirckheimer. Having retired from the Nuremberg Small Council in 1523 due to poor health, Pirckheimer focused on research and writing. Dürer wrote this epitaph: "One lives through genius; the rest will belong to death 1924."[5]

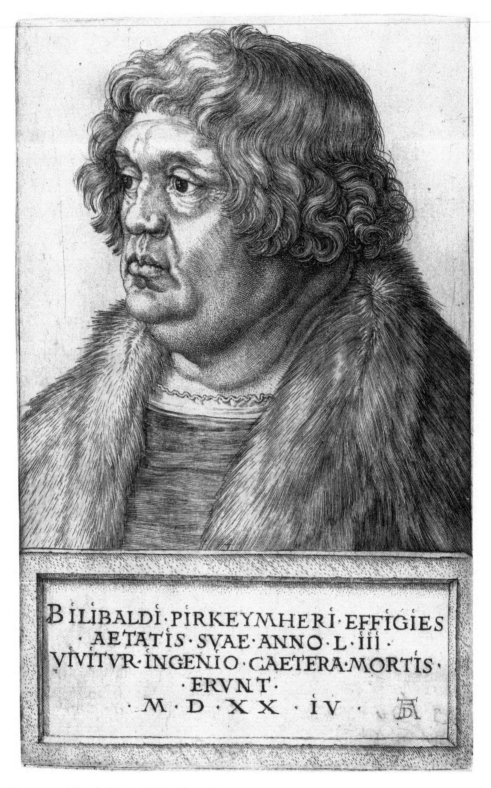

BILIBALDI · PIRKEYMHERI · EFFIGIES
· AETATIS · SVAE · ANNO · L · III ·
VIVITVR · INGENIO · CAETERA · MORTIS
· ERVNT ·
· M · D · X X · I V ·

Figure 100. Albrecht Dürer, *Willibald Pirckheimer*, 1524. Engraving on laid paper, 4.25 x 4 7/16 in. (10.8 x 11.2 cm.). National Gallery of Art, Washington, DC.

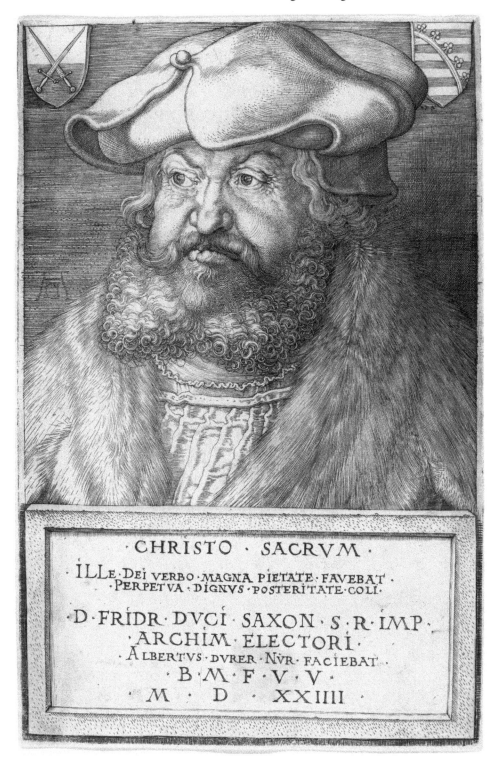

Figure 101. Albrecht Dürer, *Frederick the Wise, Elector of Saxony*, 1524. Engraving, 7.6 x 5 in. (19.2 x 12.7 cm.). National Gallery of Art, Washington, DC.

Dürer's portrait of Frederick the Wise honored the elector's 1923 declaration that the German Bible was legal in the region of Saxony. His "epitaph" was "With great piety he favored the word of God." At the imperial Diet of Nuremberg in 1522–23 Frederick and his entourage wore sleeves embroidered with "VDMIAE" to show their support for the reform movement. The acronym stands for the Latin phrase, *Verbun domini maner in aeternum* translated as "The word of the Lord stands forever" (Isaiah 40:8; 1 Peter 1:25 NIV).[6]

65

Dürer Family Chronicle

Dürer hoarded his personal papers. He was the first artist in Europe who left behind a large body of his own writing. He collected his letters, the journal from his trip to the Netherlands, sketches and drawings for paintings, marked up drafts of his books on theory and art, and even scraps of paper. Still much was lost—letters to his parents during his journeyman travels and to his wife during his visits in Venice. His language and voice, such as his use of multiple languages in his correspondence (like his art) reflected both his individuality and creativity.[1]

In 1524, Dürer also began to write a formal history of his family. He used the notes and documents that his father had kept. Dürer wrote about his father's village in Hungary, where many made a living raising horses and cattle. His father's father broke the pattern by being trained as a goldsmith. Dürer's chronicle was the first time that an artist recorded his family background.[2]

Several of his friends, including his neighbor Lazarus Spengler, the city secretary, and many prominent citizens in Nuremberg, were also writing their family chronicles. They included details about the city since their lives and location were linked together.[3]

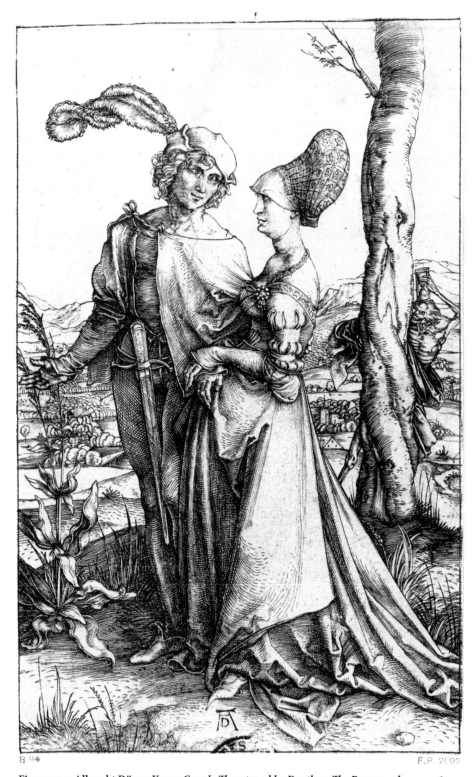

Figure 102. Albrecht Dürer, *Young Couple Threatened by Death* or *The Promenade*, c. 1498.
Engraving, 7.72 x 4.76 in. (19.6 x 12.1 cm.). Staatliche Kunsthalle Karlsruhe.

Dürer's father had kept records of the hour and date of birth of most of his eighteen children so they could be used later to cast horoscopes. For example, "Item: in the year 1478 after Christ's birth my wife Barbara bore my tenth child in the third hour of the day after Sts. Peter and Paul [June 30], and Hans Sterger, Schombach's friend, was its godfather and named my son Hanns."[4]

Dürer's own horoscope was cast in 1507 by his friend Lorenz Beheim, a canon at the Bamberg Cathedral. Beheim had predicted financial success, travel, and many loves for "our Albrecht." He justified Dürer's slender physique and his artistic genius on astrological grounds. He marveled that Dürer had only married once. Beheim sent a copy of the horoscope to Pirckheimer who circulated it among the humanist group in Nuremberg. Beheim repeatedly mocked Dürer's beard in his letters to Pirckheimer because during the Renaissance, beards were so rare they were thought to be odd, vain, and heretical.[5]

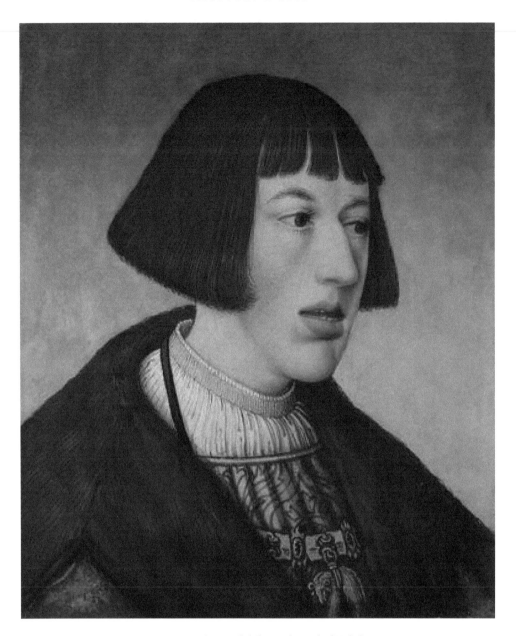

Figure 103. Hans Maler, *Archduke Ferdinand of Habsburg*, 1521.
Lime wood panel, 10 x 8.2 in. (25.3 x 20.9 cm.).
Kunshistorisches Museum, Vienna.

66

Nuremberg Follows Luther

In 1517, Anton Tucher II commissioned Viet Stoss to carve the *Annunciation in the Rosary* from a lime tree. Draped with rosary beads, Mary and Gabriel were suspended in an oval frame of roses that hung from the high vault of the choir. Tucher appointed Dürer to adjudicate the artistic quality of the work in order to determine the artist's fee. The piece was installed in St. Lorenz Church in Nuremberg. The following year, after Luther's writings discredited both praying to the Virgin and the rosary, the sculpture was hoisted to the top of the vaulting and covered with a sack. Other pieces of art were left unmolested in churches since their donors were members of the City Council.[1]

Though the Edict of Worms was posted at Nuremberg's town hall in September 1521, no one collected and burned Luther's books or prosecuted Luther's followers. When pastoral positions opened up in four parish churches in Nuremberg over the next year, all four men who were hired had connections with Wittenberg. When Archduke Ferdinand, the emperor's brother who helped him rule the large empire by overseeing Germany, threatened to remove the pro-Luther pastors, the Council called them in and urged them to speak moderately.[2]

In January 1523, when the pope's diplomat wanted to enforce the edict beginning with Nuremberg, the city council called an emergency session and decided to protect the city's freedom by force of arms if necessary. Though the annual festival after Easter brought money to the city, the council quit displaying the imperial regalia and relics after the spring of 1523.[3]

Nuremberg was not the only city to embrace Lutheran doctrine. More than fifty independent imperial cities followed Luther or had large Lutheran congregations. By 1523, many people in Germany believed Luther's plain and clear gospel of God's promises of spiritual peace and meaning for life.[4]

The next imperial diet convened in Nuremberg from January to April 1524. Some were eager to renew the Edict of Worms that outlawed Luther and his followers. Archduke Ferdinand lodged a complaint against the city for tolerating heresy. As punishment for supporting Luther, he removed the Imperial Council of Regency and the Imperial Chamber court from the city at the final recess of the diet.[5]

After Lazarus Spengler, town council secretary and Dürer's neighbor, persuaded the Nuremberg City Council to choose to follow Luther, many changes took place in the city.

> The relics of S[aint] Sebald were no more carried through the town in procession. Masses for the dead were neglected. Holy-water vessels ran dry. The *Salve Regina* [a hymn to Mary] was omitted. At last on Green Thursday [the Thursday before Easter] 1524, the deciding step was taken. Mass was said in German instead of Latin at the Augustinian Convent, and the Communion was administered in both kinds to thousands who flocked in from the country round . . . The Council, though ordered by the Emperor to interfere, refused to do so; and thus, in the year 1524, the Reformation was practically effected in Nuremberg.[6]

In January 1525, three of Dürer's former journeymen were arrested and interrogated for their social and religious views, including denying the divinity of Christ and the authority of Scripture. Shortly before, the Anabaptist Thomas Müntzer had secretly visited the city and his tracts had been distributed. The tracts were seized and the three young painters were expelled from Nuremberg.[7]

Catholic priests and Lutheran pastors debated for almost two weeks. In early March 1525, one pastor turned to the Nuremberg Council and encouraged them to wait no longer. Three days later, the Council openly broke with the papacy and mandated the institution of evangelical sermons and services. The Roman Catholic mass was outlawed; all preaching was to be according to the Bible.[8]

The city began closing monasteries and severed ties with the bishop of Bamberg. The Dominicans had already volunteered to transfer their possessions (agricultural and pastoral land, real estate, buildings, and rent payments) to the city in December 1524. The income from the sales went to the city's common chest. One monastery building became a school and another a town library. The Carthusian monastery became homes for widows of ministers and schoolmasters.[9]

Two convents were allowed to stay open, but they were not allowed to receive any more novices. Abbess Caritas Pirckheimer had been abbess for over twenty years of St. Klara's, home of sixty nuns. She petitioned that the Franciscans, who were in charge of pastoral care for the nuns, not be removed. Caspar Nützel, the Council's "caretaker" of the convent, brought in preachers to win the nuns to the new doctrine. Caritas wrote that Lent and Easter were an ordeal because the Holy Mass was forbidden. The Council sent representatives to tell the abbess that she should free the sisters from

their vows, allow them to leave the convent, to wear secular clothes, to enlarge the windows where families visited, and that each sister should make an inventory of their property. Four mothers from Nuremberg came to take their daughters away. Though the nuns were forbidden to sing choral prayers, they continued.[10]

The three young painters were quietly readmitted again to the city after the Council broke with the papacy. One of them, Georg Pencz, later completed Dürer's wall designs on the town hall and became a busy painter who received honors from the Council.[11]

Luther's teachings had far-reaching implications in towns and regions that followed them. Spirituality was no longer centered on monks and nuns, but on lay people, their marriages, and family life. Instead of listening to Latin mass, lay people heard sermons in German and read their German Bibles and Luther's *Small Catechism* (1529) to their children at home. Church doctrine was no longer recognized as a source of authority; instead, the Bible, was the ultimate authority for faith and practice. Instead of being anxious about their future, people found forgiveness and hope through trusting in Christ's death and resurrection. Since they did not have to worry about attaining merit, they could freely serve others. The emphasis was not on how they died, but on how they lived.[12]

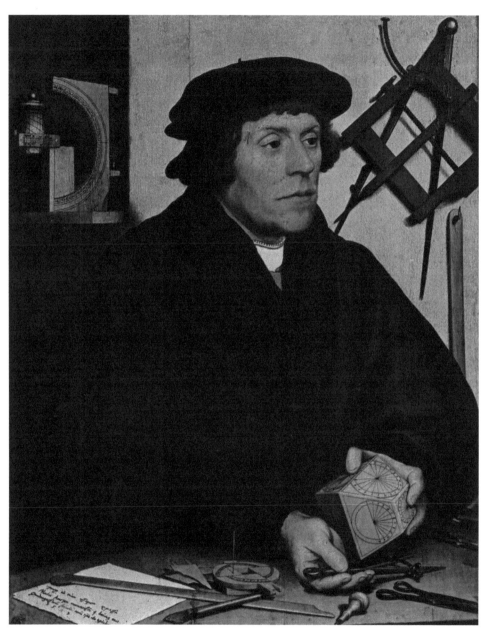

Figure 104. Hans Holbein the Younger, *Nicholas Kratzer*, 1528.
Tempura on panel, 32.7 x 26.4 in. (83 x 67 cm.).
Louvre Museum, Paris.

67

Letters to Dürer from Abroad

Dürer's friends in other countries, who were following the events in Nuremberg, sent him news about developments in their localities. A friend from Antwerp, Cornelius Grapheus, sent Dürer both a letter and messengers in February 1524 since the news was too dangerous to write on paper. Grapheus, the city secretary for Antwerp who had published some of Luther's works, was put into prison in 1522.

> To Master Albrecht Dürer, unrivalled chief in the art of painting, my friend and most beloved brother in Christ, at Nürnberg; or in his absence to Wilibald Pirkheimer . . . Of my own condition I will tell you nothing. The bearers of this letter will be able to acquaint you with everything. They are very good men and most sincere Christians. I commend them to you and my friend Pirkheimer as if they were myself; . . . Amongst us there is a great and daily increasing persecution on account of the Gospel. Our brethren, the bearers, will tell you all about it more openly.[1]

Niklas Kratzer was a German mathematician who was a professor of mathematics at Oxford and court astronomer to King Henry VIII. The astronomer had come back to Germany to collect information on the German territories and the growing Lutheran movement. He met Dürer in Antwerp when the artist was drawing Erasmus. Later in October 1524, he wrote to Dürer from London. "Now that you are all evangelical in Nuremberg I must write to you. God grant you grace to persevere; the adversaries indeed are strong, but God is stronger and is wont to help the sick who call upon him and acknowledge him."[2]

Dürer replied to Kratzer on December 5, 1524:

> We have to stand in disgrace and danger for the sake of the Christian faith, for they abuse us as heretics; but may God grant us his grace and strengthen us in his word, for we must obey Him rather than men. It is better to lose life and

goods than that God should cast us, body and soul, into hell-fire. Therefore may He confirm us in that which is good, and enlighten our adversaries, poor, miserable, blind creatures, that they may not perish in their errors.

Now God bless you! I send you two likenesses, printed from copper, which you will know well. At present I have no good news to write you, but much evil. However only God's will cometh to pass.[3]

68

Melanchthon's Reforms in Nuremberg

———————

Nuremberg's city leaders asked Melanchthon to come to Nuremberg to give advice about reforms. Late in 1525 and then again in May of the next year, Melanchthon came to Nuremberg as an official consultant.[1]

Melanchthon discussed the dissolution of the monasteries. Abbess Caritas was happy to hear that Melanchthon was coming for she had heard he was a "pious, upright man, and a lover of justice." The two talked for a long time, 29-year-old Phillip and 59-year-old Caritas. When he heard that the nuns' hope was in the grace of God and not in their own works, he said that they could be saved in the convent as well as in the world. Though the two didn't agree on everything, they became friends. Melanchthon blamed the Nuremberg Council and Nützel, the caretaker, for being too impetuous. Though the immediate threat to the convent passed, the nuns' lives were not easy.[2]

He also consulted on the establishment of a secular high school. Though the Council offered Melanchthon the job of rector (principal) of the new school, he declined and recommended a young friend and disciple, Joachim Kammermeister called Camerarius, who became friends with Dürer. Melanchthon also helped write curriculum and appoint faculty, for which the Council paid him an honorarium.[3]

Melanchthon came back for the celebration of the inauguration of the humanist academy. His speech on May 23, 1526, emphasized the role of the educated elite in growing a prosperous and religious city.[4]

Figure 105. *Nuremburg. Fuch's house; Statue of Philipp Melanchthon*. Germany, Nuremberg. [Between 1860–90] Photograph. Jacob Daniel Burgschmiet, a sculptor born in Nuremberg, made the statue out of sandstone in 1826.

Nuremberg was the first city that asked Melancthon to set up school reform. Fifty-six other cities called upon him for help. Melanchthon cultivated a humanist preparatory curriculum in German universities. Using the categories of Aristotle, Melanchthon took the totality of knowledge and broke it into manageable pieces to teach.[5]

69

Peasants' Revolt

The peasants, who had been feared since the Edict of Worms was published in 1521, rose up in revolt in southwest Germany in 1524. The rebellion spread among townspeople and villagers to almost every region of Germany. Atrocities were widely publicized. Peasants caught the Count of Helfenstein and his soldiers outside their garrison near Wiensberg. They stabbed the count to death and killed twenty-four nobles and their servants. Other peasants burned convents and castles.[1]

Luther responded to the uprising by writing *Admonition to Peace* on April 19. He condemned the lords who oppressed the peasants and commended the peasants for their willingness to accept correction. He was upset that many good people had been forced to fight in the battles. He worried that Germany would be destroyed. He believed that the battle was cosmic and that anarchy would smother the gospel of hope flowering in the new society.[2]

On May 5, 1525, Elector Frederick the Wise died at age 62 at his favorite hunting lodge fifty miles southwest of Wittenberg in Lochau. His body was placed on a bier and drawn through the towns and villages while church bells rang and the people gathered along the roadside to pay their respect. Spalatin, the prince's secretary, asked Luther and Melanchthon to reevaluate the funeral service for a prince. Most of the rituals could be retained, but no masses were held, no black clothing or altar cloths were used, and no offerings were brought to the altar. After the bier was carried into the Castle Church in Wittenberg, hymns and psalms were sung, Melanchthon delivered a Latin address and Luther preached a sermon in German. The next morning, a grave was dug near the altar, and after Luther gave another sermon, the prince's body was lowered into the earth. Luther had never met the prince who had saved his life multiple times.[3]

Frederick's brother, Johannes, became the new elector of Saxony. He was an even stronger supporter of church reform.[4]

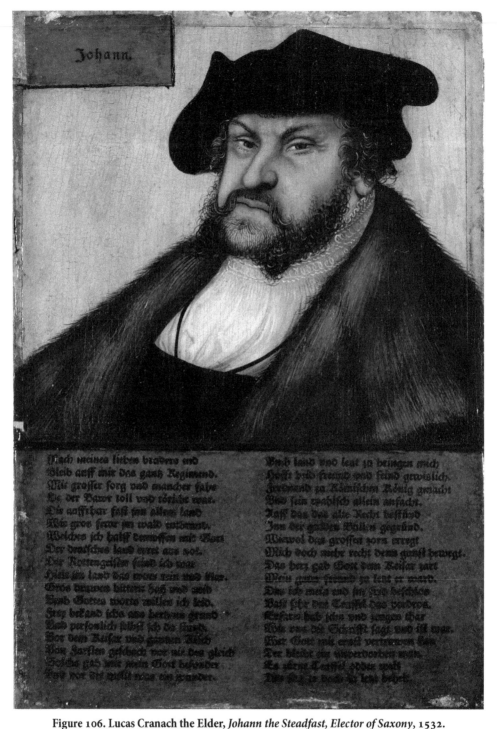

Figure 106. Lucas Cranach the Elder, *Johann the Steadfast, Elector of Saxony*, **1532.**
Oil on beech, 5.2 x 5.7 in. (13.2 x 14.6 cm.).
Klassik Stiftung Weimar.

A month later, in Thuringia (central Germany), Thomas Müntzer and six thousand poorly-armed "elect people of God," who thought they would bring about an

egalitarian society, faced an army commanded by Catholic Duke George of Saxony and his son-in-law, Lutheran Count Philip of Hesse. On May 15, 1525, five thousand peasants were slaughtered. Thomas Müntzer was executed. This was the last major battle of the Peasants' War. Several months later, the Nuremberg Council passed a resolution banning the work of Karlstadt as well as the Swiss reformer, Ulrich Zwingli, who died in battle in 1531 while defending Zurich from an army drawn from five Catholic cantons.[5]

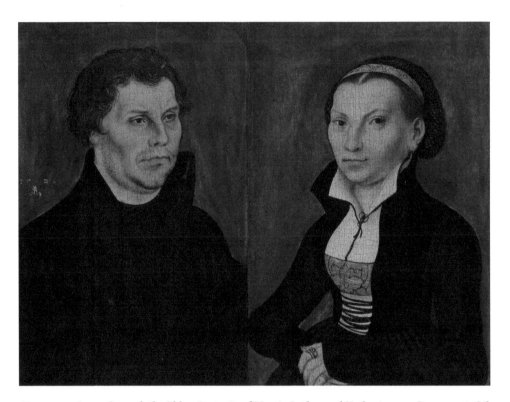

Figure 107. Lucas Cranach the Elder, *Portraits of Martin Luther and Katharina von Bora*, 1526. Oil on panel, 6.2 x 8.9 in. (15.8 x 22.6 cm.) and 6.3 x 8.9 in. (16 x 22.6 cm.). Wartburg Stiftung, Eisenach.

70

The Marriage of Martin and Katharina

Katharina von Bora was one of twelve nuns who escaped from the convent on Easter 1523 and came to Wittenberg, where she lived with the Cranachs. She was still unmarried in 1525. Bora, a daughter of a lower nobleman, was born in January 29, 1499, near Leipzig. Before she was six, her mother died. After her father remarried, he placed her in a Benedictine convent and paid a large sum for her to be reared and educated there. Later, she moved to a Cistercian convent near Leipzig. At the age of sixteen, she took the vows of poverty, chastity, and obedience.[1]

Luther joked for years with friends about not getting married. He did not think it was wise for him since he expected to die for being a heretic. However, after a visit with his parents, he decided to get married. His gave three reasons: to "please his father, to spite the pope and the Devil, and to seal his witness before martyrdom." He wrote to Spalatin, "You must come to my wedding. I have made the angels laugh and the devils weep."[2]

On June 13, 1525, Martin Luther, an ex-monk, married Katharina von Bora, an ex-nun. Pastor Johannes Bugenhagen and four guests attended the ceremony. Lucas Cranach served as both surrogate father of the bride and the best man to the groom. Later, he painted the new couple as a "pair painting."[3]

The Luthers lived in the cluttered former monastery, a gift from the new elector Johannes. Their first guest (on their wedding night) was Karlstadt, who had been arrested in Frankfurt. After Karlstadt forswore in writing to Luther that he had not supported Thomas Müntzer or an insurrection, Karlstadt and his family were released and entered Saxony secretly. He stayed with the Luthers for eight weeks while his wife stayed with her parents. The new bride, Katharina, became the godmother of the Karlstadts' newborn child, Andres.[4]

Wedding gifts and Katharina's hard work helped pay the bills. Archbishop Albrecht of Mainz sent an unexpected gift of twenty florins and the elector sent one

hundred florins. Johannes also doubled Luther's salary and frequently sent game, clothes, and wine. Katharina gardened, brewed beer, hosted guests, and raised cattle and pigs. She also kept the money since Luther was liberal in his gift-giving. Since one of Katharina's tasks was to keep Luther well, she became a mistress of herbs and poultices.[6] She later managed a farm and took in student lodgers who recorded Luther's comments, later published as *Table Talk*.[5]

Figure 108. The Luthers' home in the former Augustinian cloister. The bronze statue of Katharina von Bora, made by Nina Koch in 1999, is in the central courtyard.

Luther began arguing that marriage, not monastic life, as the school for character. Family life was a place to learn patience, charity, and humility. He believed that since his nearest neighbor was his wife, she should be his dearest friend. He saw the greatness of the grace of God when love persisted in marriage: "The first love is drunken. When the intoxication wears off, then comes the real marriage love."[6]

The former monastery was soon filled with six children (three boys and three girls) plus four orphans. Cranach became the godfather to Luther's firstborn child. Their first daughter, Elizabeth, died in 1528 during the plague before turning one. Luther and Katharina were later distraught over the death of their second daughter, Magdalena, who died at age fourteen in 1542.[7]

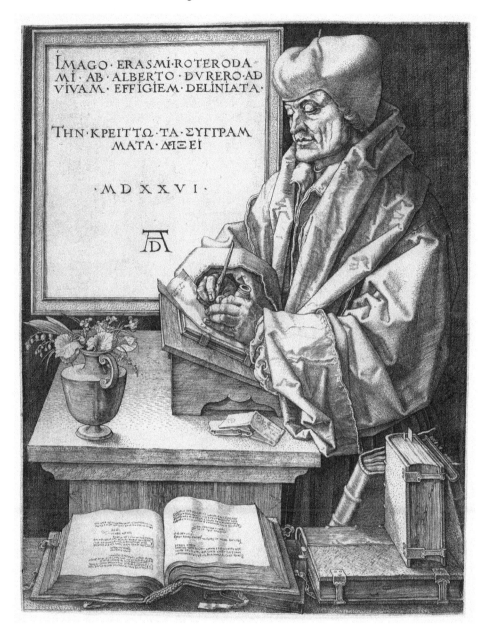

Figure 109. Albrecht Dürer, *Erasmus,* **1526. Engraving, 9.34 x 7.5 in. (24.8 x 19.1 cm.). Metropolitan Museum of Art, New York.**

71

Erasmus and *Melanchthon* (1526)

Dürer made his last two "Roman" engravings in 1526. Erasmus and Melanchthon were the two most important textual authorities on the New Testament of this period.[1]

Though Dürer had sketched Erasmus while he was in the Netherlands, he had never finished the painting. In 1523, Erasmus wrote Pirckheimer: "I wish Dürer joy with all my heart. He is an artist worthy to live forever. He began a portrait of me in Brussels. If only he had finished it!" One and a half years later, Erasmus wrote to Pirckheimer that he was enjoying Dürer's portrait of Pirckheimer that he had sent. Erasmus asked Pirckheimer to speak to Dürer about completing his picture. He wrote that Dürer was, "A man who wins highest praise for his art and also is no less admired for his singular knowledge . . . I should not object to having my portrait painted by Dürer, that great artist; but how this can be done I do not see. Once at Brussels he sketched me, but after a start had been made the work was interrupted by callers from the Court. Though I have long been a sad model for painters, and am likely to become a sadder one still as the days go on."[2]

In his portrait, Erasmus is shown in the role of a Renaissance St. Jerome. He is writing a letter, a defining characteristic of Jerome and Erasmus. The bouquet of violets and lilies of the valley testifies to Erasmus's love of beauty and symbolizes humility and purity. The Greek inscription on the oversized tablet is translated, "The better image will his writings show." This was the only time that Dürer showed a contemporary scholar in his study. After Erasmus received the engraving, he wrote Pirckheimer, "That the portrait is not an altogether striking likeness is no wonder. I am no longer the person I was five years ago." Dürer had difficulty capturing the quiet, ironical face of Erasmus.[3]

Dürer's last "Roman" portrait was of Melanchthon, the prodigy and educator (see figure 92). The inscription was: "Dürer was able to depict the face of the living

Philipp; The learned hand was not able to depict his mind." Similar to his inscription for Erasmus's portrait, Dürer admits to the limitations of portraiture.[4]

When Melancthon spent time in Nuremberg at Pirckheimer's home advising about the changes in churches and schools, Dürer was often invited to dinner. Melancthon said that though "Dürer excelled in the art of painting, it was the least of his accomplishments." Disputes often arose between Dürer and Pirckheimer, who had a choleric temperament and was suffering from terrible gout. "Dürer was an excessively subtle disputant and refuted his adversary's arguments, just as if he had come fully prepared for the discussion." Melancthon was astonished at Dürer's "ingenuity and power" in arguing with a man of Pirckheimer's renown.[5]

Dürer's portraits characteristically show the light coming through window cross-bars, reflecting as a cross on the sitter's eyes. (Even the eye of *The Hare* shows this.) Each of these "Roman" portraits continued that pattern. Though Melancthon was standing in an open space, Dürer still drew this reflection in his eye. The cross was before him, too.[6]

In 1520, Erasmus was shocked when Luther burned the canon-law books in Wittenberg and wrote *On the Babylonian Captivity of the Church*. In 1524, Erasmus wrote *On Free Will*. Luther countered sixteen months later (December 1525) with *Bondage of the Will*. "[W]e are enabled to understand the twin truths, namely we can do none of the things commanded, and yet at the same time we can do them all; true, that is, if we ascribe our impotence to our own strength and our ability to the grace of God." The theological debate had little effect on the reforms, but Erasmus and Luther were irreconcilably divided. Erasmus and Melanchthon, however, remained friends through the years, writing occasionally.[7]

More than ten years later, Luther joked about the four men:

> Substance and words, Melanchthon;
> Words without substance, Erasmus;
> Substance without words, Luther;
> Neither substance nor words, Karlstadt.[8]

Figure 110. Hartenfels Castle in Torgau.

72

Elector Johannes and the Relics

When Frederick's relics had been brought out in Wittenberg for All Saints Day on November 1, 1522, the crowd had booed. Since the relics had been used to advertise indulgences in order to make money for the Castle Church and the University at Wittenberg, they had lost their purpose. Frederick did not bring them out again, but he could not bring himself to destroy or give away the great collection that he had worked so hard to obtain.[1]

In 1526, the new elector Johannes was looking for a new way to support the Castle Church and university, and George Spalatin presented a plan. Since private masses for the dead were no longer performed, the group of priests at All Saints who were living off those endowments were no longer needed. After the funds from the endowments were transferred, two-thirds of the money went to support the university and one-third for the Castle Church.[2]

The same group of priests managed the relic collection. Elector Johannes asked that the relic collection be brought secretly to his castle in Torgau, about thirty miles up the Elbe River. A goldsmith separated the valuable parts into piles of gold, silver, pearls, and precious stones. The gold and gems were made into utensils and jewelry, while the silver was sold in Nuremberg. The 25,000 guilders went to pay expenses at the Torgau court.[3]

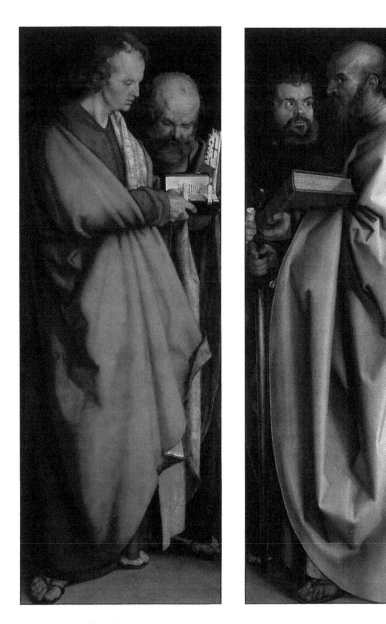

Figure 111. Albrecht Dürer, *The Four Apostles*, 1526. Oil and tempura on linden wood, 80.3 x 29.1 in. (204 x 740 cm.) (each panel). Alte Pinakothek, Munich.

73

The Four Apostles (1526)

In October 1526, Dürer presented two panels to the Nuremberg City Council called *The Four Holy Men* (commonly known as *The Four Apostles*). In an accompanying letter, Dürer wrote, "Therefore I present it to your Wisdoms with the humble and urgent prayer that you will favourably and graciously receive it."[1]

The four figures of John, Peter, Mark, and Paul, larger than life-sized, fill the two panels. Dürer arranged Paul, left, and John, right, in the front to match Luther's preferences for those authors. St. Paul, who wrote the Letter to the Romans, a book close to Luther's heart, dominates St. Peter, holding the keys to the Kingdom, because he is traditionally considered the first bishop and the first pope in Rome. St. John holds a copy of the Bible, open to John 1: "In the beginning was the Word" from Luther's 1522 translation. Luther described John's Gospel as "the one, fine, true, and chief gospel." The only man not holding a Bible is St. Peter.[2]

Below the four images are passages from John's Revelation, 2 Peter, I John, Mark, and 2 Timothy, quoting Luther's September Testament. Most verses warn about bad rulers and false prophets. Dürer also added his own warning: "All worldly rulers in these dangerous times should give good heed that they receive not human misguidance for the Word of God, for God will have nothing added to His Word nor taken away from it. Hear therefore these four excellent men, Peter, John, Paul, and Mark, their warning." Johannes Neudorffer, the author of *Fundamentals of Handwriting* (1519), inscribed the passages for Dürer. The two paintings hung in the Small Council chamber.[3]

The Council gave Dürer a "return present" of one hundred guilders Rhenish, as well as twelve guilders for his wife and two for his servant.[4]

Figure 112. Martin Luther, "A Mighty Fortress Is Our God,"
from *Spiritual Hymns in Wittenberg*, second edition, 1533. Luther House, Wittenberg.

74

Luther's "A Mighty Fortress Is Our God"

After the Diet of Worms in 1521, Jerome Aleander, the papal legate, suggested that Luther's appeal would diminish if a half-dozen of Luther's followers were burned and their possessions seized. After six people were martyred, nineteen pamphlets (including three by Luther) detailing their last days were published in 1523 to honor them.[1]

Henry of Zutphen, an Augustinian friar who had studied in Wittenberg, introduced Luther's writing to a cloister in Antwerp. When those friars began to share Luther's ideas outside the cloister, they were arrested. All but three recanted. Two of those friars who did not recant were burned at the stake in Brussels. Upon hearing the news, Luther published a hymn praising their faith. He adapted the music from a medieval folk ballad. The music and lyrics of *A New Song* were printed on a broadsheet and distributed.[2]

Believing that music was second only to theology among God's most precious gifts, Luther knew music refreshed people's hearts and minds so they could forget "all wrath, unchastity, arrogance and the like." John Walter's *Spiritual Songbooklet*, published in 1524, included 24 chorales by Luther.[3]

Churches following Luther changed the singing in their services. In the past, most of the singing was done by the priest and the choir of priests or nuns. The congregation sang only a few responses. Luther changed portions of the liturgy to hymns. Entire congregations attended mid-week practices to learn to sing. The emphasis on congregational singing was another way to reflect the doctrine of the "priesthood of all believers."[4]

Luther's best-known hymn, "A Mighty Fortress is Our God," written sometime between 1527 and 1529, was based on the Vulgate version of Psalm 46, the version of the Bible Luther knew best. The song also summarizes much of Luther's life, thought, and work.

A mighty fortress is our God, a bulwark never failing;
Our helper He, amid the flood of mortal ills prevailing.
For still our ancient foe does seek to work us woe;
His craft and power are great, and armed with cruel hate,
On earth is not his equal.

Did we in our own strength confide, our striving would be losing,
Were not the right Man on our side, the Man of God's own choosing.
You ask who that may be? Christ Jesus, it is he;
Lord Sabaoth his name, From age to age the same;
And he must win the battle.

And though this world, with devils filled should threaten to undo us,
We will not fear, for God has willed his truth to triumph through us.
The prince of darkness grim, we tremble not for him;
His rage we can endure, for lo! His doom is sure;
One little word shall fell him.

That Word above all earthly powers—no thanks to them—abideth
The Spirit and the gifts are ours through him who with us sideth.
Let goods and kindred go, this mortal life also;
The body they may kill: God's truth abideth still;
His kingdom is forever![5]

This song celebrates that in the midst of the difficulties and temptations of life on earth, God has given us his Son, his Spirit, and the gifts of the Spirit. We do not ear evil because Jesus has already won the battle. The King welcomes us to heaven, where he rules forever.

Printers in the 1530s were busy publishing hymns and song sheets needed for congregational singing. More lay people sang Luther's hymns than ever read his pamphlets or heard his sermons. Melanchthon knew that "lyrics entered our ears more quickly and stuck more stubbornly in the brain if those words were accompanied by music." Aleander's prediction that a few martyrs would slow down the reform movement did not come true.[6]

Figure 113. Albrecht Dürer, *Angel with the Key to the Bottomless Pit and the Vision of the New Jerusalem*, 1498. Woodcut from the *Apocalypse*, 15.6 x 11.2 in. (39.6 x 28.5 cm.). The final print shows one angel locking Satan in the pit, while another angel points out the heavenly city to John (Revelation 20:1–3; 21:9–12).

Figure 114. Albrecht Dürer, *Self-Portrait as the Man of Sorrows*, 1522. Metalpoint on blue-green primed paper, 16.1 x 11.4 in. (40.8 x 29 cm.). Kunsthalle, Bremen–Der Hunstverein in Bremen. Lost during Second World War. The phrase, "man of sorrows," describes the coming Messiah as someone "rejected by men . . . pierced for our transgressions . . . and by his wounds we are healed" (Isaiah 53:3–5 NIV).

75

Dürer's Death

Albrecht Dürer died in Nuremberg on the Monday before Easter, April 6, 1528, at the age of fifty-seven. He and Agnes had been married almost thirty-four years. He was buried in the gravesite of his wife's family in the cemetery of Johannes Friedhof Church outside the walls of Nuremberg. Since 1505, the City Council forbade burials within the walls because of the plague. Pirckheimer's inscription on the gravestone was "Whatever of Albrecht Dürer was mortal is laid under this tombstone." On the following day, his friends opened his grave in order to make a death mask of his face, an ancient way of having an image of a person as a momento or a basis for a portrait. A lock of hair was also cut.[1]

Though both Erasmus and Lorenz Beheim, the canon at the Bamberg Cathedral, had often written to Pirckheimer asking about Dürer's health, his death came as a surprise.[2]

Pirckheimer wrote a friend: "I cannot say that the passing of any loved one provoked in me such grief as does now the sudden departure from life of our best and beloved friend Albrecht Dürer . . . [I] loved him all the more for his innumerable virtues and unique probity [integrity]." Joachim Camerarius, the young rector in the school in Nuremberg, wrote a short biography. Another person wrote this epitaph:

> Intellect, honesty, frankness, prudence, excellence,
> Art, piety, and trust, all these lie heaped here.

Many friends and acquaintances wrote letters of condolence to Pirckheimer and Camerarius, but not to Agnes, because she and Pirckheimer had not gotten along.[3]

Two weeks after Dürer's death, Luther wrote Helius Eobanus Hessus, who was a high school teacher in Nuremberg: "To lament Dürer, that best of men, is the duty of every one with decency. Yet you will rightly give thanks that Christ has provided for him a blessed end, and has delivered him from these turbulent times, which may

become yet more turbulent still, so that he who was worthy to see only the best, shall not be compelled to witness the worst. May he rest in peace with his forebears. Amen."[4]

A few days later, Luther wrote Wenzeslaus Linck, a schoolmate who succeeded Staupitz as vicar-general of the Augustinian order in 1517: "Dürer and Volpracht, excellent men, seem to me to have been snatched so that they should not see the ills you know of raging and threatening. On every side wars hang threateningly over us." Volpracht was the last prior of the Nuremberg Augustinians before the town reformed. Was it Charles V's threat or the Ottoman storm that Luther was writing about?[5]

Though Dürer left no will, Agnes inherited all of his property since they had no children. Dürer's estate made her one of Nuremberg's wealthier citizens. She continued to live in the house in the Zisselgasse.[6]

While Dürer was in Antwerp in 1520, he had sent money and a model to Hans Schwarz, Germany's first major medalist. Schwartz had used the boxwood model to create medals cast in silver, bronze, and lead which Dürer had given as gifts. In 1527, Matthes Gebel had settled in Nuremberg and cast a new portrait medal of Dürer at age fifty-eight. This medal was reissued after his death with the inscription "His life shone forth in brilliance."[7]

Figure 115. Hans Schwarz, *Portrait Medal of Albrecht Dürer*, 1520. Bronze, 2.3 in. (58 cm.) diameter. Germanisches Nationalmuseum, Nuremberg. Boxwood model is in Herzog Anton-Ulrich Museum, Braunschweig.

Soon after his death, Dürer's greatest self-portraits (figures 21 and 32) were moved to the city hall. They joined the portraits of *Charlemagne*, *Sigismund*, and the *Four Apostles*, creating an early Dürer Museum.[8]

Many factors shaped Dürer's life and art: his parents' piety, his father's skill, Nuremberg's craftsmen, printing and politics, his travels to Italy and the Netherlands, his friends in the humanist group and across Europe, working for Elector Frederick, Cardinal Albrecht and Emperor Maximilian, and the writings of Martin Luther. Dürer's own temperament and skills, combined with the solidity of his community and the wide-ranging changes across the broader empire, enabled him to "pour out new things."[9]

76

More Wonderful, Rare, and Artistic Things

————————

Dürer never finished proofreading the *Four Books of Human Proportion*. Agnes Dürer published it posthumously with Pirckheimer's help. The book, published in November 1528, was dedicated to his friend, who wrote a note at the end of the fourth book:

> Although these four Books were written by the pious and artful Albrecht Dürer, yet he only revised and corrected the first; for, before he came to the other three, the swiftness of death overtook him, so that he could revise them no further . . . None the less, however, have his good friends judge it more expedient to issue the other three books, though uncorrected, rather than that they should remain unprinted and unknown; even though there be somewhat therein (as to which however they are not careful) which might be bettered. Moreover had God spared his life longer to him, he would have brought and given to the light many more wonderful, rare, and artistic things, of particular service to the art of painting, landscape, colours, and the like. He had it also in his intention to write and publish at great length and more clearly about perspective than he had done before. But God who ordereth all things for the best ordained otherwise. Praise and honour be unto His name for ever.[1]

Camerarius translated Dürer's idiosyncratic German found in the *Four Books* into Latin in 1532/33, which made it easier to translate into other languages.[2]

77

Seven-Headed Luther

Though the Catholic printers were slower to take advantage of the printing press, between 1520 and 1525, sixty Catholic writers produced more than two hundred pamphlets and books against Luther and other reformers. However, most lay people could not read Latin.[1]

Those following Luther's teachings wrote five times more pamphlets than the Catholics. When Martin Bucer, the reformer in Strasbourg, urged the Wittenberg theologians to get into the world and preach, Luther replied: "We do that with our books."[2]

The Catholics also drew caricatures. The cover of one book, published in 1929, depicted Luther as a seven-headed false prophet, like the beast in Revelation. The various heads show him, starting out on the right side, as a doctor (scholar) and ending as the leader of a rebellion.

1) Doctor— a doctor's beret

2) Martinus—a monk's cap

3) Luther—a Turkish turban (insinuating the falseness of the first two heads)

4) Clergyman—a humble priest's cap while impersonating a high churchman

5) Enthusiast—a fanatical or mentally ill person, indicated by a crown of hornets.

6) Jurist—a complete fraud because he presumes to judge the pope.

7) Barabbas—the convicted murderer whom the crowd in Jerusalem set free in the place of Christ (Luke 23:18–25).[3]

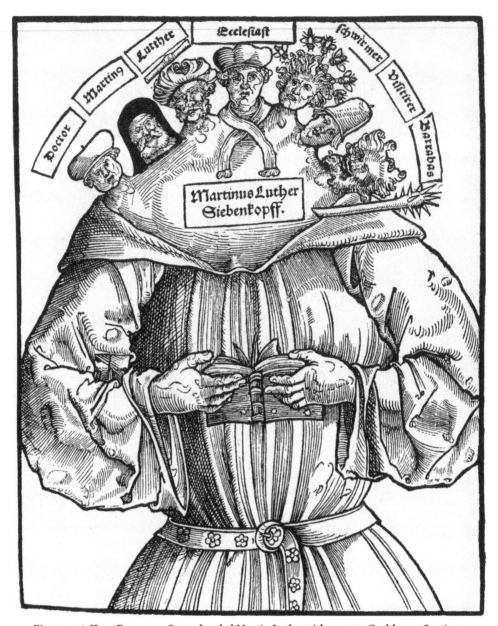

Figure 116. Hans Brosamer. *Seven-headed Martin Luther*, title page to Cochlaeus, *Septiceps Lutherus*, Leipzig: Valentin Schumann, 1529. Woodcut and letterpress, 7 x 5.3 in. (17.8 x 13.5 cm.).

78

The *Augsburg Confession*

The Archduke Ferdinand, the emperor's younger brother, presided over the Diet of Speyer in March 1529. He blamed the princes who were sympathetic to Luther for the Ottoman's victory in Hungary that allowed Suleiman the Magnificent to threaten Vienna. Ferdinand also accused the towns following Luther's teachings of violating the Edict of Worms and ordered them to accept the Latin mass.[1]

Six princes, including Elector Johannes of Saxony, and the representatives of the fourteen imperial cities who followed Luther, responded with a written protest that Ferdinand rejected. This lead to the term "Protestant." The Protestants were not a unified group. Some followed Luther, some followed Ulrich Zwingli of Switzerland, and others followed the Anabaptists (later known as Mennonites or Baptists).[2]

After several victories at Mohacs and Buda, Suleiman and his army headed across Hungary toward Vienna. Because of heavy rains and floods, his large cannons were bogged down in the mud. Ferdinand, who Suleiman called the "little man of Vienna," recruited troops to protect the city. After Suleiman's fourth attempt failed to bring down the walls of Vienna in a period of nineteen days, in October, the sultan turned his troops toward Persia.[3]

During the 1520s, many people hoped that the Catholic Church would reform itself so that all would be reconciled. Charles V wrote to the pope asking for a general council, but Pope Clement VIII refused because he did not want to weaken papal authority. The popes also wanted to curb Charles V's power and rule through the continued instability in Germany. Charles was more interested in religious reform than the popes.[4]

Figure 117. Titian, *Suleyman the Magnificent*, 1530.
Oil on canvas, 39 x 33 in. (99 x 85 cm.). Kuntshistorisches Museum, Vienna.

Figure 118. Albrecht Dürer, *Landscape with the Cannon*, 1518.
Etching on iron, 8.6 x 12.7 in. (21.8 x 32.2 cm.).
National Gallery of Art, Washington, DC.
This enigmatic German landscape has an Ottoman standing next to
an older cannon that has an N for Nuremberg marked on it.

Emperor Charles V called for a diet in Augsburg to begin in 1530. He had not been in Germany for ten years. He announced that it would be safe for both Catholics and Protestants to come. Because Luther did not want to be arrested, he asked the Nuremberg Council if he could follow the proceedings from their town. The Council declined because they did not want to be known as harboring an outlaw. So Luther and an assistant went to Elector Johann's Veste Castle in Coburg, at the southern edge of Saxony.[5]

Figure 119. Veste Castle, Coburg.

The Protestants wanted to convince the emperor that they were legitimate Christians. However, Johann Eck collected 404 theological statements from writings and stamped them as heretical. He sent a copy of the document to the emperor. Melanchthon worried that the Lutherans would be lumped together with the Anabaptists, who advocated baptism for adult believers rather than infants. He wrote the *Augsburg Confession* to make distinctions between the two groups. After Melanchthon and his colleagues finished writing the first draft, they sent it to Luther by mounted messenger. Luther responded: "It pleases me very much; I know nothing to improve or change in it."[6]

On June 15, 1530, Charles arrived in Augsburg with his courtiers, clergy, cooks, falconers, and two thousand Spanish dogs, all guarded by a thousand infantrymen. He wanted to celebrate the festival of Corpus Christi the next day with a high mass, but the Protestant princes did not want to participate. Charles called them to the palace and

insisted. After the princes argued, Charles agreed to a compromise the next morning. Neither side would be allowed to preach at the Diet. Both sides were writing letters to Erasmus, who replied to both with sharp comments.[7]

Figure 120. Philipp Melanchthon, editor. Title page of *Augsburg Confession*. 1530. 5.8 x 3.7 in. (14.7 x 9.5 cm.).

On June 25, the Protestant theologians and princes presented the *Augsburg Confession* to Charles, signed by the princes of seven Protestant territories and two city councils, Reutlingen and Nuremberg. After Charles rejected the first draft, Melanchthon wrote another draft that was presented to the diet on August 3, 1530. After the Catholics presented their document, the emperor chose the Catholic one and told the Protestant leaders that they had until April 15, 1531, to tell him whether or not they would return to the Roman church. If they did not agree to the Edict of Augsburg, Charles threatened to attack their cities. The *Augsburg Confession* of 1530 established the official alternative to Catholicism. Cardinal Albrecht wrote: "There is now no hope of unanimity [agreement] in the faith."[8]

The imperial cities who had become Protestant wondered if it was appropriate to resist the emperor militarily since they had given him their allegiance. On the last day of 1530, Elector Johannes of Saxony, Elector Philip of Hesse, and fourteen cities joined in an alliance called the Schmalkaldic League, stating that they would defend the Protestant cause against the threat of the emperor. Over the past ten years, the Protestants had grown strong enough to decide to fight their emperor in order to have freedom to follow their beliefs.[9]

Nuremberg did not join the league because her councilors did not want to endorse the rights of subjects to fight the emperor. They felt Nuremberg was only a city, not a territorial state, and needed to be connected with the empire to preserve the city's security. If Nuremberg joined the league and the emperor won, he could avenge their rebellion. If the emperor lost, the empire might collapse. The council's decision cost Nuremberg her role as leader for the Protestant cities in southern Germany.[10]

Around 1530, Elector Johannes presented Luther with a new family shield and trademark, a multilayered White Rose. The cross is within a blooming white rose, a symbol of comfort, joy, and the peace of faith here and in heaven. The rose is encircled and his initials, "M" and "L" are above the circle on either side.[11]

79

Pirckheimer Dies a Catholic

One week before the Nuremberg Council decided not to join the league with other Protestant states and cities, Willibald Pirckheimer, Dürer's good friend, died in Nuremberg. He was buried in the same cemetery as Dürer.[1]

Though Erasmus never met Pirckheimer, he had corresponded with him over the years and had Dürer's "Roman" engraving of him on his wall. Six years earlier, Pirckheimer had written to Erasmus telling of his break with Luther because of Luther's rejection of free will. This strengthened the two men's friendship. Erasmus wrote a letter that served as an obituary, praising Pirckheimer for his human qualities and civic virtues.[2]

Pirckheimer also had personal reasons for breaking with Luther. His older sister, Abbess Caritas was not the only family member in a convent. Six other sisters and three daughters were highly placed nuns in convents in Nuremberg and elsewhere.[3]

Pirckheimer's short temper had kept him forever engaged in private rows with members of the Nuremberg City Council. Days before his death, an ill and moody Pirckheimer, wrote to a friend in Vienna about his disenchantment with the Lutherans in Nuremberg, but he did not send the letter. "I admit that in the beginning I was also a good Lutheran, just like our late Albrecht [Dürer], for we hoped that the Roman corruption along with the thievery of the monks and priests would be remedied. But as one now sees, the matter has gotten so much worse that the evangelical criminals make the other criminals look pious."[4]

Luther, too, was disappointed by the failure of the Lutherans to live up to the morals they claimed to believe. As an idealist, he dreamed of worship "centered on God's word, prayer and love." Though good works no longer earned merit, he hoped that religion would spill over into daily life—seeking justice and demonstrating love. He knew that all men were sinners, but he still encouraged people to love God and their neighbors. "Temptations of course cannot be avoided, but because we cannot prevent the birds from flying over our heads, there is no need that we should let them nest in our hair."[5]

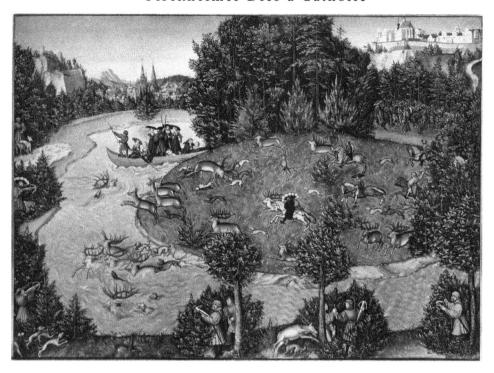

Figure 121. Lucas Cranach, *A Stag Hunt with Elector Frederick the Wise,* 1529.
Oil on lime, 31.6 x 44.9 in. (80.2 x 114.1 cm.). Kunsthistorisches Museum, Vienna.
On the far right is Elector Johann the Steadfast. As neither Ekector Friedrick (center foreground)
nor Emperor Maximilian I (right) were still alive in 1529, Johann must have commissioned the
painting to recall a hunt, which may have taken place in 1497 when both of the Saxon princes were
guests at Maximilian's court in Innsbruck.

80

Between Life and Death

When Luther, Melanchthon, and their colleagues returned to Wittenberg after the Diet of Augsburg, Luther met with his team of Bible translators fifteen times between mid-January to March 1531. He believed the Old Testament was the first part of the Christian Bible since the authors of the New Testament referred to three hundred passages from it. The group's goal was not a literal translation of the Hebrew, but one that would reflect how Germans spoke.[1]

The Ottoman threat continued to provide the reformers in Germany some breathing room. As the deadline of Charles's threat to attack Protestant cities in April 1531 approached, Archbishop Albrecht of Mainz and another Catholic elector asked the emperor to negotiate with the Protestants. If Charles V wanted Protestant money and troops to fight the Ottoman Turks in Hungary and have Archduke Ferdinand become king of Germany, he could not enforce the Edict of Augsburg. In June 1532, both sides signed the Peace of Nuremberg.[2]

In 1532, Suleiman marched his men into Hungary once again. The weather was terrible, making them abandon the largest cannon because it was too difficult for the oxen to pull it through the mud. A small fort at Guns, seventy miles south of Vienna, held out for almost a month against the Sultan's much larger force. Vienna was saved again because it was too late in the campaign season for a full-scale siege to succeed. Agreeing that Ferdinand could possess northern and western Hungary, Suleiman went home.[3]

On August 16, 1532, Elector Johann died from a stroke at his hunting castle near Wittenberg. He was buried in the Castle Church in Wittenberg. At the service, Luther praised the elector for his courage for signing the *Augsburg Confession* two years earlier. Elector Johann Frederick I, age twenty-nine, succeeded his father. He was even more pro-Lutheran policies than his father, and sometimes more ardent than Luther himself. He became co-leader of the Schmalcaldic League with Philip of Hesse.[4]

Abbess Caritas Pirckheimer died on August 19, 1532. Earlier, Erasmus compared her to Thomas More's eldest daughter, Margaret, who was well educated: "England has its Mores, Germany its Pirckheimers."[5]

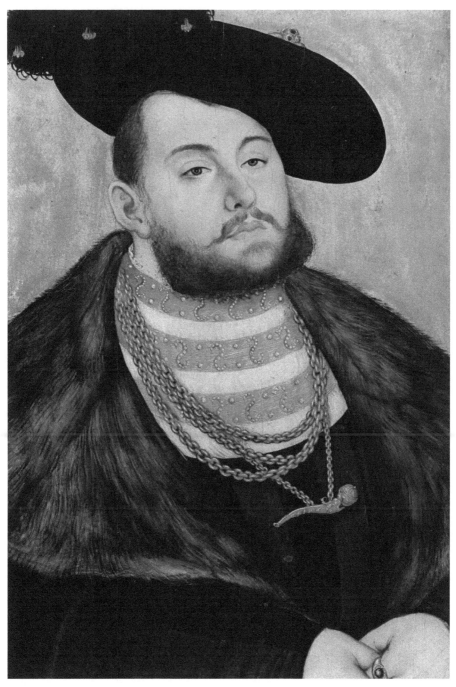

Figure 122. Cranach the Elder, Elector *John Frederick the Magnanimous of Saxony*, 1531.
Oil on panel, 20.1 x 14.6 in. (51 x 37 cm.).
Louvre Museum, Paris.

Finishing the translation of the Old Testament was a high priority for Luther, but many other matters interfered. Luther wrote: "I have enough to do with our own folk—teaching, encouraging, correcting and supervising them. By itself the task of translating the Bible is enough to keep all of us busy. Satan tried his best to make me desert my valuable work and chase after matters of no substance." The complete Bible was published in 1534. The German language he used was from the court of electoral Saxony, mixed with other dialects that he had heard while traveling. Luther said that translating required a "right pious, faithful, diligent, God-fearing, experienced, practical heart."[6]

Figure 123. Title page of Entire Holy Scripture, German. Wittenberg: Hans Lufft, 1534.
Luther House, Wittenberg.

Lazarus Spengler, Dürer's neighbor and secretary of the Nuremberg Council, who prodded the town toward Protestantism, died in September 1534. He appreciated the clarity and simplicity of Luther's writings and wanted his fellow citizens to know the truth so they could also have spiritual peace. He was buried in the same cemetery as Dürer and Pirckheimer.[7]

Erasmus, the prince of humanists, died in Protestant Basel, Switzerland, in July 1536. In his book, *The Preparation for Death*, written two years before, he differed from the Catholic view of last rites. He argued that the final hour of feverish thoughts did not determine one's outcome, but one's whole life. The historian R. J. Schock pointed out that both sides misunderstood Erasmus. "To Reformers he was one who

could not take the final step and leave the Rome of which he was critical; to Roman Catholics he was one who was almost a fifth columnist in his failure to condemn all Reformers outright."[8]

William Tyndale, an Englishman who studied at Wittenberg from 1522–24, began translating the New Testament into English using Erasmus's *New Testament* and Luther's 1521 September Testament. Tyndale's *New Testament* was printed in Protestant Worms in 1526 and smuggled into England. He was arrested for heresy near Brussels, strangled, and then burned in October 1536. His translation served as the foundation for the King James Version, published in England in 1611.[9]

In the summer of 1537, Luther returned to his primary job of lecturing on the books of the Bible. For two years he had wanted to speak about Genesis, but was interrupted by illness or political obligations. After reflecting on Genesis 20, where Abraham and Sarah lied to King Abimelech about Sarah being his sister rather than his wife, he wrote to a friend: "In every life it happens that many things we plan, say, and do have harmful consequences. But God uses these failings to humble his saints and turns our misdeeds to better account. Perhaps God would not do that if we did not have this defect."[10]

In October 1537, Lucas Cranach's eldest son, Hans, died at the age of twenty-four. He had been busy in the workshop in Wittenberg painting "many thousands of copies" of Luther's portrait.[11]

In September 1538, the Ottoman navy defeated the fleet of Charles V and his alliance of the Papacy, Spain, Republic of Genoa, Republic of Venice, and the Knights of Malta at the Battle of Preveza in northwestern Greece. Venice lost more possessions and had to pay an indemnity in gold. The Ottomans now ruled the eastern Mediterranean.[12]

In July 1539, Luther began revising the German Bible. He would continue this effort until he died.[13]

Figure 124. Albrecht Dürer, *Dürer's Wife*, detail of *A Young Woman from Cologne and Dürer's Wife* (recto), 1520. Silverpoint, 5.08 x 7.48 in. (12.9 x 19 cm.). Albertina, Vienna.

81

Agnes's Death and Will

Agnes Dürer spent years defending her late husband's intellectual property through having the Nuremberg City Council prevent plagiarizing and through enlisting the Council's support in obtaining copyright protection from the emperor. The printing process that brought him fame and wealth also made it much easier to copy his work.[1]

In 1539, Agnes Dürer died. In her will, made the year before, she gave Dürer's printed work, including his blocks and plates, his books, and his goldsmith's masterwork, to his brother Endres, who was also a painter.[2]

Agnes supported the reformed faith by establishing a scholarship fund for sons of artisans from Nuremberg to study theology at the University of Wittenberg. The men had to have already studied liberal arts for four years. The forty florins would support students for five years. She knew this type of person. Her husband, an artisan's son, who enjoyed discussing theology with his humanist friends.[3]

Melanchthon, the owner of most, if not all, of Dürer's prints, and overseer of education in Protestant areas of Germany, wrote from Wittenberg in 1540: "For Dürer's widow's legacy and its educational value, I praise God. I have preached on this *katorthoma* [good deed] in the presence of Luther and others."[4]

82

Surrounded by a Great Cloud
of Witnesses

In March of 1540, Philipp of Hesse, staunch supporter of Luther, and co-leader of the Schmalgaldic League, married a second wife, the eighteen-year-old Margarete von der Saale. When Martin Bucer (of Strasbourg), Luther, and Melanchthon failed to convince him not to commit bigamy, they absolved the prince and suggested he keep it a secret. The public scandal weakened the Protestant cause.[1]

Figure 125. Hans Krell, *Portrait of Philip I, Landgrave of Hesse*, 1534.
Oil on oak panel, 31.7 x 25.2 in. (80.5 x 64 cm.). Wartburg-Stiftung, Eisenach.

On Christmas Eve, 1541, Andres Bodenstein von Karlstadt died of the plague in Basel, Switzerland. After leaving the protection of the Luthers' home in Wittenberg, he had allied himself with an Anabaptist and then became chair of Old Testament in the University of Basel in 1534.[2]

In the fall of 1544, Luther and Johannes Bugenhagen went to Torgau to dedicate a large hall, the first space constructed specifically for Lutheran worship. The building, built into the north wing of Elector Johann Frederick's castle, had an imposing pulpit and a stone table, but no altar, at the front.[3]

Figure 126. Lucas Cranach the Elder, *Johannes Bugenhagen*, 1537.
Oil on beech, 14.4 x 9.4 in. (36.5 x 24 cm.). Luther House, Wittenberg.

In January 1545, Elector Frederick's former secretary and chaplain, Georg Spalatin, died at home in Altenburg after two years of deep depression.[4]

Archbishop Albrecht moved out of his favorite residence in Halle because he and the city council had a conflict over taxes. They also called a Lutheran preacher from

Wittenberg to serve in the church. Albrecht, who ruled over more land than anyone except the emperor, died at age fifty-five in Mainz in September 1545.[5]

Luther, who had a long history of headaches, dizziness, and depression, died on February 18, 1546, in Eisleben, where he was born. He was there to try to help the princes of Mansfeld reconcile. His body was brought back to Wittenberg with crowds standing along the road. Pastor Bugenhagen, who had officiated at Luther's wedding and was part of Luther's translation team, preached the sermon and Melanchthon delivered the Latin oration. Luther was buried inside the Castle Church.[6]

Figure 127. Lucas Cranach the Elder, *The Wiittenberg Altarpiece*, 1547.
Oil on panel, 100.4 x 180.3 (255 x 458 cm.). Town Church (St. Mary's), Wittenberg.

One year later, Cranach finished the altarpiece for St. Mary's Church in Wittenberg. The first Christians of Jerusalem stand and sit alongside the community of saints in Wittenberg. In the center panel Jesus sits at the left side of a round table, placing some food in the mouth of Judas, who holds a stuffed jeweled pocketbook and has already turned to leave the room. A cupbearer offers a cup to one of the disciples,

Luther disguised as Junker Jörg. On the left panel, Melanchthon baptizes a child while the women of Wittenberg watch. On the right panel, Bugenhagen, Luther's former confessor, listens to a penitent burgher confess. On the predella below the centerpiece, Luther points to Jesus on the cross while the congregation, including Luther's family and Cranach (the elderly man), listen attentively. Cranach's wife, the late Barbara Cranach, and the Luthers' deceased daughter, Magdalena, are in the congregation.[7]

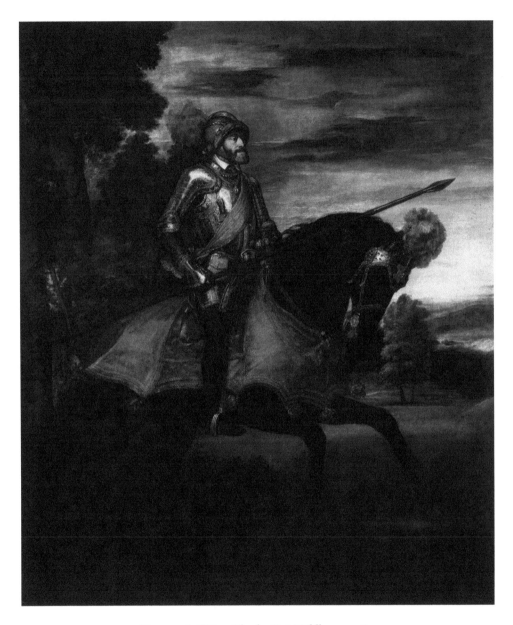

Figure 128. Titian, *Charles V at Mühlberg*, 1548.
Oil on canvas, 131.9 x 111.4 in. (335 x 283 cm.). Prado, Madrid.

83

The Emperor Finally Attacks

After the Ottomans successfully took several strategic forts in Hungary, Ferdinand sued for peace and signed a five-year truce in 1547. Though Ferdinand still controlled the northern and western regions of Hungary, he had to pay an annual tribute to Sultan Suleiman. Many Hungarian nobles had become Protestants, so Ferdinand could not be too harsh because he needed them to defend the land against the Ottomans.[1]

In April 1547, Emperor Charles V and his army attacked the army of the Lutheran Schmalcaldic League near Mühlberg. The two leaders of the league, Philipp of Hesse and Johann Frederick of Saxony, surrendered to Charles V. In order to save himself and his land, Elector Johann Frederick gave up the Ernestine line of the Saxon lands and title to the rival Duke Maurice of the Albertine Saxony.[2]

After the imperial army besieged Wittenberg, the city surrendered in May 1547. The emperor rode on horseback through the city to the Castle Church where Luther was buried. Though some of his Spanish retinue hoped that Luther's remains would be exhumed and burned, Charles vetoed the act. Katharina Luther and three of the children had already fled Wittenberg. She and the children and Melanchthon returned to Wittenberg once it was safe. In order to survive, she turned the cloister into a boarding house.[3]

Charles asked the ageing painter Titian to come to Augsburg to paint a picture commemorating his victory. The life size canvas depicts both Charles as the Defender of the Catholic Faith as well as his loneliness and weariness. Charles is shown holding the holy lance, a relic of the lance used to pierce Jesus's side, which is a part of the imperial regalia kept in Nuremberg.[4]

Though Spanish troops were stationed to enforce the Latin liturgy, vestments, and fast days in the German villages, only the areas controlled by the troops were

successful. Otherwise, the ruling was denounced or ignored. Melanchthon refused to join those who wanted to rebel against the return to Catholic rituals.[5]

Charles took the two defeated leaders of the league to the Netherlands under house arrest as a way to guarantee the submission of the league. They served the emperor at his castles in the Netherlands, Germany, Switzerland, and Austria.[6]

Johann Frederick's two sons asked Cranach to send Dürer's painting, the *Martyrdom of the Ten Thousand* (Figure 47), on display in the Castle Church, into safekeeping in Leipzig in an effort to rescue some of the elector's treasures. Other paintings were shipped to Antwerp where Johann Frederick gave them as ransom to the emperor. After three years of refusing to join the elector in imprisonment, Cranach went to Augsburg in July 1550, where he was offered an annual payment as well as commissions.[7]

In 1551, Maurice of Saxony turned on Charles and joined the league because his father-in-law, Philip of Hesse, was still imprisoned by the emperor. The French, Charles's enemy for decades, provided finances to the league to fight the emperor. In the spring of 1552, while Charles's army was in Italy, the league attacked Innsbruck, where Charles was quartered. He fled to Villach, Austria. Johann Frederick of Saxony and Philip of Hesse were released. Johann Frederick moved his government to Weimar, where he died two years later.[8]

While fleeing a plague in Wittenberg in 1552, Katharina Luther fell from a wagon. She died three months later at the age of fifty-three. She was buried at St Mary's Church in Torgau.[9]

Lucas Cranach, the court painter, who followed his prince Johann Frederick to Weimar, died there in October 1553, at the age of eighty-one. The inscription on his headstone in the St. James graveyard praised him for his piety, "speedy painting," virtue, and the high esteem held by three electors of Saxony. The carved gravestone portrays a full-size Cranach holding a circular palette in his hand.[10]

Cranach had begun painting an altarpiece in 1552 for St. Peter and St. Paul Church in Weimar. His son, who completed the piece in 1555, wedged Cranach in between John the Baptist, who is pointing to the lamb (John 1:29), and Luther, who is holding a Bible and pointing to Hebrews 4:16 "Let us then approach the throne of grace with confidence, so that we may receive mercy and find grace to help us in our time of need. (NIV)" In the upper right, the encamped Israelites are being attacked by snakes in the desert. God tells Moses that if the people will look at the Bronze Serpent raised on the stake, they will be healed (Numbers 21:4–9; John 3:14–16). On the left side of the painting, Jesus, the Conqueror, dressed in red, stands on Death and the Devil.[11]

Unlike Dürer's *Adoration of the Lamb* (figure 27), where the lamb's blood flows into a goblet held by a bishop, Cranach shows the blood from the side of Jesus, who is lifted up on the cross, falling only and directly onto the elder Cranach. Friedrich Ohly, a professor who specialized in the Middle Ages in Germany at the University of Munster, called the Weimar altarpiece the "single most important visual monument of the German Reformation."[12]

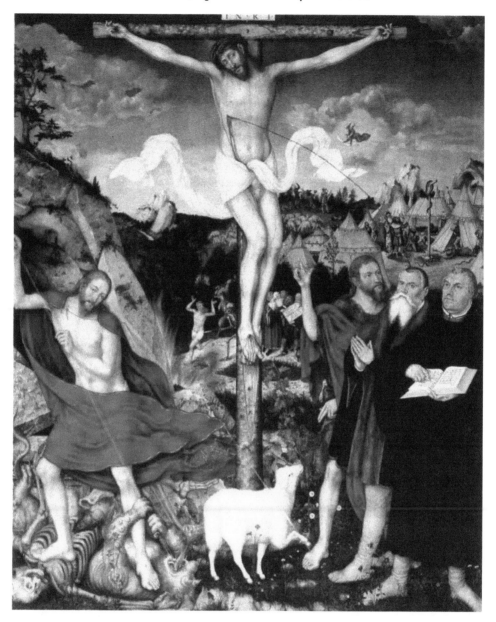

Figure 129. Lucas Cranach the Elder and Lucas Cranach the Younger, *The Fall and Redemption of Man,* **center panel of The** *Weimar Altarpiece,* **1555. Oil on panel, 360 x 311 cm. Stadtkirche St. Peter and Paul, Weimar. Elector John Frederick of Saxony and his family are on the two wings of the altarpiece.**

In September of 1555, Arch Duke Ferdinand and the princes of the Schmalgaldic League signed a treaty called the Peace of Augsburg. Every ruler of a state was given a choice of the state being Catholic or Lutheran. Their subjects were to abide or peacefully leave that state. This brought Germany peace for sixty years.[13]

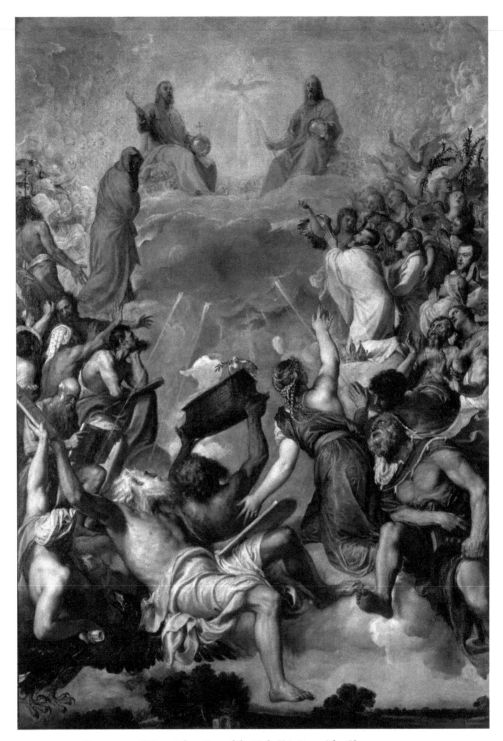

Figure 130. Titian, *Adoration of the Holy Trinity* or *The Glory*, 1551–54. Oil on panel, 136.3 x 94.5 in. (346 x 240 cm.). Prado, Madrid.

Charles V's hope for a unified empire had failed. Some of his imperial cities re-sisted his edicts and even fought against him. Struggling with various illnesses and

depression, the emperor abdicated his throne in 1556 in favor of his brother, Ferdinand. After being emperor for thirty-seven years, Charles retreated to a monastery in Yuste, Spain, where he spent time praying and sitting on a sunny terrace. He surrounded himself with art, including Titian's *Adoration of the Holy Trinity* that shows the emperor at the right center. He has laid his crown beside him and is wearing a shroud. Holy Roman Emperor Charles V died at age of fifty-eight on September 21, 1558.[14]

Figure 131. Albrecht Dürer, *Philosophia* from Konrad Celtis, *Quattuor libri Amorum*
(Four Books of Love), Nuremberg, 1502. Woodcut, 8.6 x 5.8 in. (21.9 x 14.7 cm.).

84

Albrecht Dürer's Influence on Art

The poet Konrad Celtis and his humanist friend and host Willibald Pirckheimer had hoped that Dürer would reform German painting. Dürer did more than that. When he died, only Raphael and Michelangelo were more famous than he.[1]

During his lifetime, Dürer created more than six dozen paintings, more than one hundred engravings, two hundred and fifty woodcuts, more than one thousand drawings, and three printed books on geometry, fortification, and the theory of human proportions. This book contains sixty pieces of his artwork, only 2 percent of his extensive portfolio. Authors have found it difficult to contain "The Complete Dürer" in one book, so they often focus on one medium.[2]

Dürer experimented with many kinds of media. He painted watercolor landscapes with towns, watermills, and mountains. His decorative work included a bookplate for Celtis, a design for a fountain, and Maximilian's *Arch* and *Prayerbook*. His nature studies included flowers, a bird's wing, as well as stag beetles, a lobster, and a walrus. His goal of accuracy caused the beauty of each to become evident. He drew designs for fortifications, for stained glass windows, and for dragon chandeliers made from reindeer antlers.[3]

After learning from his mentor, Wolgemut, and reading books about human proportions, Dürer raised the bar for both woodcuts (*Apocalypse*) and engravings (*Adam and Eve*). He was asked to make portraits of some of the most important people of his time. Dürer's portraits give later generations insights into their distinct faces and personalities. He sketched young and old people, capturing their likeness and character.[4]

Figure 132. Albrecht Dürer, *Head of a Walrus*, 1520–21. Pen and brown ink with watercolor, 8.3 x 12.3 in. (21.1 x 31.2 cm.). British Museum, London.

Erasmus sent his overdue thanks to Dürer with high compliments in March 1528, just before Dürer's death.

> Although Dürer is to be admired in other respects too, what is there that he cannot express monochrome, that is in black lines alone?—shadows, light, brightness, object in the foreground and objects in the background; though depending on position it is not just a single mental image of one object that present itself to the eye of the beholder. He accurately observes symmetry and balance. There is nothing he does not picture, why, he even seems to depict what cannot be pictured—fire and rays of light, thunder, sheets and bolts of lightning, or even, as the saying goes, clouds upon a wall, sense, all emotions, in short the entire soul of man, as it reveals itself in the garment that is his body, almost the very voice itself. He set all this before our eyes with the most felicitous strokes, those black lines, so that you would inflict injury on the image if you were to daub it with colour.[5]

Joseph Koerner, professor of history of art and architecture at Harvard University, argues that Dürer's printing and trademarking does not explain his massive effect.

> Through his imagination, craft and entrepreneurial drive, he invented, or made pictorially available, a whole range of new subjects for art: figures from myth, folklore, history and everyday life; contemporary monsters and miracles; the free play of ornament for its own sake. And he made even the old subjects so much his own that, as a result of his woodcut and engraved biblical scenes,

Christian iconography seemed, for a time, a Dürerian invention . . . Partly this influence was due to his story-telling gift.[6]

Dürer's influence and success can be measured in various ways. His sketches, portraits, woodcuts, and engravings were prized by people across the empire. His engravings and woodcuts were forged and copied by many. Both his people's poses and his animals' perfection made them more definitive as an ideal than live models. Craftsmen were inspired by his images, which appeared on church bells, pulpits, baptismal fonts, book bindings, goldsmith works, lead wall plaquettes, painted enamel (Limoges), pottery, stone reliefs, and tombs. His woodblocks were still in use after his death. His paintings were sought by princely Catholic collectors in Bavaria and Prague. Van Dyck, Rubens, Rembrandt, and El Greco were among the young artists who studied Dürer's works. When Rembrandt was twenty-nine years old, he purchased nine sets of the *Life of the Virgin* series, a *Passion* series, and other Dürer prints.[7]

Jane Hutchison, a biographer, wrote, "No Western artist has been more consistently admired than Dürer who, unlike Raphael, Rembrandt, and others, has never suffered a period of stylist eclipse." In 2016, the Unterlinden Museum in Colmar, France, provided small copies of Dürer's etchings to compare with the work of other artists.[8]

Figure 133. Albrecht Dürer, *View of Trent from the North*, 1495. Watercolor and gouache, 9.4 x 14 in. (23.8 x 35.6 cm.). Kunsthalle, Bremen.

Unlike some artists who were jealous of other's ability, or did not want to share the mysteries of their art, Dürer "rejoiced without jealousy in all noble works of art

by whomsoever made. He was ever ready with his help. Hence he was glad of any discovery he could make," so he could share it with others. He influenced a generation of German artists and beyond through his art and books on measurement and human proportion.[9]

His goals changed over the span of his life. Melanchthon recalled a conversation with Dürer:

> As a young man he had liked elaborate and complicated pictures, and as an admirer of his own works was thoroughly delighted in contemplating this complexity in some of his pictures. He said that subsequently as a mature man he had begun to observe nature, and tried to grasp her actual appearance, and then realized that simplicity was the highest glory of Art. Since he was quite unable to attain it, he said that he was no longer an admirer of his own works as once he was, but would often sigh when looking at his own pictures and acknowledge his own weakness."[10]

Perfection was difficult to attain. Carl Gustav Carus, a Romanticist doctor-painter, interpreted Dürer's *Melencolia I* as a "restless craving for a perfection never to be attained, and an acute awareness of problems never to be resolved." The art historian Erwin Panovsky wrote that this was "perhaps the most significant aspect of Dürer's personality." Dürer's two books, *Course in the Art of Measurement* and *Human Proportion*, were less than what Dürer had planned, but nevertheless, more, because they were richer in content and more scientific in method and presentation. Panovsky wrote that "Dürer was not only a geometrical genius and a great technician, he also was a thinker; and no matter how specialized and at times abstruse his researches became, he never lost sight of those fundamental problems."[11]

Camerarius, who translated Dürer's *Human Proportion* into Latin, commented on Dürer's ability as an artist. "In fact this consummate artist's mind, endowed with all knowledge and understanding of the truth and of the agreement of the parts one with another, governed and guided his hand and bade it trust to itself without any other aids . . . If there was anything at all in that man which could seem like a fault, it was his excessive industry, which often made unfair demands upon him."[12]

Panovsky described the tension between patient observer and visionary that Dürer felt as an artist:

> The very fact that the most productive artist of a country previously averse to theorizing in the field of art should have felt the urge to undertake scientific treatises on perspective, human proportions, etc., reveals the tension between conflicting psychological impulses. Dürer was the most patient observer of re-alistic details and was enamored of the most "objective" of all techniques, line engraving in copper; yet he was a visionary, "full of inward figures," to quote his own characteristic words. Convinced that the power of artist creation was a "mystery," not to be taught, not to be learned, not to be accounted for except

by the grace of God and "influences from above," he yet craved rational principles . . . Yet he untiringly repeated that theoretical rules were incapable of doing justice to the "infinite complexity of God's creation," and that their value were sorely limited, not only by the inequality of individual gifts and tastes but also by the finiteness of human reason.[13]

Dürer's continual desire to learn and experiment, to adapt and change, not only fit his temperament as an artist, but also as a thinker. His "restless craving for perfection" in both art and life, and his inability to achieve it, pointed to the fact that there was no perfection except for God. Writing his ideas on art also revealed his limitations, for he did not complete what he had planned.[14]

While Dürer longed to express this transcendence, he was also engaged with the tumultuous realities of his own time. The threatening outer storm of the Ottoman Turks threads its way through Dürer's works: a portrait of Suleiman, a landscape of cannons overlooking German countryside, and a written treatise on fortifications. The ongoing threat of Sulieman weakened the popes' and emperor's ability to quench the reformation, allowing Luther's teachings to flower in Dürer's heart, and flourish across the German territories and throughout Europe.[15]

Dürer found rest for his soul in the closer of the two storms. Luther taught that God's love, not the fear of death, was a better motivation for people's thoughts and actions. This echoed what Dürer already knew: it was the grace of God that gave him the power to be an artist. Dürer recognized that the grace of God, shown through the redemption of Christ, also enabled him to serve the Lord joyfully in this life, and be welcomed into heaven after death. All were glorious mysteries. God's creation was more wonderful than an artist could capture and God's grace in Jesus was more amazing than even Dürer could imagine.[16]

Epilogue

In 1559, Johannes von Staupitz's works were placed on the *Index of Prohibited Books* by Pope Paul IV along with Erasmus's and Luther's. Printers in Paris and the Netherlands used the Index as a guide for printing and keeping their firms solvent.[1]

Melanchthon died in 1560 in Wittenberg. He had encouraged building bridges between churches at a time when most were focusing on differences. He tried to incorporate the teachings of the Church Fathers into the new Lutheran church and made claims of reason and philosophy in an era of prophets like Luther. He and Luther were entombed across from each other in the Castle Church in Wittenberg.[2]

Suleiman the Magnificent died September 7, 1566, in his tent among his troops, while besieging Szigeth, Hungary, another fort that blocked his way to Vienna. He had ruled the Ottoman Empire for forty-seven years, thirty of which he spent on campaigns. The Ottomans did not threaten Vienna again until 1683.[3]

Many factors led to Nuremberg's decline after 1550. The earlier shift in the center of trade from Venice to Antwerp took a toll. In 1566 and 1570, Nuremberg was assessed among the highest contributors to the defense of the empire against the Ottomans. Heavy tariffs by France and countries to the east made trade unprofitable for German merchants. By 1574, representatives from eighteen Italian firms in Nuremberg took over the trade in spices, silk, velvet, and other luxuries. The Netherlands' war against their Spanish Catholic rulers interrupted commerce. When the Spaniards plundered Antwerp in 1576, twenty trading houses belonging to Nuremberg firms were pillaged. Amsterdam became the commercial center of Europe while Nuremberg became a quiet backwater.[4]

In 1620, Willem Janssen, a publisher in Antwerp, acquired Dürer's *Rhinoceros* woodblock in order to make a seventh edition of the print. By then the block had chipped edges, wormwood holes, and a long horizontal crack running through the legs. To give the block new life, Janssen made prints in olive green, dark green, or blue-grey.[5]

The Catholic elector Maximilian of Bavaria pressured the city council of Nuremberg to give him Dürer's *Four Apostles* in 1627. He cut off the scripture passages from the Luther Bible on the bottom and sent them back to Nuremberg. The scriptures were

reattached to the painting in 1922. The painting can be seen in Munich at the Alte Pinakotheck.[6]

Figure 134. Albrecht Dürer, *View of Nuremberg from the West*, 1496. Watercolor and gouache, 6.4 x 13.5 in. (16.3 x 34.4 cm.). Kunsthalle Bremen—Der Kunstverein in Bremen. Lost during the Second World War. The fortified town is on the right. Dürer was buried in the cemetery of Johannes Friedhof Church beyond the northwestern gate, on the left side of the watercolor in the distance.

The Thirty Years War between Protestants and Catholics lasted from 1618–48. The Bohemian Protestant nobility opposed the new Catholic king of Bohemia, Ferdinand, who wanted to reduce their political and religious privileges. When Ferdinand II, who became the Holy Roman emperor in 1619, countered the reforms in Germany, he even provoked Catholic princes. The war was between territorial princes and a powerful emperor. Sweden, France, and Spain became involved. Many issues and many fronts made the war drag on. The Peace of Westphalia, a compromise between

Protestants and Catholics, as well as between the emperor and the princes, was signed in 1648.[7]

In 1748, eight letters written by Dürer were found hidden in the wall of the family chapel of Pirckheimer's son-in-law when the house was remodeled. Copies of other Dürer letters had already been collected. They are the oldest personal letters from an artist to a friend to have survived.[8]

As Napoleon's French troops approached, the imperial treasury was moved from Nuremberg to Regensburg to Vienna in 1800.[9]

In celebration of Nuremberg's Dürer Jubilee in 1828, Ludwig, king of Bavaria, ordered Christian Daniel Rauch to create a bronze statue of Dürer. The larger than life statue was finally erected in 1840, Europe's first public monument honoring an artist.[10]

In the eighteenth century, someone called Dürer's engraving, *The Rider*, the *Knight, Death and the Devil*. The name stuck.[11]

When a collection of Dürer's prints were bought by the Academy of Fine Arts in Vienna in 1873, the collection included a silver reliquary with a lock of Dürer's hair. The relic is on display in the Academy's library.[12]

Mattias Grünewald, Albrecht Dürer, and Lucas Cranach are commemorated as artists and saints by the Lutheran Church each April 6, on the anniversary of Dürer's death.[13]

Acknowledgments

This book began in a class at Regent College, Vancouver, called "The Spiritual Vision of the Great Artists," taught by Laurel Gasque. Thank you to Laurel and my fellow students for rich discussions.

I'm thankful for friends who read some or all the manuscript and gave feedback: Jason Helopoulos, Bill and Bev Hobson, Nancy House, Manan Liu, Lora Pence, Pat Quinn, and Keith Widders. Special thanks to Sara Stadt who read several drafts. I appreciate Ryan Eschart's editing with an artist's eyes.

Thanks to Ginevra Eickhoff for help in translating and to Robert Cronan of Lucidity Information Design, LLC, for making a beautiful map. Thank you to the staff and students at MSU's Fine Arts Library for their cheerful assistance. I'm grateful to Laura Mason for editing and preparing the manuscript for publishing.

Thank you to the many sources that gave permissions to use all the beautiful artwork. I appreciate the Dürer and Luther scholars who have invested their time so we can know these two men better.

My love goes to Renee, our daughter, who has shared her love of art with us through the years. My husband, Tom, has helped, once more, with pictures and editing. His encouragement and thoughtfulness makes writing a pleasure. For these reasons and many more I dedicate this book to the two of you.

Discussion Questions

1. What is your favorite artwork by Durer? Why?

2. What factors shaped Durer's character, thoughts, and art?

3. What were some of Durer's innovations in art? In business?

4. What motivated Luther?

5. What roles did Staupitz play in Luther's life?

6. What evidence is there for Dürer's Protestant sympathies?

7. Discuss the influence of Erasmus's books, letters, and conversations. Would there have been a Reformation without him?

8. Give several reasons why Frederick protected Luther.

9. What role did the court painter Lucas Cranach play in the Reformation?

10. Discuss four or five factors that allowed the Reformation to spread across Germany and beyond.

11. Compare the forms and practices of Medieval Christianity with Protestant Christianity, including language, worship, communion, learning, spirituality, and authority.

12. Discuss changes in Protestant towns and regions, including social, financial, and political structures.

13. Why did Erasmus, Pirckheimer, and his sister Caritas remain Catholics?

14. What were some unintended consequences of the Reformation?

15. Why did Luther believe that his most important work was translating the Bible into German?

Dürer's Art in World Museums

Germany

Nuremberg: Dürer's home; Nuremberg Municipal Museum; Germanisches Nationalmuseum

Berlin: Berlin State Museum, Kupferstickkabinett (Museum of Prints and Drawings)

Munich: Alte Pinakothek

Weimar: Schlossmuseum

Frankfurt: Historical Museum

Austria

Vienna: Albertina Museum; Kunsthistorisches Museum

England

London: British Library; National Gallery; Courtauld Institute Galleries

Oxford: Ashmolean Museum

Cambridge: Fitzwilliam Museum

Manchester: Whitworth Art Gallery

Windsor Castle: The Royal Library

France

Paris: Louvre

USA

New York City: Metropolitan Museum of Art; Pierpont Morgan Library

Washington, D.C.: National Gallery of Art

Boston: Museum of Fine Art

Detroit: Detroit Institute of Art

Scotland

Glasgow: Hunterian Museum

Ireland

Dublin: Chester Beatty Library

Italy

Florence: Galleria degli Uffizi

Spain

Madrid: Museo de Prado

Russia

St. Petersburg: Hermitage

Figure Credits

1. Lucidity Information Design, LCC.

2. By Václav Brožík—W. Rebel, Public Domain, https://commons.wikimedia.org/w/index.php?curid=14702142. {{PD-Art}}

3. By Michel Wolgemut, Wilhelm Pleydenwurff (Text: Hartmann Schedel)—Own work (scan from original book), Public Domain, https://commons.wikimedia.org/w/index.php?curid=882186.

4. By Gentile Bellini—The Yorck Project: 10.000 Meisterwerke der Malerei. DVD-ROM, 2002. ISBN 3936122202. Distributed by DIRECTMEDIA Publishing GmbH., Public Domain, https://commons.wikimedia.org/w/index.php?curid=147845.

5. By Albrecht Dürer—Web Gallery of Art: Image Info about artwork, Public Domain, https://commons.wikimedia.org/w/index.php?curid=15495042.

6. By Michel Wolgemut, Wilhelm Pleydenwurff (Text: Hartmann Schedel)—Own work (scan from original book), Public Domain, https://commons.wikimedia.org/w/index.php?curid=872178. {{PD-Art}}

7. Creative Commons Zero CCO. Beautiful Fountain, Nuremberg, Fountain, Decorated, Max Pixel. http://maxpixel.freegreatpicture.com/Nuremberg-Beautiful-Fountain-Fountain-Decorated-206049.

8. By Albrecht Dürer—Web Gallery of Art: Image Info about artwork, Public Domain, https://commons.wikimedia.org/w/index.php?curid=12248359. {{PD-Art}}

9. By Albrecht Dürer—1. The Yorck Project: 10.000 Meisterwerke der Malerei. DVD-ROM, 2002. ISBN 3936122202. Distributed by DIRECTMEDIA Publishing GmbH.2. Dürerforschung, Germanisches Nationalmuseum, Public Domain, https://commons.wikimedia.org/w/index.php?curid=150466.

10. By Albrecht Dürer—Web Gallery of Art: Image Info about artwork, Public Domain, https://commons.wikimedia.org/w/index.php?curid=12247308.

11. By Albrecht Dürer—Fig 37 from Self Portrait: Renaissance to Contemporary (Anthony Bond, Joanna Woodall, ISBN 978–1855143579). Public Domain, https://commons.wikimedia.org/w/index.php?curid=11862094.

12. By Albrecht Dürer—Web Gallery of Art: Image Info about artwork, Public Domain, https://commons.wikimedia.org/w/index.php?curid=15495045.

13. Photograph by T. R. Bieler.

14. Photograph by T. R. Bieler.

15. By Martin Schongauer—Public Domain, https://commons.wikimedia.org/w/index.php?curid=8397108.

16. By Albrecht Dürer—Web Gallery of Art: Image Info about artwork, Public Domain, https://commons.wikimedia.org/w/index.php?curid=12247928.

17. By Albrecht Dürer—Kupferstichkabinett, Public Domain, https://commons.wikimedia.org/w/index.php?curid=48489960.

18. By Albrecht Dürer—"Am Anfang war Sigena. Ein Nürnberger Frauengeschichtsbuch." ars vivendi verlag, Cadolzburg 1999. ISBN 3–89716-092–7, Public Domain, https://commons.wikimedia.org/w/index.php?curid=5234320.

19. By Albrecht Dürer—Web Gallery of Art: Image Info about artwork, Public Domain, https://commons.wikimedia.org/w/index.php?curid=2287051.

20. By Albrecht Dürer—Web Gallery of Art: Image Info about artwork, Public Domain, https://commons.wikimedia.org/w/index.php?curid=15393517.

21. By Albrecht Dürer—Museo Nacional del Prado, Galería online, Public Domain, https://commons.wikimedia.org/w/index.php?curid=17628367.

22. By Albrecht Dürer—Own work based on: File: Albrecht Dürer—Monogramm.png, Public Domain, https://commons.wikimedia.org/w/index.php?curid=20656440.

23. Photograph by T. R. Bieler. Special Collections, Michigan State University.

24. By Albrecht Dürer—2. GallerixRu 1. Web Gallery of Art: Image Info about artwork, Public Domain, https://commons.wikimedia.org/w/index.php?curid=15307126.

25. By Albrecht Dürer—Higher resolution scan of the woodcarving, Public Domain, https://commons.wikimedia.org/w/index.php?curid=6377660.

26. By Albrecht Dürer—http://www.wga.hu/html/d/durer/2/12/2apocaly/index.html, Public Domain, https://commons.wikimedia.org/w/index.php?curid=95226.

27. By Albrecht Dürer—National Gallery of Art: online database: entry 1941.3.7, Public Domain, https://commons.wikimedia.org/w/index.php?curid=24073522.

28. Photograph by T. R. Bieler.

29. Gutenberg-Museum Mainz.

30. Photograph by T. R. Bieler. The National Museum of the Middle Ages (Cluny Museum), Paris.

31. Photograph by T. R. Bieler. Germanisches Nationalmuseum, Nuremberg.

32. By Albrecht Dürer (1471–1528): Fig 36 from Self Portrait: Renaissance to Contemporary (Anthony Bond, Joanna Woodall, ISBN 978–1855143579)., Public Domain, https://commons.wikimedia.org/w/index.php?curid=11862035.

33. By Albrecht Dürer—Rijksmuseum, Public Domain, https://commons.wikimedia.org/w/index.php?curid=14696714.

34. By Albrecht Dürer—AAETMvKqvXDNXg at Google Cultural Institute maximum zoom level, Public Domain, https://commons.wikimedia.org/w/index.php?curid=21791980.

35. By Albrecht Dürer—NgGmZAZW17zfhw at Google Cultural Institute maximum zoom level, Public Domain, https://commons.wikimedia.org/w/index.php?curid=21792126.

36. By Albrecht Dürer—http://www.she-philosopher.com/gallery/melancholyP1.html, Public Domain, https://commons.wikimedia.org/w/index.php?curid=3907823.

37. © The Trustees of the British Museum.

38. © The Trustees of the British Museum.

39. By Albrecht Dürer—themorgan.org, Public Domain, https://commons.wikimedia.org/w/index.php?curid=18682721.

40. By Albrecht Dürer—Web Gallery of Art: Image Info about artwork, Public Domain, https://commons.wikimedia.org/w/index.php?curid=15495072.

41. Courtesy of Lessing J. Rosenwald Collection. Pdf. Retrieved from the Library of Congress, https://www.loc.gov/item/50042683/. (Accessed March 30, 2017.)

42. By Albrecht Dürer—4QHm8iCbgjn1Og at Google Cultural Institute maximum zoom level, Public Domain, https://commons.wikimedia.org/w/index.php?curid=22189541.

43. By Giovanni Bellini—National Gallery, London, Public Domain, https://commons.wikimedia.org/w/index.php?curid=85107.

44. By Albrecht Dürer—ngGI_fW-CrcSrw at Google Cultural Institute maximum zoom level, Public Domain, https://commons.wikimedia.org/w/index.php?curid=22491854.

45. Detail of #43.

46. Photograph by T. R. Bieler.

47. By Albrecht Dürer—The Yorck Project: 10.000 Meisterwerke der Malerei. DVD-ROM, 2002. ISBN 3936122202. Distributed by DIRECTMEDIA Publishing GmbH. (Version online: Zeno.org, ID 2000399497X.), Public Domain, https://commons.wikimedia.org/w/index.php?curid=150461.

48. By Lucas Cranach the Elder—Detail from 1514 painting by Lucas Cranach the Elder, Public Domain, https://commons.wikimedia.org/w/index.php?curid=9865015.

49. The Art Institute of Chicago/Art Resource, NY.

50. By Albrecht Dürer—National Gallery of Art: online database: entry 1943.3.3588, Public Domain, https://commons.wikimedia.org/w/index.php?curid=24076554.

51. By Albrecht Dürer—National Gallery of Art: online database: entry 1943.3.3625, Public Domain, https://commons.wikimedia.org/w/index.php?curid=24093569.

52. Photograph by T. R. Bieler.

53. By Giotto di Bondone, Public Domain, https://commons.wikimedia.org/w/index.php?curid=93816.

54. By Lucas Cranach the Elder—1. Unknown; 2. Web Gallery of Art: Image Info about artwork, Public Domain, https://commons.wikimedia.org/w/index.php?curid=1085306.

55. By Michel Wolgemut, Wilhelm Pleydenwurff (Text: Hartmann Schedel)—Own work (scan from original book), Public Domain, https://commons.wikimedia.org/w/index.php?curid=882251.

56. By Albrecht Dürer—Web Gallery of Art: Image Info about artwork, Public Domain, https://commons.wikimedia.org/w/index.php?curid=15495106.

57. By Albrecht Dürer—Web Gallery of Art: Image Info about artwork, Public Domain, https://commons.wikimedia.org/w/index.php?curid=15393298.

58. By Albrecht Dürer—National Gallery of Art: online database: entry 1941.1.20, Public Domain, https://commons.wikimedia.org/w/index.php?curid=23418160.

59. By Albrecht Dürer—Web Gallery of Art: Image Info about artwork, Public Domain, https://commons.wikimedia.org/w/index.php?curid=15495100.

60. By Albrecht Dürer, Siglo XVII—Public Domain, https://commons.wikimedia.org/w/index.php?curid=4553216.

61. By Albrecht Dürer—Own work, Hiart, CC0, https://commons.wikimedia.org/w/index.php?curid=20900064.

62. By Albrecht Dürer—Web Gallery of Art: Image Info about artwork, Public Domain, https://commons.wikimedia.org/w/index.php?curid=2656460.

63. By Albrecht Dürer—Web Gallery of Art: Image Info about artwork, Public Domain, https://commons.wikimedia.org/w/index.php?curid=12342846.

64. By Albrecht Dürer—National Gallery of Art: online database: entry 1991.200.1, Public Domain, https://commons.wikimedia.org/w/index.php?curid=24094955.

65. From *Dürer's Drawings for the Prayer-Book of Emperor Maximilian*. With kind permission from Dover Publications.

66. By Albrecht Dürer—National Gallery of Art: online database: entry 1943.3.3544, Public Domain, https://commons.wikimedia.org/w/index.php?curid=24042967.

67. By Raphael—qwF04XF73Dmd1Q at Google Cultural Institute, zoom level maximum, Public Domain, https://commons.wikimedia.org/w/index.php?curid=13520356.

68. By Unknown—http://bildsuche.digitale-sammlungen.de/index.html?c=viewer&l=en&bandnummer=bsb00012453&pimage=00006&v=100&nav=, Public Domain, https://commons.wikimedia.org/w/index.php?curid=48805839.

69. Photograph by T. R. Bieler.

70. By Martin Luther, 1483–1546—http://dl.wdl.org/7497.pngGallery: http://www.wdl.org/en/item/7497/, Public Domain, https://commons.wikimedia.org/w/index.php?curid=31602986.

71. By Lucas Cranach the Elder—1. Unknown; 2. nevsepic.com.ua, Public Domain, https://commons.wikimedia.org/w/index.php?curid=519903.

72. By Albrecht Dürer—GalleriX, Public Domain, https://commons.wikimedia.org/w/index.php?curid=23246677.

73. Public Domain, https://commons.wikimedia.org/w/index.php?curid=552755. {{PD-Art}}

74. By Minucchio da Siena (Italian, 14th century)—Marie-Lan Nguyen (October 2009). Public Domain, https://commons.wikimedia.org/w/index.php?curid=18272024.

75. By Martin Luther—flickr, Public Domain, https://commons.wikimedia.org/w/index.php?curid=3757900.

76. By Lucas Cranach the Elder—3. nevsepic.com2. unbekannt1. Leipzig, Museum der Bildenden Künste, Public Domain, https://commons.wikimedia.org/w/index.php?curid=721925. {{PD-Art}}

77. 1520: Public Domain, https://commons.wikimedia.org/w/index.php?curid=552807.

78. © The Trustees of the British Museum.

79. By Michel Wolgemut, Wilhelm Pleydenwurff (Text: Hartmann Schedel)—Own work (scan from original book). Public Domain, https://commons.wikimedia.org/w/index.php?curid=872121.

80. By Albrecht Dürer—The Yorck Project: 10.000 Meisterwerke der Malerei. DVD-ROM, 2002. ISBN 3936122202. Distributed by DIRECTMEDIA Publishing GmbH., Public Domain, https://commons.wikimedia.org/w/index.php?curid=6274845.

81. By Denis van Alsloot—http://collections.vam.ac.uk/item/O132427/the-ommeganck-in-brussels-on-oil-painting-alsloot-denys-van/#, Public Domain, https://commons.wikimedia.org/w/index.php?curid=35640073.

82. By Jakob Seisenegger—[2], Public Domain, https://commons.wikimedia.org/w/index.php?curid=47427733.

83. By Albrecht Dürer—The Yorck Project: 10.000 Meisterwerke der Malerei. DVD-ROM, 2002. ISBN 3936122202. Distributed by DIRECTMEDIA Publishing GmbH., Public Domain, https://commons.wikimedia.org/w/index.php?curid=150442.

84. By Albrecht Dürer—http://www.zeno.org/Kunstwerke/B/D%C3%BCrer,+Albrecht%3A+Das+M%C3%BCnster+von+Aachen?hl=aachen, Public Domain, https://commons.wikimedia.org/w/index.php?curid=2494007.

85. Photograph by T.R. Bieler.

86. By Albrecht Dürer—"Am Anfang war Sigena. Ein Nürnberger Frauengeschichtsbuch." ars vivendi verlag, Cadolzburg 1999. ISBN 3–89716–092–7. Public Domain, https://commons.wikimedia.org/w/index.php?curid=5234337.

87. By Staatliche Münzsammlung München—Own work, CC BY-SA 3.0, https://commons.wikimedia.org/w/index.php?curid=30072998.

88. By Jan van Eyck—Web Gallery of Art: Image Info about artwork, Public Domain, https://commons.wikimedia.org/w/index.php?curid=4484562.

89. By Unknown—Unknown, Public Domain, https://commons.wikimedia.org/w/index.php?curid=552816.

90. Photograph by T. R. Bieler.

91. By Lucas Cranach the Elder—1. Unknown; 2. nevsepic.com.ua, Public Domain, https://commons.wikimedia.org/w/index.php?curid=648719.

92. By Albrecht Dürer—National Gallery of Art: online database: entry 1943.3.3552, Public Domain, https://commons.wikimedia.org/w/index.php?curid=24065345.

93. By Albrecht Dürer—National Gallery of Art: online database: entry 1943.3.3688, Public Domain, https://commons.wikimedia.org/w/index.php?curid=24090436.

94. By Lucas Cranach the Elder—Public Domain, https://commons.wikimedia.org/w/index.php?curid=44702372.

95. By Workshop of Lucas Cranach—Württembergische Landesbibliothek Stuttgart: http://digital.wlb-stuttgart.de/digitale-sammlungen/seitenansicht/?no_cache=1&tx_dlf%5Bid%5D=592&tx_dlf%5Bpage%5D=1. Public Domain, https://commons.wikimedia.org/w/index.php?curid=20885741.

96. By Albrecht Dürer—http://www.usc.edu/schools/annenberg/asc/projects/comm544/library/images/626.html. Public Domain, https://commons.wikimedia.org/w/index.php?curid=1206785.

97.href=http://archive.org/stream/hierinnsindbegrioodure#page/151/mode/1up"; http://archive.org/stream/hierinnsindbegrioodure#page/151/mode/1up. Public Domain, https://commons.wikimedia.org/w/index.php?curid=24987909.

98. By Albrecht Dürer—SLUB Dresden, Public Domain, https://commons.wikimedia.org/w/index.php?curid=7456473.

99. By Albrecht Dürer—National Gallery of Art: online database: entry 1943.3.3550, Public Domain, https://commons.wikimedia.org/w/index.php?curid=24042910.

100. By Albrecht Dürer—National Gallery of Art: online database: entry 2005.105.1, Public Domain, https://commons.wikimedia.org/w/index.php?curid=24100120.

101. By Albrecht Dürer—National Gallery of Art: online database: entry 1943.3.3551, Public Domain, https://commons.wikimedia.org/w/index.php?curid=24062612.

102. By Albrecht Dürer—Unknown, Public Domain, https://commons.wikimedia.org/w/index.php?curid=638889.

103. By Hans Maler zu Schwaz—Kunsthistorisches Museum: Bilddatenbank. Public Domain, https://commons.wikimedia.org/w/index.php?curid=4597281.

104. By Hans Holbein—The Yorck Project: 10.000 Meisterwerke der Malerei. DVD-ROM, 2002. ISBN 3936122202. Distributed by DIRECTMEDIA Publishing GmbH. Public Domain, https://commons.wikimedia.org/w/index.php?curid=152952.

105. *Nuremburg. Fuch's house; Statue of Melancthon.* Germany Nuremberg, None. [Between 1860 and 1890] Photograph. Retrieved from the Library of Congress, https://www.loc.gov/item/94512875/.

106. By Lucas Cranach the Elder and workshop—1. Unknown; 2. nevsepic.com.ua, Public Domain, https://commons.wikimedia.org/w/index.php?curid=518829.

107. By Lucas Cranach the Elder—Google Art Project (original file link), Conference of National Cultural Institutions, Public Domain, https://commons.wikimedia.org/w/index.php?curid=44385120.

108. Photograph by T. R Bieler.

109. By Albrecht Dürer—http://www.metmuseum.org/art/collection/search/336231, Public Domain, https://commons.wikimedia.org/w/index.php?curid=9642095.

110. By Wolkenkratzer—Own work, CC BY-SA 3.0, https://commons.wikimedia.org/w/index.php?curid=20262378.

111. By Albrecht Dürer—Scanned from book by Immanuel Giel, Public Domain, https://commons.wikimedia.org/w/index.php?curid=2635385.

112. Photograph by T. R. Bieler.

113. By Albrecht Dürer—Bibioteca Nacional Digital, Brasil: info; file, Public Domain, https://commons.wikimedia.org/w/index.php?curid=42011245.

114. By Albrecht Dürer—Web Gallery of Art: Image Info about artwork, Public Domain, https://commons.wikimedia.org/w/index.php?curid=15495138.

115. By I, Sailko, CC BY-SA 3.0, https://commons.wikimedia.org/w/index.php?curid=15866910.

116. By Unknown—Hanns Lilje: Martin Luther. En bildmonografi. Stockholm 1966. Public Domain, https://commons.wikimedia.org/w/index.php?curid=49247330.

117. By Titian—http://j-times.ru/turciya/garem-sultana-tureckij-vzglyad.html, Public Domain, https://commons.wikimedia.org/w/index.php?curid=2646041_ {{PD-Art}}

118. By Albrecht Dürer—National Gallery of Art: online database: entry 1950.17.21, Public Domain, https://commons.wikimedia.org/w/index.php?curid=24063320.

119. By Presse03—Own work, CC BY-SA 3.0, https://commons.wikimedia.org/w/index.php?curid=6251198.

120. Courtesy of James Gray.

121. By Lucas Cranach the Elder—E. Ruhmer. Cranach London: Phraidon Press, 1962. Plate 28. , Scanned by Robert E. Smith),Original uploader was CTSWyneken at en.wikipedia, 25 May 2006 (original upload date), Public Domain, https://commons.wikimedia.org/w/index.php?curid=6708690.

122. By Lucas Cranach the Elder—The Yorck Project: 10.000 Meisterwerke der Malerei. DVD-ROM, 2002. ISBN 3936122202. Distributed by DIRECTMEDIA Publishing GmbH., Public Domain, https://commons.wikimedia.org/w/index.php?curid=149746.

123. By Torsten Schleese—Own photo taken in Lutherhaus Wittenberg. Public Domain, https://commons.wikimedia.org/w/index.php?curid=460823.

124. By Albrecht Dürer—Web Gallery of Art: Image Info about artwork. Public Domain, https://commons.wikimedia.org/w/index.php?curid=15495111.

125. By Albrecht Dürer—Scanned from Albrecht Dürer 1471 bis 1528. Das gesamte graphische Werk, mit einer Einleitung von Wolfgang Hütt, Band 2: Druckgraphik,

Endnotes

1: Art, Religion, and Politics

1. Hutchison, *Albrecht Dürer*, 6–7.
2. Strauss, *Nuremberg*, 1.
3. Goodwin, *Lords of the Horizon*, 78–79, 84; Faroqhi, *Ottoman Empire*, 5.
4. Hendrix, *Martin Luther*, 108.
5. Ibid., 8–9; Goodwin, *Lords of the Horizon*, 88, footnote.

2: The Recurring Outer Storm

1. Goodwin, *Lords of the Horizon*, 48.
2. Gonzalez, *Story of Christianity*, 136–37, 392–93.
3. Ibid., 393; Latourette, *A History of Christianity*, 602, 613–14.
4. Unger, "Hi, Venice? . . ." 36.

3: The Earlier Inner Storm

1. Gonzalez, *Story of Christianity*, 416–17.
2. Ibid., 418–19, 421.
3. Ibid., 419, 421.
4. Strauss, *Nuremberg*, 12, 14, 212–13.
5. Gonzalez, *Story of Christianity*, 417, 420–21.
6. Hutchison, *Albrecht Dürer*, 7.
7. Ibid., 4, 6, 8–9; Ashcroft, *Albrecht Dürer*, 31; Gonzalez, *Story of Christianity*, 419.

4: Nuremberg

1. Hutchison, *Albrecht Dürer*, 10, 12, 14, 18, 20; Olds, "Durer and Nuremberg," 11.
2. Hutchison, *Albrecht Dürer*, 14, 18, 19, 20.
3. Ibid., 11; Conway, *Literary Remains*, 21; Strauss, *Nuremberg*, 255–60.

4. Ibid., 6–7, 18; Strauss, *Nuremberg*, 127.

5. Strauss, *Nuremberg*, 18, 27, 30–31; Conway, *Literary Remains*, 3–4.

6. Olds, "Durer and Nuremberg," 10; Strauss, *Nuremberg*, 133, 136.

7. Strauss, *Nuremberg*, 97–99, 139, 251–52, 269, 274–75.

8. Ibid., 5, 31, 34, 63.

9. Ibid., 23–24, 58–59, 86, 108–9.

5: The Young Apprentice

1. Hutchison, *Albrecht Dürer*, 19; Ashcroft, *Albrecht Dürer*, 35.

2. Hutchison, *Albrecht Dürer*, 22–23.

3. Ibid., 24.

4. Ibid., 23.

5. Ibid., 24; Panofsky, *Life and Art*, 15.

6: Woldegut's Woodcuts

1. Hutchison, *Albrecht Dürer*, 24.

2. Ibid., 25; Panovsky, *Life and Art*, 19; Hutchison, *Albrecht Dürer*, 30.

3. Panovsky, *Life and Art*, 18.

4. Eisenstein, *Printing Press*, 178, 375.

5. Ibid., 179, 191, 371, 374–75.

7: A Journeyman

1. Hutchison, *Albrecht Dürer*, 30.

2. Ibid., 30; Panofsky, *Life and Art*, 62–64.

3. Hutchison, *Albrecht Dürer*, 29.

4. Ibid., 28, 30–31; Panofsky, *Life and Art*, 5.

8: *St. Jerome in His Study* (1492)

1. Panovsky, *Life and Art*, 6; Hutchison, *Albrecht Dürer*, 38.

2. Hutchison, *Albrecht Dürer*, 38; Price, *Albrecht Dürer's Renaissance*, 194–95, 203–4.

3. Price, *Albrecht Dürer's Renaissance*, 194–97.

4. Panofsky, *Life and Art*, 24.

9: A Wedding

1. Hutchison, *Albrecht Dürer*, 40; Strauss, *Nuremberg*, 139.

2. Hutchison, *Albrecht Dürer*, 41; Strauss, *Nuremberg*, 23; Ashcroft, *Albrecht Dürer*, 968.

3. Hutchison, *Albrecht Dürer*, 41.

Endnotes

10: First Journey to Italy

1. Panovsky, *Life and Art,* 8; Hutchison, *Albrecht Dürer,* 42, 82.
2. Hutchison, *Albrecht Dürer,* 43; Smith, *Dürer,* 56.
3. Hutchison, *Albrecht Dürer,* 43, 81–82.
4. Ibid., 43.
5. Ibid., 47; Cetto, *Watercolors,* 14.

11: Setting Up His Workshop

1. Hutchison, *Albrecht Dürer,* 57, 62.
2. Strauss, *Nuremberg,* 97; Hutchison, *Albrecht Dürer,* 43.
3. Strauss, *Nuremberg,* 260; Hutchison, *Albrecht Dürer,* 57–58.
4. Hutchison, *Albrecht Dürer,* 57; Bongard and Mende, *Durer Today,* 12.
5. Werner, "Introduction," xii; Panofsky, *Life and Art,* 283; Streider, 3; Bongard and Mende, *Durer Today,* 11–12.

12: Frederick the Wise

1. Maltby, *Reign of Charles V,* 19.
2. Moser, *Lucas Cranach,* 27, 31.
3. Bainton, *Here I Stand,* 53.
4. Hutchison, *Albrecht Dürer,* 65.
5. Ibid., 66.
6. Hexhan and Kope, *Christian Traveler's Guide,* 214.

13: The *Apocalypse* (1498)

1. Parshall, "Vision of the Apocalypse," 100; Wilcock, *Message of Revelation,* 40.
2. Carey, *Apocalypse,* 8; Wolfflin, *Art of Albrecht Dürer,* 60.
3. Parshall, "Vision of the Apocalypse," 102; Hutchison, *Albrecht Dürer,* 58–59; Panofsky, *Life and Art,* 55–57.
4. Panofsky, *Life and Art,* 56–57; Wilcock, *Message of Revelation,* 41; Parshall, "Vision of the Apocalypse," 132; Couchman, *Art of Faith,* 189.
5. Wilcock, *Message of Revelation,* 68–69.
6. Parshall, "Vision of the Apocalypse," 133; Wilcock, *Message of Revelation,* 75; Price, *Albrecht Dürer's Renaissance,* 44.
7. Price, *Albrecht Dürer's Renaissance,* 62. Couchman, *Art of Faith,* 109.
8. Price, *Albrecht Dürer's Renaissance,* 32; Panofsky, *Life and Art,* 51, 52; Parshall, "Vision of the Apocalypse," 131; Strauss, *Nuremberg,* 260.
9. Panofsky, *Life and Art,* 47–48, 55.
10. Hutchison, *Albrecht Dürer,* 62.
11. Ibid., 63; Bartrum, "Catalog," 130; Price, *Albrecht Dürer's Renaissance,* 34; Panofsky, *Life and Art,* 59; Wolfflin, *Art of Albrecht Dürer,* 59.

14: 1500

1. Gonzalez, *Story of Christianity*, 391–92; Parshall, "Vision of the Apocalypse," 99–100, 107.

2. Bainton, *Here I Stand*, 35; Gonzalez, *Story of Christianity*, 144.

3. Hutchison, *Albrecht Dürer*, 64; Gonzalez, *Story of Christianity*, 443; Bainton, *Here I Stand*, 54–55.

4. Gonzalez, *Story of Christianity*, 392; Sittzer, *Water from a Deep Well*, 152, 154; Latourette, *A History of Christianity*, 538.

5. Hendrix, *Martin Luther*, 121, 129, 145, 251; Smith, *Nuremberg*, 4.

15: *Self-portrait* (1500)

1. Hutchison, *Albrecht Dürer*, 67–68; Panofsky, *Life and Art*, 43; Price, *Albrecht* Dürer's Renaissance, 144.

2. Price, *Albrecht* Dürer's Renaissance, 89, 91; Panofsky, *Life and Art*, 43; Smith, *Dürer*, 147–48; Gonzalez, *Story of Christianity*, 427.

3. Price, *Albrecht* Dürer's Renaissance, 93; Smith, *Dürer*, 147.

4. Price, *Albrecht* Dürer's Renaissance, 94.

5. Ibid., 95; Hutchison, *Albrecht Dürer*, 67; Smith, *Dürer*, 145–46.

6. Hutchison, *Albrecht Dürer*, 68; Panofsky, *Life and Art*, 45; Smith, *Dürer*, 144.

16: Loving Fathers

1. Hutchison, *Albrecht Dürer*, 64.

2. Eisler, *Dürer's Animals*, 193.

3. Ibid., 193.

4. Ibid., 193.

5. Panofsky, *Life and Art*, 76; Salley, *Nature's Artist*, 78.

6. Hutchison, *Albrecht Dürer*, 75–76; Ashcroft, *Albrecht Dürer*, 96.

7. Hutchison, *Albrecht Dürer*, 76.

17: *Madonna with a Multitude of Animals* (1503)

1. Couchman, *Art of Faith*, 128, 148, 158, 161, 163; Eisler, *Dürer's Animals*, 43, 268; Cetto, *Watercolors*, 19; Salley, *Nature's Artist*, 24.

2. Couchman, *Art of Faith*, 159, 166; Eisler, *Dürer's Animals*, 37, 42.

3. Panofsky, *Life and Art*, 36–37; Eisler, *Dürer's Animals*, 43; Salley, *Nature's Artist*, 24.

18: Animals and Plants

1. Salley, *Nature's Artist*, 66; Russell, *World of Dürer*, 93.

2. Cetto, *Watercolors*, 19; Wolfflin, *Art of Albrecht Dürer*, 141; Wolf, *Albrecht Dürer*, 40; Foister, *Durer and the* Virgin, 13, 17.

3. Hutchison, *Albrecht Dürer*, 69.

Endnotes

19: *Adam and Eve* (1504)

1. Smith, *Dürer*, 142.
2. Ibid., 126.
3. Ibid., 125–27.
4. Ibid., 142; Panofsky, *Life and Art*, 85.
5. Panofsky, *Life and Art*, 85.
6. Smith, *Dürer*, 142.

20: Durer's Friends

1. Strauss, *Nuremberg*, 249; Ozment, *Serpent & the Lamb*, 57.
2. Panofsky, *Life and Art*, 7; Hutchison, *Albrecht Dürer*, 48–49; Strauss, *Nuremberg*, 23; Panofsky, *Life and Art*, 89. For more about Pirckheimer, see Strauss, *Nuremberg*, 247–48.
3. Hutchison, *Albrecht Dürer*, 49; Strauss, Nuremberg, 246; Conway, *Literary Remains*, 26; Moser, *Lucas Cranach*, 41, Ashcroft, *Albrecht Dürer*, 77–81.
4. Hutchison, *Albrecht Dürer*, 49, 54; Strauss, *Nuremberg*, 157.
5. Hutchison, *Albrecht Dürer*, 48, 54, 70; Eisenstein, *Printing Press*, 247–8; Price, *Albrecht Dürer's Renaissance*, 16–17; Strauss, *Nuremberg*, 160, 162; Ozment, *Serpent & the Lamb*, 57.

21: Returning to Italy

1. Panofsky, *Life and Art*, 8; Hutchison, *Albrecht Dürer*, 78–79, 82; Ashcroft, *Albrecht Dürer*, 140.
2. Hutchison, *Albrecht Dürer*, 8, 83; Conway, *Literary Remains*, 17.
3. Hutchison, *Albrecht Dürer*, 79.
4. Panofsky, *Life and Art*, 108, 109.
5. Ashcroft, *Albrecht Dürer*, 139, 141.
6. Hutchison, *Albrecht Dürer*, 82; Zuffi, *Dürer*, 51.
7. Panofsky, *Life and Art*, 110–11.
8. Ibid., 110, 112.
9. Hutchison, *Albrecht Dürer*, 82; Conway, *Literary Remains*, 59; Ashcroft, *Albrecht Dürer*, 160, 162; Smith, *Nuremberg*, 40.
10. Hutchison, *Albrecht Dürer*, 86, 94; Conway, *Literary Remains*, 57–58.
11. Hutchison, *Albrecht Dürer*, 90–91; Strauss, *Nuremberg*, 109, 112; Hutchison, *Albrecht Dürer*, 98.

22: Moving to a New Home

1. Hutchison, *Albrecht Dürer*, 98; Eisler, *Dürer's Animals*, 251; Strauss, *Nuremberg*, 25–26.
2. Conway, *Literary Remains*, 60.
3. Hutchison, *Albrecht Dürer*, 98, 119–21; Ashcroft, *Albrecht Dürer*, 266, 335–36, 656–57.
4. Conway, *Literary Remains*, 24; Hutchison, *Albrecht Dürer*, 120–21; Ashcroft, *Albrecht Dürer*, 266, 283, 287–88.

5. Hutchison, *Albrecht Dürer*, 98–99; Eisler, *Dürer's Animals*, 168, 170.

6. Hutchison, *Albrecht Dürer*, 99.

7. Ashcroft, *Albrecht Dürer*, 214–16, 388–89, 1013.

8. Conway, *Literary Remains*, 70; Ashcroft, *Albrecht Dürer*, 225.

23: Lucas Cranach's Relic Sampler

1. Ozment, *Serpent & the Lamb*, 10; Heydenreich, *Lucas Cranach*, 287, 325; Moser, *Lucas Cranach*, 27.

2. Heydenreich, *Lucas Cranach*, 324, 287; Ozment, *Serpent & the Lamb*, 1.

3. Ozment, *Serpent & the Lamb*, 81.

4. Bainton, *Here I Stand*, 53; Ozment, *Serpent & the Lamb*, 81–82; Schoeck, *Erasmus of Europe*, 97; Moser, *Lucas Cranach*, 43. Moser says 117 relics. Moser, *Lucas Cranach*, 43.

5. Bainton, *Here I Stand*, 53.

6. Ozment, *Serpent & the Lamb*, 82.

24: *The Life of the Virgin* (1511)

1. Hutchison, *Albrecht Dürer*, 61, 106; Pirkheimer and Renner, viii, ix; Ashcroft, *Albrecht Dürer*, 489.

2, Eisler, *Dürer's Animals*, 190.

3. Ibid., 190.

4. Price, *Albrecht* Dürer's Renaissance, 157–59.

25: The *Small Passion* and the *Large Passion* (1511)

1. Hutchison, *Albrecht Dürer*, 106; Price, *Albrecht* Dürer's Renaissance, 181.

2. Hutchison, *Albrecht Dürer*, 106; Price, *Albrecht* Dürer's Renaissance, 16–17, 181.

3. Hutchison, *Albrecht Dürer*, 107; Bartrum, *Albrecht Dürer*, 251–53.

4. Hutchison, *Albrecht Dürer*, 107; Bartram, *Albrecht Dürer*, 239; Ashcroft, *Albrecht Dürer*, 338–39.

5. Price, *Albrecht* Dürer's Renaissance, 106, 175, 186; Panovsky, *Life and Art*, 137, 146.

6. Hutchison, *Albrecht Dürer*, 106; Price, *Albrecht* Dürer's Renaissance, 174–76; Ashcroft, *Albrecht Dürer*, 301.

26: Reform Movements with the Church

1. Gonzalez, *Story of Christianity*, 331–32; Latourette, *A History of Christianity*, 636.

2. Gonzalez, *Story of Christianity*, 147–48, 329–34; Caro, *Road from the Past*, 72.

3. Gonzalez, *Story of Christianity*, 359–60; Latourette, *History of Christianity*, 431–32.

4. Latourette, *History of Christianity*, 426, 440–41.

Endnotes

27: Martin Luther

1. Bainton, *Here I Stand*, 39.
2. Hendrix, *Martin Luther*, 17–19, 27.
3. Ibid., 33–34; Bainton, *Here I Stand*, 15, 33.
4. Hendrix, *Martin Luther*, 37.
5. Bainton, *Here I Stand*, 36; Hendrix, *Martin Luther*, 6.
6. Schoeck, *Erasmus of Europe*, 62; Bainton, *Here I Stand*, 36–38.

28: Erasmus of Rotterdam

1. Sittser, *Water from a Deep Well*, 202–4; Packer and Johnston, "Historical and Theological," 13–14; Gonzalez, *Story of Christianity*, 427–28; Chadwick, *Reformation*, 31–32; Schoeck, *Erasmus of Europe*, 134, 143.
2. Erasmus, *Praise of Folly*, 56–57.
3. Ibid., 32.
4, Ibid., 34, 38.
5. Ibid., 67–68, 71; Schoeck, *Erasmus of Europe*, 99.
6. Introductory Note, *In Praise of Folly*, v; Schoeck, *Erasmus of Europe*, 98.
7. Chadwick, *Reformation*, 38; Schoeck, *Erasmus of Europe*, 179, 183, 184.
8. Schoeck, *Erasmus of Europe*, 229; Bainton, *Here I Stand*, 67.
9. Schoeck, *Erasmus of Europe*, 175, 183, 185.

29: Dürer's Thoughts on God and Art

1. Conway, *Literary Remains*, 152–53.
2. Ibid., 152–53.
3. Ibid., 152–53.

30: *The Rider* (1513)

1. Schoeck, *Erasmus of Europe*, 28, 29–30, 38; Ashcroft, *Albrecht Dürer*, 394.
2. Schoeck, *Erasmus of Europe*, 28, 31, 33.
3. Ibid., 33–34.
4. Schoeck, *Erasmus of Europe*, 28, 31, 33; Ashcroft, *Albrecht Dürer*, 394.
5. Hutchison, *Albrecht Dürer*, 116; Ashcroft, *Albrecht Dürer*, 307, 392–94; Panofsky, *Life and Art*, 154; Couchman, *Art of Faith*, 152. Dürer referred to the print as "der Reuter" (the Rider) in his Netherlands journal. Cuneo, "The Artist, His Horse . . .," 116; For other theories about interpretations, see Cuneo, 117; Hermann Grimm made the first connection with Erasmus writings in 1875. Silver and Smith, *Essential Dürer*, 248, footnote 4.
6. Panofsky, *Life and Art*, 151–53.

31: Mother and *Melancolia I.*

1. Hutchison, *Albrecht Dürer*, 121.
2. Ibid., 121.
3. Hutchison, *Albrecht Dürer*, 122; Hendrix, *Martin Luther*, 284; Ashcroft, *Albrecht Dürer*, 398.
4. Hutchison, *Albrecht Dürer*, 123.
5. Panofsky, *Life and Art*, 156.
6. Couchman, *Art of Faith*, 12; Panofsky, *Life and Art*, 163–64; Price, *Albrecht* Dürer's Renaissance, 85–86.
7. Hutchison, *Albrecht Dürer*, 117; Price, *Albrecht* Dürer's Renaissance, 83; Panofsky, *Life and Art*, 157, 170; Bartrum, *Albrecht Dürer*, 188.

32: *St. Jerome in His Study* (1514)

1. Price, *Albrecht Dürer's Renaissance*, 199; Bartrum, *Albrecht Dürer*, 189.
2. Price, *Albrecht* Dürer's Renaissance, 204.
3. Hutchison, *Albrecht Dürer*, 116–17; Panofsky, *Life and Art*, 154–55; Price, *Albrecht* Dürer's Renaissance, 209–10, 212; Eisler, *Dürer's Animals*, 144.
4. Eisler, *Dürer's Animals*, 144.

33: *The Rhinoceros* (1515)

1. Salley, *Nature's Artist*, 60; Bartrum, *Albrecht Dürer*, 283.
2. Salley, *Nature's Artist*, 60; Bartrum, *Albrecht Dürer*, 285.
3. Bartrum, *Albrecht Dürer*, 285.
4. Ibid., 285–6.
5. Salley, *Nature's Artist*, 60.

34: Johann von Staupitz

1. Steinmetz, *Reformers in the Wings*, 15–16.
2. Ibid., 17; Bainton, *Here I Stand*, 41, 43, 45.
3. Steinmetz, *Reformers in the Wings*, 17; Bainton, *Here I Stand*, 45–50, 96–97; Hendrix, *Martin Luther*, 50.
4. Bainton, *Here I Stand*, 40.
5. Stauss, *Nuremberg*, 160; Hutchison, *Albrecht Dürer*, 123.
6. Panofsky, *Life and Art*, 198; Conway, *Literary Remains*, 155. Ashcroft, *Albrecht Dürer*, 456, 462. Ashcroft places the scrap of paper in 1517 because it paraphrases a passage from Johannes Staupitz' sermons from 1517, Ashcroft, *Albrecht Dürer*, 466.
7. Ashcroft, *Albrecht Dürer*, 462.

35: Emperor Maximilian

1. Panofsky, *Life and Art*, 174.

2. Hutchison, *Albrecht Dürer*, 107, 114; Panofsky, *Life and Art*, 175; Ashcroft, *Albrecht Dürer*, 350.

3. Eisler, *Dürer's Animals*, 157; Hutchison, *Albrecht Dürer*, 113; Panofsky, *Life and Art*, 175, 177.

4. Silver, *Marketing Maximilian*, 7, 27; Panofsky, *Life and Art*, 182–84.

5. Panofsky, *Life and Art*, 190.

6. Conway, *Literary Remains*, 82; Panofsky, *Life and Art*, 175, 191.

7. Conway, *Literary Remains*, 83; Hutchison, *Albrecht Dürer*, 115; Ashcroft, *Albrecht Dürer*, 415. To see the details of the arch, see an interactive screen at http://www.britishmuseum.org/whats_on/exhibitions/dürers_paper_triumph.aspx.

36: When the Coin Rings

1. Bainton, *Here I Stand*, 56; Moser, *Lucas Cranach*, 78.

2. Bainton, *Here I Stand*, 56–57.

3. Ibid., 57; Hendrix, *Martin Luther*, 56–58.

4. Bainton, *Here I Stand*, 57.

37: Ninety-five Theses

1. Packer and Johnston, *"Historical and Theological,"* 23; Bainton, *Here I Stand*, 54, 55, 57, 63; Hendrix, *Martin Luther*, 58–59.

2. Bainton, *Here I Stand*, 60–63; Hendrix, *Martin Luther*, 61; See Hendrix, *Martin Luther*, 61. For a discussion of whether or not the 95 Theses were nailed to the door of the church.

3. Hendrix, *Martin Luther*, 59–60.

4. Strauss, *Nuremberg*, 161; Bainton, *Here I Stand*, 63–64; Hendrix, *Martin Luther*, 62.

5. Bainton, *Here I Stand*, 62, 65.

38: Luther Says, "Thank You"

1. Strauss, *Nuremberg*, 58; Hendrix, *Martin Luther*, 43, 62.

2. Hutchison, 124; Ashcroft, *Albrecht Dürer*, 483.

39: The Diet of Augsburg (1518)

1. Bainton, *Here I Stand*, 70; Hendrix, *Martin Luther*, 72.

2. Bainton, *Here I Stand*, 69–70; Hendrix, *Martin Luther*, 7.

3. Conway, *Literary Remains*, 30; Silver, *Marketing Maximilian*, 211–12.

4. Conway, *Literary Remains*, 86–87; Ashcroft, *Albrecht Dürer*, 487, 489.

5. Bainton, *Here I Stand*, 70.

6. Ibid., 70–71.

7. Ibid., 71.

8. Ibid.

40: Cardinal Cajetan Interviews Luther

1. Hendrix, *Martin Luther*, 73–74.
2. Bartrum, *Albrecht Dürer*, 238; Hexham and Kope, *Christian Traveler's Guide*, 61; Hendrix, *Martin Luther*, 73.
3. Hendrix, *Martin Luther*, 73.
4. Ibid., 73.
5. Ibid. 74.
6. Bainton, *Here I Stand*, 70.

41: Fleeing by Horseback

1. Bainton, *Here I Stand*, 74–75; Hendrix, *Martin Luther*, 74–75.
2. Bainton, *Here I Stand*, 75; Hendrix, *Martin Luther*, 75; Hutchison, *Albrecht Dürer*, 125.
3. Bainton, *Here I Stand*, 77; Steinmetz, *Reformers in the Wings*, 20–21; Hendrix, *Martin Luther*, 75.
4. Hendrix, *Martin Luther*, 75.

42: Frederick Feels the Squeeze

1. Bainton, *Here I Stand*, 71; Hendrix, *Martin Luther*, 77.
2. Bainton, *Here I Stand*, 79.
3. Ibid., 79; Hendrix, *Martin Luther*, 77; Ozment, *Serpent & the Lamb*, 143.
4. Bainton, *Here I Stand*, 79; Ozment, *Serpent & the Lamb*, 141–43.
5. Bainton, *Here I Stand*, 79–80.
6. Ibid., 80; Hendrix, *Martin Luther*, 77.
7. Bainton, *Here I Stand*, 80.
8. Ibid., 80–81.
9. Hendrix, *Martin Luther*, 82.

43: "Dürer is in Bad Shape"

1. Panofsky, *Life and Art*, 198; Hutchison, *Albrecht Dürer*, 127–28.
2. Ashcroft, *Albrecht Dürer*, 502–3, 514, 519.
3. Hutchison, *Albrecht Dürer*, 127–28.
4. Panofsky, *Life and Art*, 198; Hutchison, *Albrecht Dürer*, 127–28.

44: Luther Debates Eck and Writes Tracts

1. Hendrix, *Martin Luther*, 77–78; Bainton, *Here I Stand*, 86, 92.
2. Hendrix, *Martin Luther*, 80.
3. Ibid., 83–84; Bainton, *Here I Stand*, 92.
4. Eisenstein, *Printing Press*, 303, 310–11.
5. Bainton, *Here I Stand*, 105–6; Hendrix, *Martin Luther*, 89–92, 97–98, 101.

6. Ozment, *Serpent & the Lamb*, 106–7.

7. Eisenstein, *Printing Press,* 303–4.

8. Schoeck, *Erasmus of Europe*, 270–71.

45: Durer's List and Letter

1. Hutchison, *Albrecht Dürer*, 125; Ozment, *Serpent & the Lamb*, 125; Price, *Albrecht* Dürer's Renaissance, 226–27. For Dürer's list of the 16 Luther texts, see Ashcroft, *Albrecht Dürer*, 533–34.

2. Conway, *Literary Remains*, 89–90; Moser, *Lucas Cranach*, 68–69; Ashcroft, *Albrecht Dürer*, 533.

3. Ashcroft, *Albrecht Dürer*, 535.

4. Conway, *Literary Remains*, 157.

5. Panovsky, *Life and Art*, 198.

46: The Papal Bull

1. Hendrix, *Martin Luther*, 82; Hutchison, *Albrecht Dürer*, 126.

2. Hutchison, *Albrecht Dürer*, 126; Strauss, *Nuremberg*, 162–63; Bainton, *Here I Stand*, 121; Steinmetz, *Reformers in the Wings*, 126.

3. Bainton, *Here I Stand*, 121.

4. Bainton, *Here I Stand*, 121–22; Hendrix, *Martin Luther*, 93–94, 100.

5. Bainton, *Here I Stand*, 122–24; Hendrix, *Martin Luther*, 94–95.

47: Cranach's *Luther in a Monk's Niche* (1520)

1. Ozment, *Serpent & the Lamb*, 125–26.

2. Ibid., 125–26.

3. Ibid., 130.

48: Traveling to the Netherlands

1. Hutchison, *Albrecht Dürer*, 128–30; Conway, *Literary Remains*, 92; Ashcroft, *Albrecht Dürer*, 547.

2. Hutchison, *Albrecht Dürer*, 130–31; Conway, *Literary Remains*, 92–93.

3. Hutchison, *Albrecht Dürer*, 131–32.

4. Strauss, *Nuremberg*, 36; Hutchison, *Albrecht Dürer*, 133–34; Conway, *Literary Remains*, 93–95.

5. Hutchison, *Albrecht Dürer*, 135, 149.

6. Ibid., 135; Conway, *Literary Remains*, 95–96.

49: Antwerp, A City of Wealth and Power

1. Strauss, *Nuremberg*, 125; Hutchison, *Albrecht Dürer*, 128–30.

2. Hutchison, *Albrecht Dürer*, 135–36.

3. Ibid., 136.

4. Ibid., 137.

5. Ibid., 137–38.

6. Ibid., 138.

7. Bartrum, *Albrecht Dürer*, 189; Hutchison, *Albrecht Dürer*, 130.

50: Losing His Sight

1. Conway, *Literary Remains*, 90; McColl, "Agony in the Garden," 179; Hutchison, *Albrecht Dürer*, 127. Ashcroft argues that the verb, *wurd*, means "if/when" not "so," 538.

2. Hutchison, *Albrecht Dürer*, 115, 140, 144.

3. Conway, *Literary Remains*, 101–2; Ashcroft, *Albrecht Dürer*, 489, 560, 599.

4. Hutchison, *Albrecht Dürer*, 140–45.

5. Ibid., 146.

51: Coronation at Aachen

1. Hutchison, *Albrecht Dürer*, 146–54.

2. Price, *Albrecht Dürer's Renaissance*, 107; Panofsky, *Life and Art*, 132–33, Hutchison, *Albrecht Dürer*, 112–13.

3. Hutchison, *Albrecht Dürer*, 146.

4. Ibid., 146–47.

5. Conway, *Literary Remains*, 107; Hutchison, *Albrecht Dürer*, 145.

6. Hutchison, *Albrecht Dürer*, 149–50.

7. Ibid., 150–53.

8. Conway, *Literary Remains*, 111; Hutchison, *Albrecht Dürer*, 154–55.

9. Hutchison, *Albrecht Dürer*, 154.

52: Frederick Interviews Erasmus

1. Bainton, *Here I Stand*, 134; Hendrix, *Martin Luther,* 100.

2. Packer and Johnston, "Historical and Theological," 32; Bainton, *Here I Stand*, 132.

3. Packer and Johnston, "Historical and Theological," 32; Bainton, *Here I Stand*, 132; Schoeck, *Erasmus of Europe*, 225.

4. Schoeck, *Erasmus of Europe*, 225.

5. Packer and Johnston, "Historical and Theological," 34; Schoeck, *Erasmus of Europe*, 226.

6. Schoeck, *Erasmus of Europe*, 226.

7. Bainton, *Here I Stand*, 132.

53: The Diet of Worms

1. Conway, *Literary Remains*, 105, 107, 123; Moser, *Lucas Cranach*, 100.

2. Silver, *Marketing Maximilian*, 217–18; Strauss, *Nuremberg*, 34; Ashcroft, *Albrecht Dürer*,

542; "Germany, Nuremberg, *Charles V, Emperor, 1519–1556*," on Nomos website, accessed April 5, 2017, https://nomosag.com/default.aspx?page=ucDetailsMaastrich&id=46.

3. Strauss, *Nuremberg*, 163; Smith, *Nuremberg*, 235; "Germany, Nuremberg, *Charles V, Emperor, 1519–1556*," on Nomos website, accessed April 5, 2017, https://nomosag.com/default.aspx?page=ucDetailsMaastrich&id=46.

54: Final Months in Antwerp

1. Hutchison, *Albrecht Dürer*, 158.

2. Ibid., 159; Strauss, *Nuremberg*, 128.

3. Hutchison, *Albrecht Dürer*, 163.

4. Ibid., 160–62; Conway, *Literary Remains*, 116–18.

5. Hutchison, *Albrecht Dürer*, 162–63.

6. Ibid., 166; Conway, *Literary Remains*, 102.

55: Blood

1. Bainton, *Here I Stand*, 134–35.

2. Ibid., 135.

3. Bainton, *Here I Stand*, 140–41; Hendrix, *Martin Luther*, 103.

4. Bainton, *Here I Stand*, 141; Hendrix, *Martin Luther*, 104.

5. Bainton, *Here I Stand*, 142–44; Hendrix, *Martin Luther*, 105–7.

6. Bainton, *Here I Stand*, 144; Hendrix, *Martin Luther*, 107.

7. Bainton, *Here I Stand*, 144–45.

8. Ibid., 146.

9. Ibid., 146.

10. Hendrix, *Martin Luther*, 107.

11. Ibid., 108; Bainton, *Here I Stand*, 147; Moser, *Lucas Cranach*, 109.

12. Schoeck, *Erasmus of Europe*, 227.

56: Luther is Kidnapped

1. Hutchison, *Albrecht Dürer*, 163–64.

2. Ibid., 164.

3. Ibid., 164.

4. Ibid., 164–65; Ashcroft, *Albrecht Dürer*, 618.

5. Hutchison, *Albrecht Dürer*, 165.

6. Ibid., 165; Ashcroft, *Albrecht Dürer*, 307, 620, 622.

7. Hutchison, *Albrecht Dürer*, 174–75; Panovsky, *Life and Art*, 10.

57: Wartburg Castle

1. Bainton, *Here I Stand*, 149–52; Hendrix, *Martin Luther*, 109.

2. Bainton, *Here I Stand*, 149–50; Hendrix, *Martin Luther*, 109.

3. Bainton, *Here I Stand*, 149–52; Hendrix, *Martin Luther*, 110–11.

4. Bainton, *Here I Stand*, 150–52; Hendrix, *Martin Luther*, 111–12.

5. Bainton, *Here I Stand*, 152; Hendrix, *Martin Luther*, 126.

58: Philip Melanchthon

1. Hendrix, *Martin Luther*, 119–21.

2. Ibid., 76.

3. Bainton, *Here I Stand*, 82, 86, 99; Hendrix, *Martin Luther*, 76.

4. Hendrix, *Martin Luther*, 96; Steinmetz, *Reformers in the Wings*, 49; Scheibel, "Philippus Melanchthon," 425.

5. Bainton, *Here I Stand*, 128.

6. Steinmetz, *Reformers in the Wings*, 49, 51–52.

59: Andres Bodenstein von Karlstadt

1. Steinmetz, *Reformers in the Wings*, 124; Hendrix, *Martin Luther*, 47–48.

2. Hendrix, *Martin Luther*, 120.

3. Hutchison, *Albrecht Dürer*, 179; Ashcroft, *Albrecht Dürer*, 654–55, 515.

4. Eisler, *Dürer's Animals*, 214; Panofsky, *Life and Art*, 222–23.

5. Hendrix, *Martin Luther*, 121.

6. Ibid., 140.

7. Ibid., 124.

8. Ibid., 127.

9. Ibid., 129; Ashcroft, *Albrecht Dürer*, 656.

10. Ashcroft, *Albrecht Dürer*, 656, 777.

11. Bainton, *Here I Stand*, 162.

60: Luther's New Testament in German

1. Hendrix, *Martin Luther*, 135–36; Bainton, *Here I Stand*, 152.

2. Hendrix, *Martin Luther*, 127–28; Bainton, *Here I Stand*, 164.

3. Hendrix, *Martin Luther*, 11, 128. He had visited Wittenberg anonymously in early December 1521 and was visited by Melanchthon and Cranach. Bainton, *Here I Stand*, 158; Hendrix, *Martin Luther*, 122.

4. Hendrix, *Martin Luther*, 128–31.

5. Ibid., 126.

6. Melanchthon, *Loci Communes*, 30.

61: Cranach, the Artist and Publisher

1. Ozment, *Serpent & the Lamb*, 3, 89, 103; Moser, *Lucas Cranach*, 97.

2. Ozment, *Serpent & the Lamb*, 89; Heydenreich, *Lucas Cranach*, 298.

3. Moser, *Lucas Cranach*, 98; Ozment, *Serpent & the Lamb*, 117–18.

4. Moser, *Lucas Cranach*, 98; Ozment, *Serpent & the Lamb*, 108. In the NIV Bible (1996), there is a footnote to Revelation 21:20: "The precise identification of some of these precious stones is uncertain."

5. Ozment, *Serpent & the Lamb*, 108.

6. Parshall, 102–3; Ozment, *Serpent & the Lamb*, 108–9; Wilcock, *Message of Revelation*, 158–60, 163–64, 168.

7. Ozment, *Serpent & the Lamb*, 109; Wilcock, *Message of Revelation*, 159–60.

8. Ozment, *Serpent & the Lamb*, 107–8.

9. Johnson, *History of Christianity*, 271; Hendrix, *Martin Luther*, 14.

62: Luther as Teacher and Reformer

1. Bainton, *Here I Stand*, 166, 178–79; Hendrix, *Martin Luther*, 13, 130–31.

2. Hendrix, *Martin Luther*, 138–39; Sittser, *Water from a Deep Well*, 210.

3. Ozment, *Serpent & the Lamb*, 112–13; Parshall, "Vision of the Apocalypse,"104–5.

4. Hendrix, *Martin Luther*, 144–46; Chadwick, *Reformation*, 67.

5. Moser, *Lucas Cranach*, 117; Hendrix, *Martin Luther*, 142–43.

6. Hendrix, *Martin Luther*, 151, 268–69; Hexham and Kope, *Christian Traveler's Guide*, 214.

7. Hendrix, *Martin Luther*, 133–34; Steinmetz, *Reformers in the Wings*, 21.

63: Books on Art Theory

1. Panofsky, *Life and Art*, 245, 253.

2. Ibid., 244, 247, 248, 251; Conway, *Literary Remains*, 139; Gardner, *Gardner's Art*, 8.

3. Ashcroft, *Albrecht Dürer*, 364, 366, 369.

4. Panofsky, *Life and Art*, 280.

5. Hutchison, *Albrecht Dürer*, 111; Ashcroft, *Albrecht Dürer*, 85–90, 184; 232–42.

6. Hutchison, *Albrecht Dürer*, 180.

7. Conway, *Literary Remains*, 251, Panofsky, *Life and Art*, 273–74, 280.

8. Conway, *Literary Remains*, 228–29.

9. Panofsky, *Life and Art*, 253–54. For a description of *The Course in the Art of Measurement*, see Panofsky, *Life and Art*, 253–60.

10. Panofsky, *Life and Art*, 258.

11. Ibid., 244, 245, 253; for more see Ashcroft, *Albrecht Dürer*, 14–15.

12. Eisenstein, *Printing Press*, 560; Panofsky, *Life and Art*, 270; Ashcroft, *Albrecht Dürer*, 824.

13. Panofsky, *Life and Art*, 246.

64: The "Roman" Engravings

1. Hutchison, *Albrecht Dürer*, 125–26, 184; Price, *Albrecht* Dürer's Renaissance, 225, 237–38, 248.

2. Price, *Albrecht* Dürer's Renaissance, 238–43; Ozment, *Serpent & the Lamb*, 141; "Albrecht of Brandenburg (The Great Cardinal)," Albrecht Dürer in the Serlachius Collection, accessed August 17, 2016, http://serlachius.fi/vn/durer/english/albertus/index.html; Strauss, *Complete Engravings*, 186.

3. Ozment, *Serpent & the Lamb*, 143–46.

4. Price, *Albrecht* Dürer's Renaissance, 243–44.

5. Panofsky, *Life and Art*, 239.

6. Price, *Albrecht* Dürer's Renaissance, 244.

65: *Durer Family Chronicle*

1. Ashcroft, *Albrecht Dürer*, 1–2, 11–12.

2. Hutchinson, *Albrecht Dürer*, 3, 15.

3. Strauss, *Nuremberg*, 82, 253.

4. Hutchison, *Albrecht Dürer*, 15, 18–20.

5. Ibid., 19; Ashcroft, *Albrecht Dürer*, 185–88.

66: Nuremberg Follows Luther

1. Ashcroft, *Albrecht Dürer*, 505–6; Hutchison, *Albrecht Dürer*, 180.

2. Strauss, *Nuremberg*, 4, 163–65.

3. Ibid., 166, 212–13.

4. Ibid., 164, 169–70, 173.

5. Price, *Albrecht* Dürer's Renaissance 228–29; Strauss, *Nuremberg*, 174.

6. Conway, *Literary Remains*, 18.

7. Hutchison, *Albrecht Dürer*, 181; Strauss, *Nuremberg*, 180; Ashcroft, *Albrecht Dürer*, 789.

8. Strauss, *Nuremberg*, 174–76.

9. Ibid., 176–79. For a description of changes in Wittenberg, see Hendrix, *Martin Luther*, 174.

10. Pirkheimer and Renner, vii, x, xi, 1, 65, 69, 76.

11. Hutchison, *Albrecht Dürer*, 181; Strauss, *Nuremberg*, 282.

12. Hendrix, *Martin Luther*, 112, 130–31, 175–76, 196.

67: Letters to Dürer from Abroad

1. Conway, *Literary Remains*, 130; Ashcroft, 721–23.

2. Conway, *Literary Remains*, 28, 129–30; Ashcroft, *Albrecht Dürer*, 595.

3. Conway, *Literary Remains*, 130–31.

68: Melanchthon's Reforms in Nuremberg

1. Hutchison, *Albrecht Dürer*, 183; Price, *Albrecht* Dürer's Renaissance, 277.

2. Pirkheimer, *Die Denkwurdigkeiten*, xiii, xiv, 131.

3. Hutchison, *Albrecht Dürer*, 183, Price, *Albrecht Dürer's Renaissance*, 277.

4. Price, *Albrecht* Dürer's Renaissance, 276–78.

5. Ibid., 276; Steinmetz, *Reformers in the Wings*, 53.

69: Peasants' Revolt

1. Chadwick, *Reformation*, 60; Hendrix, *Martin Luther*, 156.

2. Hendrix, *Martin Luther*, 157.

3, Ibid., 164.

4. Ibid., 173–74.

5. Chadwick, *Reformation*, 60; Hutchison, *Albrecht Dürer*, 182; Hendrix, *Martin Luther*, 156, 158 159, 193; Strauss, *Nuremberg*, 181.

70: The Marriage of Martin and Katherina

1. Hendrix, *Martin Luther*, 141–42; Bainton, *Here I Stand*, 223–24.

2. Bainton, *Here I Stand*, 224–26.

3. Ozment, *Serpent & the Lamb*, 113–14; Hendrix, *Martin Luther*, 165.

4. Bainton, *Here I Stand*, 227, 229; Hendrix, *Martin Luther*, 167.

5. Bainton, *Here I Stand*, 228–30; Hendrix, *Martin Luther*, 167–68, 241–42.

6. Bainton, *Here I Stand*, 228, 234–35.

7. Moser, *Lucas Cranach*, 134; Bainton, *Here I Stand*, 229, 237; Hendrix, *Martin Luther*, 241, 272.

71: *Erasmus* and *Melanchthon* (1526)

1. Price, *Albrecht* Dürer's *Renaissance*, 222.

2. Huizinga, *Erasmus*, 240; Price, *Albrecht Dürer's Renaissance*, 222; Ashcroft, *Albrecht Dürer*, 690, 764–65.

3. Panofsky, *Life and Art*, 239–40; Price, *Albrecht* Dürer's Renaissance, 222–23.

4. Price, *Albrecht* Dürer's Renaissance, 245–47; Ashcroft, *Albrecht Dürer*, 797.

5. Hutchison, *Albrecht Dürer*, 183–84; Ashcroft, *Albrecht Dürer*, 1022.

6. Price, *Albrecht* Dürer's Renaissance, 247; Cetto, *Watercolors*, 19.

7. Schoeck, *Erasmus of Europe*, 226; Luther, *Bondage of the Will*, 179; Hendrix, *Martin Luther*, 169–171; Scheibel, "Philippus Melanchthon," 426–29.

8. Original has "C"arlstadt." Steinmetz, *Reformers in the Wings*, 49.

72: Elector Johannes and the Relics

1. Bainton, *Here I Stand*, 192. In December 1521, Luther had contemplated a blast against Frederick if he did not disperse his relic collection. Bainton, *Here I Stand*, 158–59.

2. Hendrix, *Martin Luther*, 176–77.

3. Ibid., 177–79.

73: *The Four Apostles* (1526)

1. Conway, *Literary Remains*, 135; Price, *Albrecht* Dürer's Renaissance, 261–64.

2. Price, *Albrecht* Dürer's Renaissance, 258, 261; Panofsky, *Life and Art*, 231.

3. Price, *Albrecht* Dürer's *Renaissance*, 258, 265–66; Strauss, *Nuremberg*, 24, 261; Conway, *Literary Remains*, 134; Hutchison, *Albrecht Dürer*, 183. The passages inscribed at the bottom are Revelation 22:18, 2 Peter 2:1–2, I John 4:1–3, Mark 12:38–40, and 2 Timothy 3:1–7. Price, *Albrecht* Dürer's *Renaissance*, 265–56.
4. Panofsky, *Life and Art*, 232.

74: Luther's "A Mighty Fortress Is Our God"

1. Hendrix, *Martin Luther*, 193.
2. Ibid., 193.
3. Bainton, *Here I Stand*, 270; Hendrix, *Martin Luther*. 197–98.
4. Bainton, *Here I Stand*, 269–70.
5. Ibid., 270–71; Hendrix, *Martin Luther*, 198; *Psalter Hymnal*, 469.
6. Strauss, *Nuremberg*, 262; Bainton, *Here I Stand*, 271; Hendrix, *Martin Luther*, 198–99.

75: Durer's Death

1. Strauss, *Nuremberg*, 193; Hutchison, *Albrecht Dürer*, 189; Ashcroft, *Albrecht Dürer*, 886, 887, 913.
2. Hutchison, *Albrecht Dürer*, 184.
3. Ibid., 184–85; Ashcroft, *Albrecht Dürer*, 889, 912. For a translation of parts of Camerarius' short biography of Dürer, see Ashcroft, *Albrecht Dürer*, 951–65.
4. Ashcroft, *Albrecht Dürer*, 891, 1132.
5. Ibid., 891, 1139, 1166.
6. Hutchison, *Albrecht Dürer*, 184.
7. Smith, "Dürer and Sculpture," 94–95; Strauss, *Nuremberg*, 275; Smith, *Nuremberg*, 239.
8. Ashcroft, *Albrecht Dürer*, 814–15.
9. Panofsky, *Life and Art*, 45; Eisenstein, *Printing Press*, 248.

76: More Wonderful, Rare, and Artistic Things

1. Price, *Albrecht* Dürer's *Renaissance*, 281; Conway, *Literary Remains*, 229.
2. Conway, *Literary Remains*, 229.

77: Seven-headed Luther

1. Hendrix, *Martin Luther*, 14.
2. Eisenstein, *Printing Press*, 373.
3. Ozment, *Serpent & the Lamb*, 130.

78: The *Augsburg Confession*

1. Hendrix, *Martin Luther*, 204, 208–9; Goodwin, *Lords of the Horizon*, 87; Moser, *Lucas Cranach*, 156.

2. Hendrix, *Martin Luther*, 204. For a discussion about the differences between Luther and Zwingli, see Hendrix, *Martin Luther*, 205-8. For a discussion about the Anabaptists, see Hendrix, *Martin Luther*, 186-87.

3. Finkel, *Osman's Dream*, 124; Goodwin, *Lords of the Horizon*, 187, Hendrix, *Martin Luther*, 209.

4, Maltby, *Reign of Charles V*, 52, 54; Blockmans, *Emperor Charles V*, 110, 140.

5. Moser, *Lucas Cranach*, 163; Blockmans, *Emperor Charles V*, 83; Hendrix, *Martin Luther*, 211.

6. Hendrix, *Martin Luther*, 214.

7. Ibid., 217; Schoeck, *Erasmus of Europe*, 434.

8. Hendrix, *Martin Luther*, 218-19, 221-22; Hutchison, *Albrecht Dürer*, 179.

9. Hendrix, *Martin Luther*, 223-25; Moser, *Lucas Cranach*, 174.

10. Strauss, *Nuremberg*, 182-83.

11. Ozment, *Serpent & the Lamb*, 5.

79: Pirckheimer Dies a Catholic

1. Konneker, "Willibald Pirckheimer," 93.

2. Schoeck, *Erasmus of Europe*, 273; Strauss, *Nuremberg*, 171-72; Ashcroft, *Albrecht Dürer*, 765.

3. Hutchison, *Albrecht Dürer*, 153-54. Two of Pirckheimer's sisters were abbesses in a Benedictine nunnery near Neuburg on the Danube. Ashcroft, *Albrecht Dürer*, 543.

4. Strauss, *Nuremberg*, 172; Price, *Albrecht* Dürer's Renaissance, 229-30; Hutchison, 185. Panofsky indicates, "Dürer never wavered for a moment in his loyalty to Luther." Panofsky, *Life and Art*, 233.

5. Price, *Albrecht* Dürer's Renaissance, 229; Hendrix, *Martin Luther*, 175-76, 282; Bainton, *Here I Stand*, 176.

80: Between Life and Death

1. Bainton, *Here I Stand*, 261-62.

2. Hendrix, *Martin Luther*, 8, 229, 234, 235; Moser, *Lucas Cranach*, 180.

3. Goodwin, *Lords of the Horizon*, 88; Finkel, *Osman's Dream*, 125.

4. Hendrix, *Martin Luther*, 235-37; Moser, *Lucas Cranach*, 180.

5. Pirkheimer, *Die Denkwurdigkeiten*, ix, xiv.

6. Hendrix, *Martin Luther*, 240, 254; Bainton, *Here I Stand*, 255, 258.

7. Strauss, *Nuremberg*, 170-71, 193.

8. Schoeck, *Erasmus of Europe*, viii, ix, 357-59.

9. Moyhaman, *William Tyndale*, 55-56, 76-77.

10. Hendrix, *Martin Luther*, 254.

11. Moser, *Lucas Cranach*, 200; Heydenreich, *Lucas Cranach*, 22.

12. Finkel, *Osman's Dream*, 128.

13. Hendrix, *Martin Luther*, 262-63.

Endnotes

81: Agnes's Death and Will

1. Ashcroft, *Albrecht Dürer*, 917–18. 921–22.
2. Price, *Albrecht* Dürer's Renaissance, 7; Hutchison, *Albrecht Dürer*, 185.
3. Price, *Albrecht Dürer's Renaissance*, 7.
4. Hutchison, *Albrecht Dürer*, 184; Ashcroft, *Albrecht Dürer*, 990.

82: Surrounded by a Great Cloud of Witnesses

1. Moser, *Lucas Cranach*, 206–7; Hendrix, *Martin Luther*, 259–60.
2. Hendrix, *Martin Luther*, 271; Steinmetz, *Reformers in the Wings*, 129.
3. Hendrix, *Martin Luther*, 278–79.
4. Ibid., 280.
5. Ibid., 271, 283; Moser, *Lucas Cranach*, 220.
6. Hendrix, *Martin Luther*, 283–85.
7. Ozment, *Serpent & the Lamb*, 264–66, 271–73.

83: The Emperor Finally Attacks

1. Finkel, *Osman's Dream*, 134.
2. Ozment, *Serpent & the Lamb*, 251, 253; Maltby, *Reign of Charles V*, 59–60; Blockmans, *Emperor Charles V*, 94–96; Hendrix, *Martin Luther*, 286–87; Moser, *Lucas Cranach*, 226.
3. Chadwick, *Reformation*, 141–43; Ozment, *Serpent & the Lamb*, 253; Hendrix, *Martin Luther*, 287; Humfrey, 158, 160; Hale, *Titian*, 498, 529; Blockmans, *Emperor Charles V*, 96.
4. Hale, *Titian*, 497–99.
5. Maltby, *Reign of Charles V*, 61.
6. Moser, *Lucas Cranach*, 227; Blockmans, *Emperor Charles V*, 96.
7. Moser, *Lucas Cranach*, 227–29; Heydenreich, *Lucas Cranach*, 237; Ozment, *Serpent & the Lamb*, 253–54.
8. Moser, *Lucas Cranach*, 235; Maltby, *Reign of Charles V*, 62–63; Blockmans, *Emperor Charles V*, 154.
9. Moser, *Lucas Cranach*, 237; Hendrix, *Martin Luther*, 287–88.
10. Moser, *Lucas Cranach*, 238; Ozment, *Serpent & the Lamb*, 262.
11. Ozment, *Serpent & the Lamb*, 273–79. Joseph Koerner defends Dürer's fondness for self-portraiture by asking, "Has there ever been a more exultant artist's [self]-portrait than Cranach's in Weimar?" Ozment, *Serpent & the Lamb*, 312, footnote 38.
12. Ozment, *Serpent & the Lamb*, 312, footnote 38.
13. Maltby, *Reign of Charles V*, 114–15; Blockmans, *Emperor Charles V*, 99.
14. Moser, *Lucas Cranach*, 242; Maltby, *Reign of Charles V*, 1, 116–17; Williams, *The World of Titian*, 146.

84: Albrecht Durer's Influence on Art

1. Hutchison, *Albrecht Dürer*, 187–88.
2. Panofsky, *Life and Art*, 10. For his complete works, see Albrect Durer: The Complete

Works, albrecht-durer.org.

3. Conway, *Literary Remains*, 26, 162–64.

4. Panovsky, *Life and Art*, 19; Eisenstien, *Printing Press*, 234.

5. Ashcroft, *Albrecht Dürer*, 859–60.

6. Joseph Koerner, "Albrecht Dürer," 32.

7. Eisler, *Dürer's Animals*, 329; Smith, "Dürer and Sculpture," 87; Hutchison, *Albrecht Dürer*, 186–87, 190; Bartrum, *Albrecht Dürer*, 239, 256, 257–59.

8. Hutchison, *Albrecht Dürer*, 190.

9. Conway, *Literary Remains*, 182–83; Smith, *Nuremberg*, 45.

10. Ashcroft, *Albrecht Dürer*, 1006–7.

11. Panofsky, *Life and Art*, 11, 272.

12. Conway, *Literary Remains*, 138–39.

13. Panovsky, *Life and Art*, 12.

14. Ibid., 11, 272.

15. Hendrix, *Martin Luther*, 8–9; Goodwin, *Lords of the Horizon*, 88, footnote.

16. Panovsky, *Life and Art*, 12; Hutchison, *Albrecht Dürer*, 164.

Epilogue

1. Steinmetz, *Reformers in the Wings*, 21; Eisenstein, *Printing Press*, 415, 416.

2. Moser, *Lucas Cranach*, 242; Hendrix, *Martin Luther*, 77; Steinmetz, *Reformers in the Wings*, 56.

3. Goodwin, *Lords of the Horizon*, 158–59.

4. Strauss, *Nuremberg*, 147–49.

5. Smith, *Dürer*, 257.

6. Panofsky, *Life and Art*, 234; Price, *Albrecht* Dürer's Renaissance, 260–61.

7. Fulbrook, *Concise History*, 55–60.

8. Hutchison, *Albrecht Dürer*, 85.

9. Moxey, "Impossible Distance," 219.

10. Smith, "Dürer and Sculpture," 98.

11. Cuneo, "The Artist," 115–17.

12. Hutchison, *Albrecht Dürer*, 188. For a history of the hair, see Ashcroft, *Albrecht Dürer*, 1017–19.

13. Ramshaw, *Keeping Time*, 208.

Bibliography

Ashcroft, Jeffrey. *Albrecht Dürer: Documentary Biography.* New Haven: Yale University Press, 2017.

Bainton, Roland H. *Here I Stand: A Life of Martin Luther.* New York: Meridian, 1995.

Bartrum, Giulia, ed. *Albrecht Dürer and His Legacy: The Graphic Work of a Renaissance Artist.* Princeton: Princeton University Press, 2002.

Bartrum, Giulia, Rhoda Eitel-Porter, and Frances Carey. "Catalog." In *The Apocalypse and the Shape of Things to Come*, edited by Frances Carey, 125–207. Toronto: University of Toronto Press, 1999.

Biertenholz, Peter G. and Thomas Brian Deutscher, eds. *Contemporaries of Erasmus: A Biographical Register of the Renaissance and the Reformation.* 3 vols. Toronto: University of Toronto Press, 2003.

Blockmans, Wim. *Emperor Charles V: 1500–1558.* New York: Oxford University Press, 2002.

Bongard, Willi, and Matthias Mende. *Dürer Today.* Bonn-Bad Godesberg: Inter Nationes, 1971.

Carey, Frances, ed. *The Apocalypse and the Shape of Things to Come.* Toronto: University of Toronto Press, 1999.

Carey, Frances. Preface to *The Apocalypse and the Shape of Things to Come*, edited by Frances Carey, 6–9. Toronto: University of Toronto Press, 1999.

Caro, Ina. *The Road from the Past: Travelling through History in France.* San Diego: Harcourt Brace, 1996.

Cetto, Anna Maria. *Watercolors by Albrecht Dürer.* New York: Macmillan, 1954.

Chadwick, Owen. *The Reformation.* New York: Penguin, 1964.

Cuneo, Pia F. "The Artist, His Horse, a Print, and Its Audience: Producing and Viewing the Ideal in Dürer's Knight, Death and the Devil (1513)." In *The Essential Dürer*, edited by Larry Silver et al., 115–29. Philadelphia: University of Pennsylvania Press, 2010.

Couchman, Judith. *The Art of Faith: A Guide to Understanding Christian Images.* Brewster, MA: Paraclete, 2012.

Conway, William Martin, ed. and trans. *Literary Remains of Albrecht Dürer.* New York: Philosophical Library, 1958.

Eisenstein, Elizabeth L. *The Printing Press as an Agent of Change: Communications and Cultural Transformations in Early-Modern Europe.* Vols. 1 and 2. Cambridge: Cambridge University Press, 1980.

Eisler, Colin. *Dürer's Animals.* Washington, DC: Smithsonian, 1991.

Erasmus, Desiderius. *In Praise of Folly.* Translated by John Wilson. Mineola, NY: Dover, 2003.

Bibliography

Faroqhi, Suraiya. *The Ottoman Empire: A Short History*. Translated by Shelley Frisch. Princeton: Markus Wiener, 2009.

Finkel, Caroline. *Osman's Dream: The Story of the Ottoman Empire 1300–1923*. New York: Basic Books, 2005.

Foister, Susan. *Dürer and the Virgin in the Garden*. New Haven, CT: Yale University Press, 2004.

Fulbrook, Mary. *A Concise History of Germany*. Cambridge: Cambridge University Press, 1990.

Gardner, Helen. *Gardner's Art through the Ages*. 7th ed. Revised by Horst de la Croix and Richard G. Tansey. New York: Harcourt Brace Jonanovich, 1980.

Goodwin, Jason. *Lords of the Horizon: A History of the Ottoman Empire*. New York: Holt, 1998.

Gonzalez, Justo L. *The Story of Christianity*. Vol. 1, *The Early Church to the Dawn of the Reformation*. Rev. ed. New York: Harper Collins, 2010.

Hale, Sheila. *Titian: His Life*. New York: Harper, 2012.

Hendrix, Scott H. *Martin Luther: Visionary Reformer*. New Haven: Yale University Press, 2015.

Hexhan, Irving, and Lothar Henry Kope. *The Christian Traveler's Guide to Germany*. Grand Rapids: Zondervan, 2001.

Heydenreich, Gunnar. *Lucas Cranach the Elder: Painting Materials, Techniques and Workshop Practice*. Amsterdam: Amsterdam University Press, 2007.

Huizinga, Johan. *Erasmus and the Age of Reformation*. New York: Harper Torchbooks, 1957.

Humfrey, Peter. *Titian*. New York: Phaidon, 2007.

Hutchison, Jane Campbell. *Albrecht Dürer: A Biography*. Princeton: Princeton University Press, 1990.

Johnson, Paul. *A History of Christianity*. New York, Atheneum, 1976.

Koerner, Joseph. "Albrecht Dürer: A Sixteenth-Century Influenza." In *Albrecht Dürer and His Legacy*, edited by Giulia Bartrum, 18–38. Princeton: Princeton University Press, 2002.

Konneker, Barbara. "Willibald Pirckheimer." In *Contemporaries of Erasmus: A Biographical Register of the Renaissance and the Reformation*, edited by Peter G. Biertenholz et al., 3:90–94. Toronto: University of Toronto Press, 2003.

Latourette, Kenneth. *Beginnings to 1500*. Vol. 1 of *A History of Christianity*. New York: Harper & Row, 1975.

Luther, Martin. *The Bondage of the Will*. Translated by J. I. Packer and O. R. Johnston. Grand Rapids: Revell, 1957.

Maltby, William. *The Reign of Charles V*. New York: Palgrave, 2002.

McColl, Donald. "Agony in the Garden: Dürer's 'Crisis of the Image.' " In *The Essential Dürer*, edited by Larry Silver, et al., 166–84. Philadelphia: University of Pennsylvania Press, 2010.

Melanchthon, Philip, and Charles Leander Hill. *The Loci Communes of Philip Melanchthon*. Boston: Meador, 1944.

Moxey, Keith. "Impossible Distance: Past and Present in the Study of Dürer and Grunewald." In *The Essential Dürer*, edited by Larry Silver, et al., 206–66. Philadelphia: University of Pennsylvania Press, 2010.

Moynahan, Brian. *William Tyndale: If God Spare My Life*. London: Abacus, 2003.

Moser, Peter. *Lucas Cranach: His Life, His World and His Art*. Translated by Kenneth Wynne. Bamberg: Babenberg, 2005.

Olds, Clifton C. "Dürer and Nuremberg." In *Dürer's Cities: Nuremberg and Venice*, edited by Robert A. Yassin, 9–15. Ann Arbor: University of Michigan Museum of Art, 1971.

Ozment, Steven. *The Serpent & the Lamb: Cranach, Luther, and the Making of the Reformation.* New Haven: Yale University Press, 2011.

Packer, J. I. and O. R. Johnston. "Historical and Theological Introduction." In *The Bondage of the Will* by Martin Luther, translated by J. I. Packer and O. R. Johnston, 13–61. Grand Rapids: Revell, 1957.

Panofsky, Erwin. *The Life and Art of Albrecht Dürer.* Princeton: Princeton University Press, 1955.

Parshall, Peter. "The Vision of the Apocalypse in the Sixteenth and Severnteenth Centuries." In *The Apocalypse and the Shape of Things to Come,* edited by Frances Carey, 99–124. Toronto: University of Toronto Press, 1999.

Pirkheimer, Charitas. *Die Denkwürdigkeiten der Äbtissin Caritas Pirckheimer.* Edited by Frumentius Renner. St. Ottilein: EOS, 1982.

Price, David Hotchkiss. *Albrecht Dürer's Renaissance: Humanism, Reformation , and the Art of Faith.* Ann Arbor: University of Michigan Press, 2003.

Psalter Hymnal. Grand Rapids: CRC, 1988.

Ramshaw, Gail, and Mons Teig. *Keeping Time: The Church's Year.* Using Evangelical Lutheran Worship 3. Minneapolis: Augsburg Fortress, 2009.

Russell, Francis and the Editors of Time-Life Books. *The World of Dürer 1471–1528.* New York: Time Inc., 1967.

Salley, Victoria. *Nature's Artist: Plants and Animals by Albrecht Dürer.* New York: Prestel, 2008.

Scheibel, Heinz. "Philippus Melanchthon." In *Contempories of Erasmus: A Biographical Register of the Renaissance and the Reformation,* edited by Peter G. Biertenholz and Thomas Brian Deutscher, 2:424–29. Toronto: University of Toronto Press, 2003.

Schoeck, R. J. *Erasmus of Europe: The Prince of Humanists, 1501–1536.* Edinburgh: Edinburgh University Press, 1993.

Silver, Larry. *Marketing Maximilian: The Visual Ideology of a Holy Roman Emperor.* Princeton, NY: Princeton University Press, 2008.

Silver, Larry, and Jeffrey Chipps Smith, eds. *The Essential Dürer.* Philadelphia: University of Pennsylvania Press, 2010.

Sittser, Gerald L. *Water from a Deep Well: Christian Spirituality from Early Martyrs to Modern Missionaries.* Downers Grove, IL: InterVarsity, 2007.

Smith, Jeffrey Chipps. *Dürer.* London: Phaidon, 2012.

———. "Dürer and Sculpture," in *The Essential Dürer,* edited by Larry Silver et al., 74–98. Philadelphia: University of Pennsylvania Press, 2010.

———. *Nuremberg: A Renaissance City, 1500–1618.* Austin: University of Texas Press, 1983.

Strauss, Gerald. *Nuremberg in the Sixteenth Century.* New York: Wiley, 1966.

Strauss, Walter L., ed. *The Complete Engravings, Etchings and Drypoints of Albrecht Dürer.* Mineola, NY: Dover, 1972.

Steinmetz, David C. *Reformers in the Wings: From Geiler von Kayserberg to Theodore Beza.* 2nd ed. Oxford: Oxford University Press, 2001.

Strieder, Peter. *Albrecht Dürer: Paintings, Prints, Drawings.* Translated by Nancy M. Gordon and Walter L. Strauss. New York: Abans, 1982.

Unger, Miles. "Hi, Venice? It's Istanbul. Can You Send a Painter?" *New York Times,* December 22, 2005, Arts, 36.

Bibliography

Werner, Alfred. Introduction to *The Writings of Albrecht Dürer*. Translated and edited by
 William Martin Conway, ix–xviii. New York: Philosophical Library, 1958.

Wilcock, Michael. *The Message of Revelation*. Downers Grove, IL: InterVarsity, 1975.

Williams, Jay. *The World of Titian c. 1488–1576*. New York: Time-Life, 1968.

Wolf, Norbert. *Albrecht Dürer 1471–1528: The Genius of the German Renaissance*. Cologne:
 Taschen, 2006.

Wolfflin, Heinrich. *The Art of Albrecht Dürer*. Translated by Alistair and H. Grieve. New
 York: Phaidon, 1971.

Zuffi, Stefano. *Dürer*. Translated by Anna Bennett. New York: DK, 1999.

Subject Index

Sctipture Index

34

CPSIA information can be obtained
at www.ICGtesting.com
Printed in the USA
BVHW021913130919
558404BV00017B/223/P

9 781532 619656